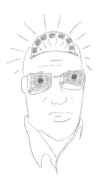

W9-CNQ-968

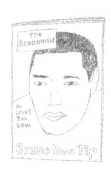

BILL GATES

150

The Canadians

Glorious & Free

Kim Bozak and
Rita Field-Marsham

Foreword by
Yann Martel

Distributed in Canada by
House of Anansi Press through:

Distributed in the United States
by House of Anansi Press through:

University of Toronto Press
5201 Dufferin Street
Toronto, ON M3H 5T8
Toll free tel. 1-800-565-9523

Publishers Group West
1700 Fourth Street
Berkeley, CA 94710
Toll free tel. 1-800-788-3123

21 20 19 18 17 1 2 3 4 5

Library and Archives Canada Cataloguing in Publication
Field-Marsham, Rita, author Glorious & free : the Canadians / Rita Field-Marsham and Kim Bozak ; foreword by Yann Martel ; illustrations by Frank Viva.

Issued in print and electronic formats.

ISBN 978-1-4870-0352-4 (hardcover).--ISBN 978-1-4870-0353-1 (EPUB).--
ISBN 978-1-4870-0354-8 (Kindle)

1. Successful people--Canada--Biography. 2. Success--Canada--Case studies.
3. Creative ability--Canada--Case studies. 4. Canada--Biography. I. Bozak, Kim, author II. Title. III. Title: Glorious and free.

FC25.F54 2017 971.009'9 C2017-902288-1
C2017-902289-X
Library of Congress Control Number: 2017937808

Page 396 constitutes a continuation of this copyright page.

We acknowledge for their financial support of our publishing program the Canada Council for the Arts, the Ontario Arts Council, and the Government of Canada through the Canada Book Fund.

Printed and bound in Canada

This book is available at special discounts when purchased in quantity for premiums and promotions as well as fundraising or educational use.

Special editions can also be created to specification. For details, contact sales@gloriousandfree.ca.

Kim Bozak and
Rita Field-Marsham

Photographs by
Joanne Ratajczak

Foreword by
Yann Martel

Illustrations by
Frank Viva

AMBROSIA

An imprint of House
of Anansi Press Inc.

all free to
be whoever
we dream
to be.

The world is more beautiful when we are

The Canadians

Foreword by
Yann Martel

Let's talk about Homer and Jesus.

Homer, if he was indeed a single, actual person, is thought to have lived during the eighth century BCE in some part of the lands inhabited by the Greek people. He's also considered the author of two epics, the *Iliad* and the *Odyssey*, that mark the beginning of Western literature—its first two books. The *Iliad* recounts an episode in a disastrous ten-year war fought some four centuries earlier between forces from Mycenaean Greece and the city of Troy. Shortly after the end of the Trojan War, Mycenaean Greece collapsed. The cause of this calamity is not known. An earthquake? An invasion from the north by a people named the Dorian? Whatever the cause, a long and depleting war would not have helped. The collapse was dramatic: politics, commerce, culture all shrank to shadows of their former selves, and the Greeks even forgot how to read and write. This period, known as the Greek Dark Ages, lasted for over three hundred years.

During those centuries, the darkness was complete except for one ray of light: oral tales, most notably the *Iliad* and the *Odyssey*. Decade after decade, century after century, bards recited stories of the Trojan War and of Odysseus's wanderings to rapt listeners, passing the tales on to succeeding generations of bards. These sagas became the only link between the forgotten Greece of the twelfth century and the awakening Greece of the ninth.

And what a beacon they were. Homer's two epics are the founding myth of the Greek people—their bible. They told them not only who they were but how they should be. Without those stories, the Greeks would not be Greeks.

But here's the curious part: there is very little evidence the Trojan War actually took place and no evidence whatsoever about a war fought over a beautiful woman named Helen, led on the one side by Priam and his sons Hector and Paris and on the other by Agamemnon, Menelaus, and heroes such as Achilles, Odysseus, and Ajax. The evidence is circumstantial, elusive.

There was a city named Troy, famously excavated by the German archaeologist Heinrich Schliemann in the 1870s and located at a site now called Hisarlik on the western coast of Anatolia in modern Turkey. Of the nine compressed levels he unearthed of the vanished ancient Troy, level VIIa is possibly Priam's Troy. And some inscribed tablets found in central Anatolia among the remains of the capital of the Hittites, another powerful empire at the time, speak of clashes between a people who might be the Mycenaeans and another people who perhaps were the Trojans. Possibly ... might ... perhaps—it's not much to go on. We have a wisp of historical evidence, two dazzling stories about this wisp, and then we have the Greeks. That is the order of things: a wisp, a story, a people.

Now, Jesus. Jesus—to some no more than a charismatic Jewish rabble-rouser, to others the very son of God—was born, grew up, preached, was killed, and then may have risen from the dead. But how did his story, which lies at the heart of Western history, come to us? Jesus didn't write anything that has survived —he very likely was illiterate—and he seems to have been surrounded by illiterates, because no one who met him wrote anything about the encounter that has survived. The Apostle Paul's epistles are the earliest Christian documents we have—but Paul never met Jesus. Paul wrote his letters twenty years after Jesus died. The Evangelists—Matthew, Mark, Luke, and John, none of whom knew Jesus—are even more removed in time from the Jesus of history. The oldest Gospel, Mark, is thought to have been written thirty-five to forty years after the death of Jesus.

As for the Romans, not a single Roman administrator, soldier, merchant, traveller, philosopher, scholar, or anyone else wrote anything about Jesus at the time. There is a similar blank slate about the living Jesus on the Jewish side. The Romans Pliny the Younger and Tacitus wrote briefly about him, as did the Jew Josephus, but all three did so toward the end of the first century CE. There is, then, not a single written word from any source about a direct, factual encounter with Jesus of Nazareth. Essentially, there is nothing strictly historical about him at all.

So how did Jesus the man survive to become the Jesus of Christianity? Oral tales once again. Clearly, among all the many messiahs of the time, Jesus stood out. There was something about him, a quiet yet dazzling charisma expressed in his words, his manner and actions, his very being, that struck people so forcefully that they remembered him. More than that: they talked about him—for years.

And in that talking about him, year after year, only the essential was preserved. That's how oral tales work. They hold onto the essential, expressing it in concise, often symbolic terms that are easy to remember and retell, and they let go of the trivial. Isn't it extraordinary, for instance, that we haven't a clue about the appearance of this man who changed the course of world history? Was he tall? Was he thin? What colour were his eyes, his hair? He is traditionally portrayed in a way that fulfills our expectations of an attractive man: lean, toned, glabrous, a handsome face. But in truth we have no idea what Jesus looked like. It's of no consequence and so was forgotten. In the Gospels we do not have the factual Jesus of history. What Matthew, Mark, Luke, and John wrote down were, rather, symbolic texts, using such artful devices as metaphors and parables. In the Gospels we have the Jesus of oral tales, the Jesus of story, the Jesus of significance.

We have a wisp of historical evidence, four stories about this wisp, and then we have the Christians. That is once again the order of things: a wisp, a story, a people. The pattern is the same as with Homer.

Yann Martel is the author of a book of short stories, a collection of letters to former prime minister Stephen Harper, and four novels, most notably the Man Booker Prize–winning *Life of Pi*. His latest novel is *The High Mountains of Portugal.*

Why is this relevant to Canada in 2017, on the sesquicentennial of our nation? Who cares about the historicity of Homer and Jesus?

Here's why it's relevant. We live in a time where rationality, science, technology, accounting, bureaucracy, fact-checking, data collecting, and other forms of close attention to details are the triumphant mode of apprehension of our world. We disregard what cannot be precisely quantified. And we've done very well living like that. Most of us live far better than people did in earlier times, certainly better than the average Greek or Trojan at the time of Homer or the average Roman or Jew at the time of Jesus.

But still: life is not essentially about rationality. We want to be rational to a degree, but our deepest mode of apprehension of life, of what it means to be human, is not through fact-checking. You need only so many facts in life to get by. Facts are kindling. What keeps us staring in fascination is the fire that comes from this kindling, the fire of our dreams and stories. What we want, while we maintain a sensible level of reasonableness (to ward off insanity or ignorance), is a lively and active imagination, a deep, life-changing imagination. That is not a given in this age where we are suspicious of flights of fancy. But look at the Greeks and the Christians, the two legs of Western civilization: before being, before becoming, they listened to stories.

And if you feel this line of reasoning is still remote, then look at those who first populated Canada. We have there, before our eyes, a living example of what I'm talking about. I don't mean that the Indigenous peoples of Canada, the First Nations, our collective landlords, are like the Trojans, assaulted and under siege by the Greek forces—in this case the European colonizers and their descendants—nor that they have been made to suffer very much like Jesus did, though both statements are true. What I mean is that they have kept their traditions alive in precisely the way the Homeric bards did during the Greek Dark Ages or the early Christians did after the death of Jesus—by oral storytelling. This tradition has preserved the essential elements of their history and provided a means to understand and shape who they are as people. As an elder in British Columbia long ago said to a government official who claimed ownership over the group's territory, "If this is your land, where are your stories?" It's all about stories.

And so this book, in which an array of wildly creative Canadians are on display. We live in a country of extraordinary freedom—a hard-earned gift we must do everything to preserve —and each of these brilliant individuals has made the most of that freedom. This book is a celebration of both the Canadian story and the people of that story.

Share the story, spread it, add to it.

"We're Kim and Rita, close friends and neighbours living the Canadian urban experience. We were born worlds apart: Kim into a Ukranian-British-Norwegian family in Saskatchewan; Rita into a Dutch-Kenyan family in Nairobi. We each have what you might call an 'insider' and 'outsider' view of Canada."

Introduction

Kim Bozak

I'm a third-generation Canadian from a modest middle-class Prairie family. As an adult I moved from Western Canada to the east, finally settling in Ontario. Through the years my life has changed in ways I couldn't have predicted; living here afforded me the freedom to leave a career in politics and finance to pursue my passion for art. That passion was sparked by *The Art Book*—a compendium of the world's great artists I saw at Costco one day while shopping with my dad. (I was twenty-three at the time.) The book cost $26, which was steep for me, so I asked for it as a Christmas gift. My family's story is one of hardship and transformation—a familiar narrative for many Canadians—and it gave me the courage to risk a change of course in my life. When my Ukranian grandfather arrived here in the 1930s he played professional hockey but was forced to change into his gear outside in the cold. Back then dressing rooms were reserved for players of Anglo-Saxon heritage. Two generations later his grandson Tyler Bozak is one of the leading players on the Toronto Maple Leafs.

Rita Field-Marsham

After moving to Canada in 2004, I took a while to apply for citizenship. I wasn't yet thinking of myself as an immigrant—I, personally, wasn't fleeing persecution or hardship back in Kenya. I had earlier lived in Montreal to attend McGill University, then returned home. More than a decade later, my Canadian husband and I moved to Toronto. In those days I thought of immigration almost in the negative, in terms of leaving home because you have to. But then, as I found my way in this diverse Canadian society that gradually became so inspiring to me, I saw the power in positively choosing to become a part of something larger and more magnificent— Canada. And so I took the oath of citizenship. Like all immigrants, finding my place meant reinventing myself and embracing my life story in a new country—a tolerant one full of open spaces and largely free of injustice and the constraints of tradition. This is the story of Canada that I tell children in Kenya and in refugee camps who want to move here. It's not a story about the snow. It's about the people who live here and their values, attitudes, and empowering culture.

Seven years ago, while carpooling our kids, we hit upon something in one of our daily chats. Despite our very different backgrounds, we agreed that the best thing about this country was the freedom to be who you want to be. Nothing in Canada had ever prevented us from doing the things we wanted to do, no matter how daunting they were or how unlikely we were to succeed. The people around us were also living to their fullest expression, with few limitations, whatever their backgrounds, talents, and dreams. As we looked beyond our circles, we saw this experience mirrored by many other vastly diverse Canadians, even in the remotest islands and corners of the country. One thing became obvious: we Canadians are free to be whoever we dream to be if we're courageous enough to embrace it. That is the fiery, new identity we celebrate in this book.

Books, words, art, photography, film, travel, family, friends, and role models have played a powerful part in our own lives, so creating a visual storybook about the lives of contemporary Canadians felt like the best and most natural way to celebrate this identity. Our curiosity led us to seek out and go behind the scenes with thirty-three of Canada's most daring and creative individuals. Among this group we saw millions of hidden Canadian heroes who, regardless of background and obstacle, actively pursue their dreams. Despite their different life stories, we found more similarities than differences. They're original, audacious, hard-working risk-takers. They're creators and doers who have a vision of how they want to live and then make it happen. They succeed, fail, invent, and reinvent over and over again.

They've embraced what sets them apart. The poet Mustafa Ahmed put it to us this way: "I'm willing to lose friends who aren't comfortable with me because I am an inner-city Muslim who prays openly anywhere, any place, any time, and I love Drake, who's Jewish, and the Weeknd, who's Christian, and I love Allah and rap concerts and going to the mosque. Co-existence is the reality on the ground." They also recognize it is a uniquely Canadian combination of values— openness, compassion, diversity—that has made their rich lives possible. As we were told by Nathalie Bondil, a museum curator originally from France: "It's really great to be in Canada right now because Canada is not as divided by conflicts or as polarized as other countries. Here you are defined by who you are as an individual." Which is why we call the individuals gathered in this book the glorious and free—the living, breathing, and walking proof of a Canada that is less a mosaic than an intricately beautiful, vibrant, and constantly changing kaleidoscope.

To produce this book, our brilliant, nomadic photographer, Joanne Ratajczak, spent more than a year criss-crossing the continent, assigned with the task of creating a collective portrait of Canada—an authentic and intimate picture of who we are today. As you leaf through these pages, you may imagine bumping into any one of these individuals on the street or in a crowded bar. They all spoke to us with disarming candour, eager to share how they've lived and learned. Perhaps you'll even see a bit of yourself reflected in their stories. We hope they will inspire you, just as they inspired us, to fall deeply in love with life, to use your energy, gifts, vision, and heart to put your own stamp on the world. As you do, you'll be contributing something bigger than yourself to the ever-changing beauty of Canada—spreading a culture that is glorious and free.

The Canadians

Glorious
& Free

Like many aspiring architects, Alex Josephson used his own apartment for one of his earliest projects. But he didn't just paint it or redo the lighting. Inspired by the "unlivable" space of Weimar-era Surrealist Kurt Schwitters, Alex gutted the top floor of one of the oldest buildings in Toronto's tony Yorkville neighbourhood and transformed it into an aggressively stripped-down industrial loft. He slept on a salvaged tatami mat. The bathroom had no walls. It was a home but also a calling card—with his business partner, Pooya Baktash, Alex started his own design firm, Partisans, in the loft in 2011.

Alex Josephson

Architect

Toronto, ON

Maker of Worlds

The apartment didn't have air conditioning, naturally, and one particularly humid summer night, the two men worked outdoors, shirtless, on the deck. The opera-loving Baktash put on some Puccini. By midnight, residents of the thirty-storey condo next door came out on their balconies to listen. They lit candles, poured wine, and the moment became an impromptu celebration of aesthetic and urban harmony— and, for Alex, an illustration of Partisans' very ethos.

"When you have great architecture," he says, "you have to see it as an opera rather than a building. You have to have the collaboration of scientists, engineers, artists, city planners, clients, and financiers. It requires so many different levels of cooperation and coordination to be meaningful."

Alex earned this wisdom. As a kid with hearing problems, he struggled in school but learned to express himself with drawing and modelling clay. He was attracted to art and architecture but found little support from school. "I went to a boys private school and they had no fucking clue how to encourage someone to be an architect. Being an architect was my form of rebellion." His parents, on the other hand, were supportive if "healthily skeptical." (Alex's mom studied interior design at the Parsons School of Design in New York.) "That was good for me," he says. "It made me understand how difficult it would be." One of his biggest heroes remains his beloved grandmother, a brash, colourful woman fond of Prada leather pants. When his grandfather couldn't walk anymore, Alex would be her date for art-show openings and other cultural events. "The things I took from her are in my DNA," says Alex (himself fond of an all-black uniform and occasional nail polish).

Contemporary architecture teems with avant-garde virtuosos and rabble-rousing rule benders. But Alex is cut from more roguish cloth—he rebels against many of the tenets of architectural practice itself. He studied architecture for ten years but still doesn't have a licence. He doesn't like to call Partisans a design or architectural firm but prefers the terms "movement" or "syndicate." The firm's projects strenuously blur the border between art and architecture, form and function. And while their designs require bleeding-edge technology to execute, he's galvanized by more ancient inspiration: "We draw from more primal, organic, indigenous forms of architecture—it's beautiful, it's our roots, it's what is unique to Canada." That influence is evident in two of Partisans' first, award-winning bespoke projects: Bar Raval, one of Toronto's most alluring taverns, and the voluptuous Grotto Sauna in Georgian Bay.

Alex's biggest act of rebellion might be his refusal of stereotypical Canadian modesty: "We're working on what I think, as a larger project, is just plain cleverness. There's a real cleverness and invention in each of the projects we do." For a boutique shop, Partisans scaled up quickly: they recently designed the retail concourse at Union Station, one of the largest civic infrastructure revitalization efforts in the world; brought on two new partners in Jonathan Friedman and Nicola Spunt; and overhauled the decommissioned Hearn Generating Station for the 2016 Luminato Festival with spectacular results. In 2017 Partisans officially launched Gweilo, a sculptural lighting system, which the firm oversaw from prototype to commercial product.

Every movement ultimately has a leader. Ask Alex what he does for a living, and the answer is characteristically provocative: "World builder. You know, maker of worlds."

Alex's old apartment in Yorkville area in Toronto.

"The biggest difference of my generation is the availability of porn. We respond to this with explicitness in our architecture, with sensuality."

Right: A carved figurine amplifies the scale and erotic nature of the model's architecture.

Below: Partisans' ideas extend beyond structures to custom prayer mats.

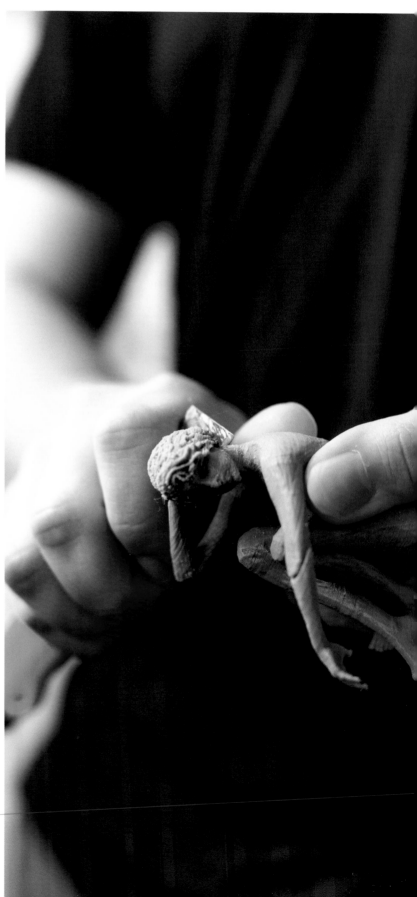

"We have this naive notion that architecture can be politically relevant."

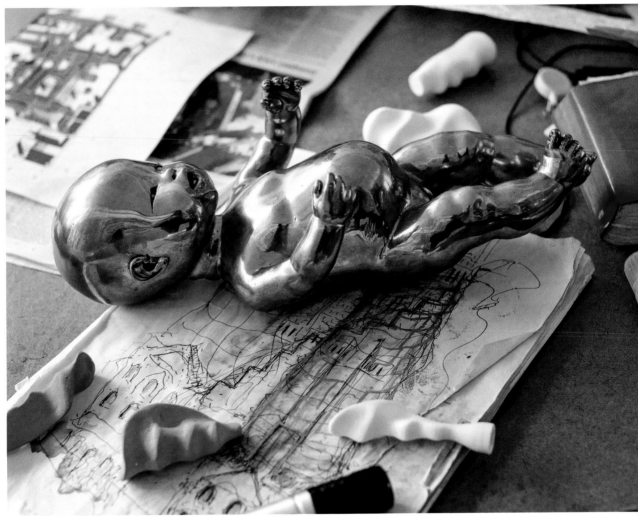

As a protest against China's one-child policy, Alex created hundreds of these Baby Girl sculptures and delivered them to the Chinese consulate daily to represent the number of girls lost. "Our roots are in things like this," says Alex. "Our roots aren't in architecture; they're in the ideas that spawn architecture."

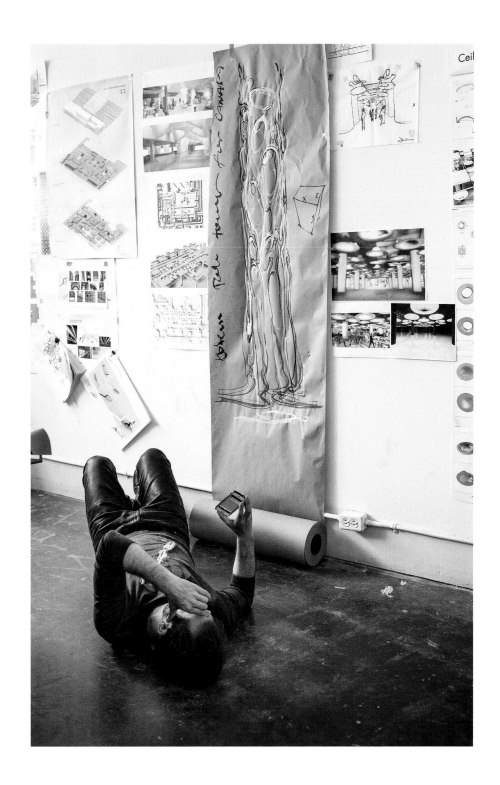

"I went to a boys private school and they had no fucking clue how to encourage someone to be an architect."

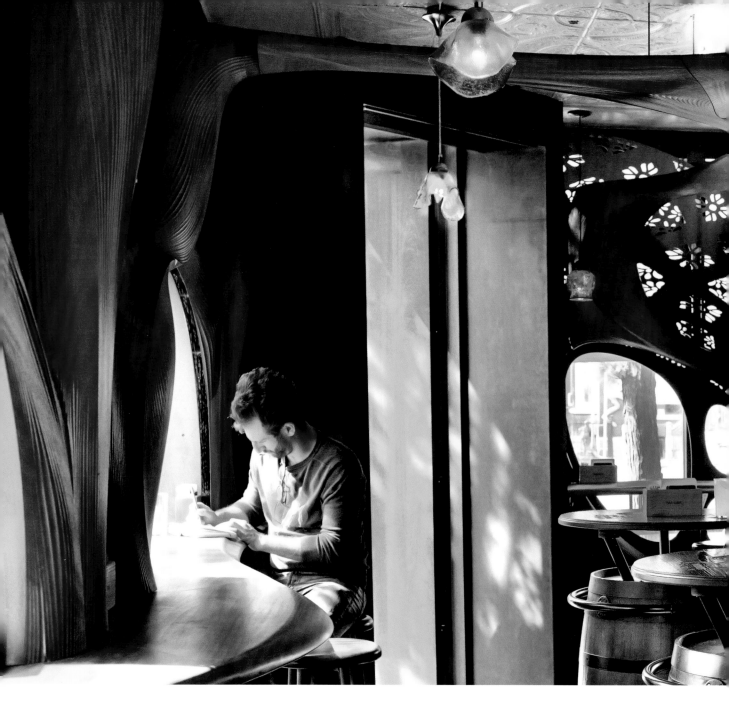

"Misery is having to do what someone tells me to do. What I want is the freedom to express myself. And my art form is architecture."

The Antoni Gaudi-inspired design of Toronto's Bar Raval was created by Alex (seated at left) with his partners at Partisans.

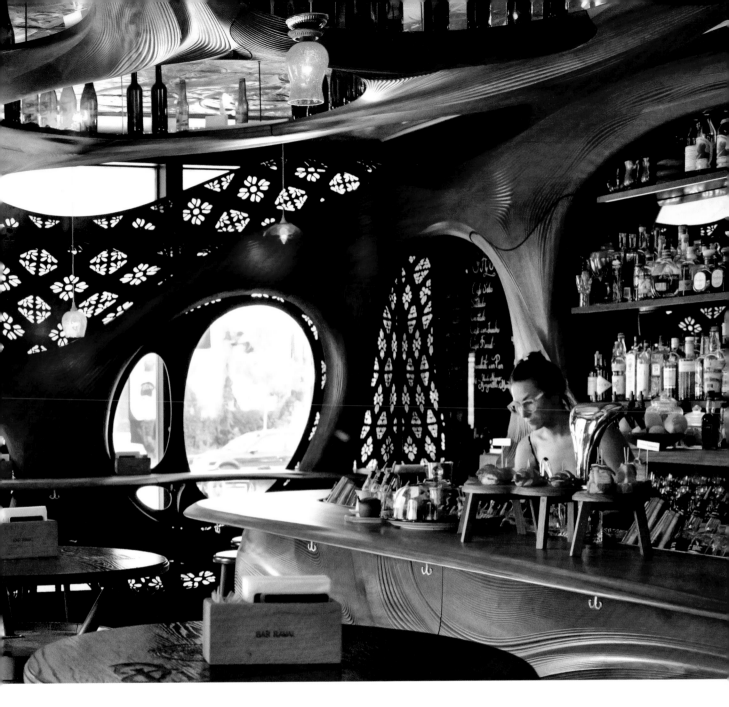

1985 Born in Toronto, ON

2009 Awarded a New York Prize Fellowship
by the Van Alen Institute for his project
"Beijing Strain," a collaboration with
Elisa Fuksas

2011 Launches the firm Partisans with his
partner, Pooya Baktash

2015 Partisans earned rave reviews for the design
of Toronto tavern Bar Raval, which won a Design
Excellence Award from the Ontario Association
of Architects. Partisans was also awarded Best
Emerging Practice by the OAA

2016 Co-authored the book *Rise and Sprawl:
The Condominiumization of Toronto* with
Hans Ibelings

FUTURE Aspires to win the Nobel Peace Prize.

Zita Cobb

Global Village Visionary

Fogo Island, a rocky outcropping off the coast of Newfoundland, has long been known for its harsh natural beauty and even harsher economic landscape. When Zita was ten, she saw how the loss of the cod fisheries devastated the community. Over the past decade, however, she has used her blend of holistic philosophy, business sense, and technological smarts to help Fogo Islanders transform their economy. "Every human being has special gifts," she says, "and it's our job to figure out how to use them for the society we live in."

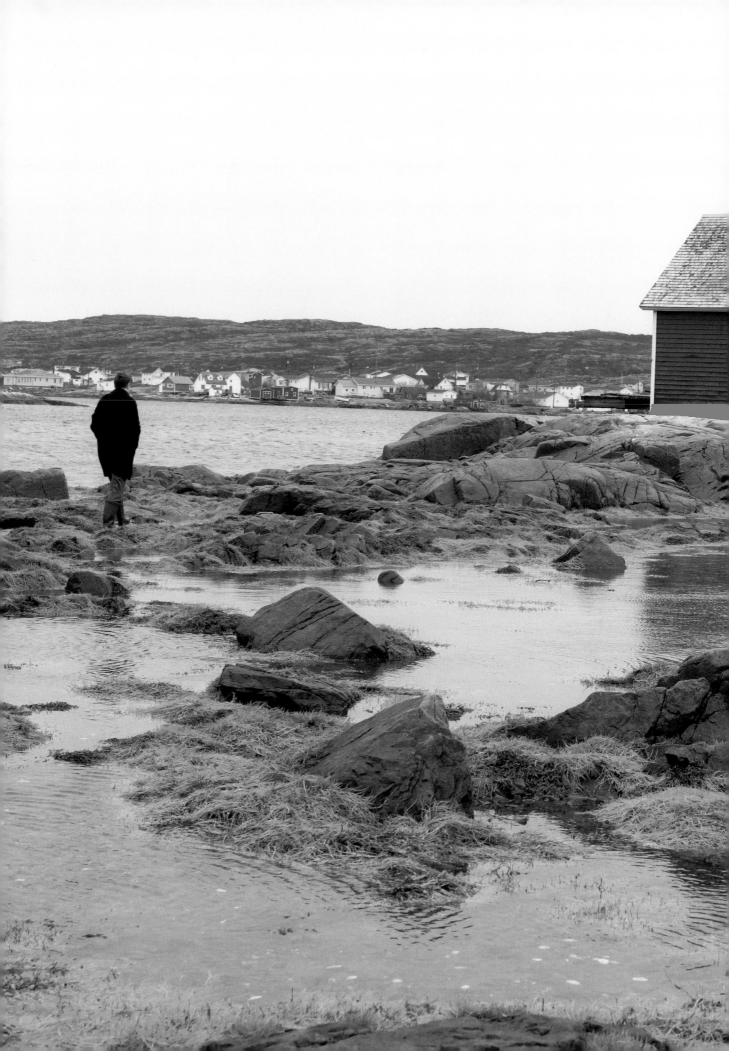

The only girl in a fishing family of seven children, Zita grew up in Joe Batt's Arm on Fogo's northern tip, where her ancestors have fished for four hundred years. In a community of eight hundred people, she says, you see each person as an individual and you feel accountable to them. She found a magic in her childhood close to the land and in her parents' self-reliance and ingenuity: "There is no greater entrepreneur on earth than a fisherman," she says, her accent still salt scoured. In 1975 she left the island to attend university in Ontario.

From there, Zita joined the company that would become JDS Uniphase, a manufacturer of fibre-optic products for the telecommunications industry, rising to senior vice-president of strategy. She came to see that globalized corporate systems were exploiting local workers—people like her own family—and she remembered a line from Polish poet Stanisław Jerzy Lec: *Each snowflake in an avalanche pleads not guilty.* "I am a snowflake in this frigging avalanche," she thought.

Zita left the high-tech sector soon after, enriched with stock options. She remembered her father's advice, "Always be useful," and in 2003 moved back to Fogo. She established Shorefast, a foundation to develop commercial prospects that protect local culture and traditions. "I believe in business, I believe in capitalism," she says, but "I don't think it needs to be done the way it's been done. Why can't we show a better example?"

Shorefast's most visible project is the Fogo Island Inn. Opened in 2013, it was designed by architect Todd Saunders, a Newfoundlander based in Norway.

The five-star hotel combines local materials, the traditional craftsmanship of Fogo's builders, and a stark modernist look unlike anything else on the island. Along with four studios for artists-in-residence, Shorefast's buildings resemble a flock of futuristic seabirds on Fogo's rocky cliffs.

The Fogo Island Inn has pioneered what Zita calls "economic nutrition labelling." Room rates are broken down to show how much of the money will stay on the island. Instead of ordering designer furniture, she hired local carpenters. "You could order a chair from Italy, but why would you?" she asks. "You've got people here who know how to make a boat. They can certainly figure out how to make a chair." Zita believes her Asset-Based Community Development approach—ABCD—could save rural economies throughout Canada and the world. "Communities will only survive, people will only survive, if they get economic nutrition." For her, "sacred capital" is the most important capital of all—the deep traditions that keep small communities alive.

A mix of cosmopolitan sophistication and local know-how, Zita always keeps two items in her fridge: champagne for spontaneous celebrations and partridge-berry jam, made from berries she picks every fall. Her favourite drink is a "properly made cappuccino." She's not easily impressed by technology, has never owned a TV, and loves to travel. "We should be experiencing the world with our whole bodies," she says, "not just with our brains framed to a screen."

Whether she is backpacking in the Arctic or sailing across the ocean, she always takes with her a banded "wishing rock" she picked up on Fogo's shore as a child. "Everything I know has really come out of this rocky place, with the Atlantic pounding up against it," she says. "Any strength or courage I have comes out of these rocks."

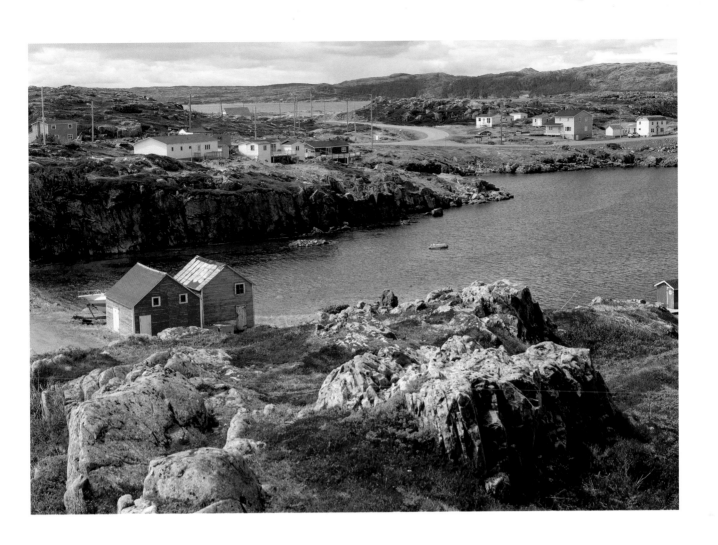

"We built the inn 'old.'
You feel the hands of the people who made it."

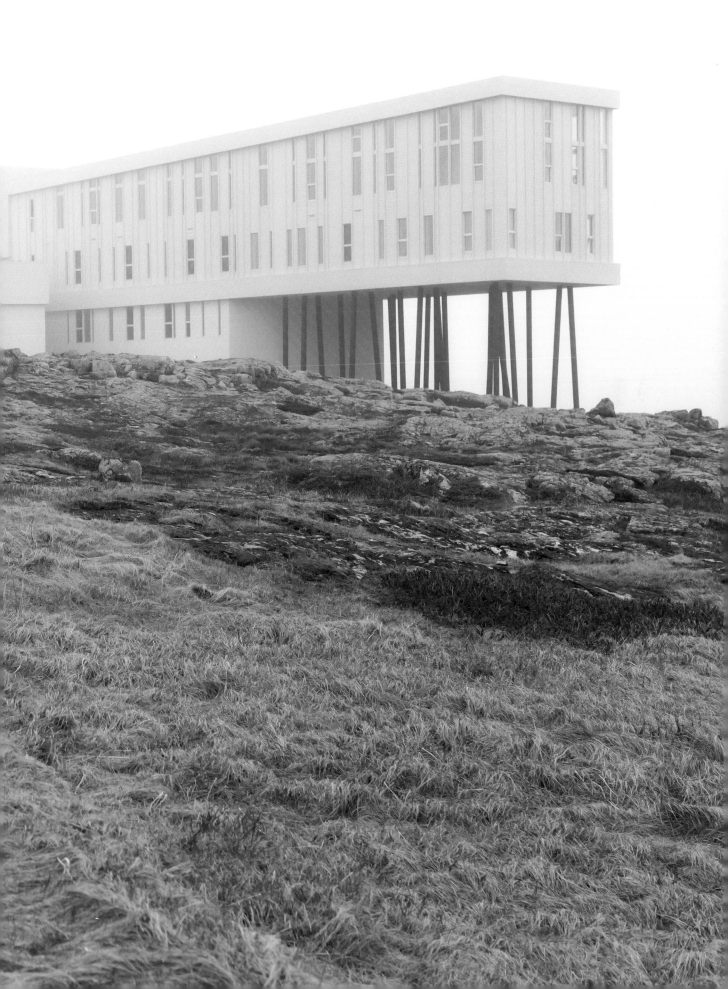

"All my life I've followed the path that wants to emerge."

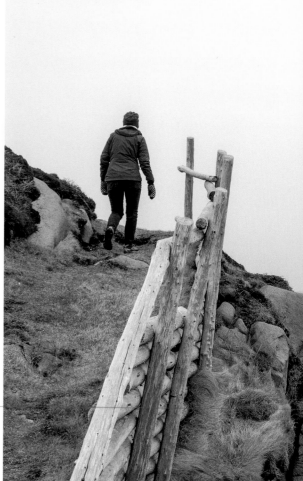

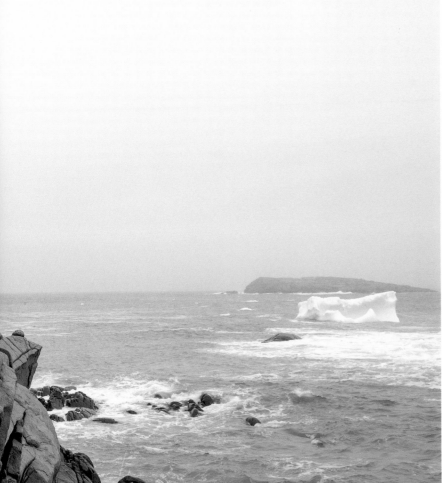

Colourful bum pads, cushions, and floor mats are all created by local women in traditional styles. "I am obsessed with things being as good as they can be," says Zita. "Mediocrity makes me sad, really sad."

Room keys are bronze sculptures fashioned from objects found around the island.

Cocktail hour at the inn includes drinks mixed with ice from passing icebergs. The crackle can be heard across the room.

Following page: The caribou wallpaper design —one of several designs made specifically for the Fogo Island Inn.

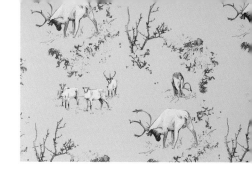

1958	Born in Joe Batt's Arm, NL	2014	Awarded the Gill-Chin Lim Award for leadership and innovation in humanistic globalization
2000	Appointed senior vice-president of strategy for JDS Uniphase	2016	Awarded Doctor of Letters honoris causa by McGill University
2006	Founded Shorefast Foundation		
2013	Opened Fogo Island Inn	FUTURE	To know that small islands are very relevant to the big island we call Earth.

Madeleine Thien

43 years old

A Life of
Passages

Montreal, QC

Rawi
Hage

53 years old

In the annals of literary history, you can count the number of writer couples on two hands. There's Mary and Percy Shelley, of course, and closer to home, Linda Spalding and Michael Ondaatje as well as Graeme Gibson and Margaret Atwood. But one author per household is usually plenty—the egotism and isolation that writing typically demands doesn't always make for the best domestic arrangement.

Not so for Madeleine Thien and Rawi Hage, who first met at the Winnipeg International Writers Festival in 2006. They were a decade apart in age and from entirely different cultural backgrounds: Madeleine (known to friends and family as Maddie) was born in Vancouver, the daughter of Chinese immigrants from Malaysia; Rawi was born and raised in Beirut, Lebanon, and lived in New York for several years before arriving in Montreal in 1992. Maddie received an MFA in creative writing at UBC and went on to publish several award-winning books, including the novels *Certainty, Dogs at the Perimeter*, and *Do Not Say We Have Nothing*, which was shortlisted for the 2016 Man Booker Prize and won both the Scotiabank Giller Prize and the Governor General's Award for fiction. Whether writing about the Cambodian genocide or the political revolutions that upended twentieth-century China, Maddie's a writer of uncommon subtlety, grace, and sensitivity.

Writers

Rawi, who studied photography at Dawson College and Concordia University while working as a cab driver, became a writer almost accidentally, first drafting short stories on a whim about fellow photographers and then having his first novel, *De Niro's Game,* discovered in the slush pile at Anansi, the renowned Toronto literary publishing house. His subsequent two novels, *Cockroach* and *Carnival*, with their allegorical heft and gritty energy, were as acclaimed as his first. "I like to think of my writing as intense and engaged," Rawi says, "a bit philosophical sometimes and hopefully entertaining." Maddie's take on their mutual work is somewhat more exultant. She argues that their fiction not only defies genre but creates new ones: "We always want to be breaking new ground because it allows you to say something else."

Literature offers escape for almost every reader, but for Maddie and Rawi that escape had a particularly urgent cast. In Maddie's case, the library was a second home, and books offered her a respite from the pressures of being part of a striving immigrant family focused on survival. "You feel a bit trapped between worlds," she says, "what's inside your home and what you're learning about in the world outside. For me, literature was a way to bridge that gap. It showed me you could have multiple ways of thinking about things and still have a cohesive self." For Rawi, a Nietzsche devotee who grew up in a besieged Beirut plagued by constant power outages, reading was a low-tech way to transport himself elsewhere: "Living in the war, you're confined to the same place for a long time, and you always look for some kind of alternative existence."

In various ways, they both continue to look for that alternative existence. In the spring of 2015 the couple presented "Arrival," a special multimedia lecture at Simon Fraser University. Here, too, they used different forms—Maddie a story, Rawi an essay—and they arrived at different thoughts on related ideas, describing a world in a constant state of motion, expansion, and collapse, the paradoxes of self-invention, the possibility and impossibility of renewal. "I'm passionate about movement," Maddie says. "I'm a kind of restless person, and I feel lucky I live in a time when you can find a way to see different parts of the world, where you can stop for long periods of time in other places. The feeling of movement is a kind of oxygen for me."

Maddie and Rawi currently live together in Montreal, but they have not stopped moving—between genres, between cultures, between countries. Their work demands it, but so too does their idea of selfhood. Ask Rawi what he thinks is beautiful in the world, and he says "passages." Not passages in a book but, rather, "street passages, transitional passages." The places that one moves through and from, where someone can enter as one thing and come out another. The freedom to move.

Maddie frames this sense of possibility in another way, speaking of the perspective that their shared cosmopolitan experience has given them. "In different places, in different cultures with different political histories, you tend to get a very complex idea of what freedom means and also a complex way of observing how people are able to utilize that freedom. How they choose to use it or not. The meditation on what it actually means to be free, or how we use our freedoms, is so much the work of the artist."

"It's becoming more and more untenable to hold the
middle ground, because forces are trying to push you
from one extreme to the other. It's the Chinese curse:
we live in interesting times, but that means there are
things to be done—that means, actually, you can
do something."

Maddie

Rawi's favourite author is the philosopher Friedrich Nietzsche. "He's fearless: I like his directness, his honesty. It's a challenge, but I find his kind of uncompromising criticism necessary for democracy, for thought. Unfortunately, it's becoming rare now, because of conservatism, political correctness, complacency. That fuels me and has a lot of influence in my writing."

"There's something about being in Canada that I really cherish— a sense of safety, of goodness. But we're too egalitarian, too humble, and it's such a mistake. In Europe, nobody takes us seriously."

Rawi

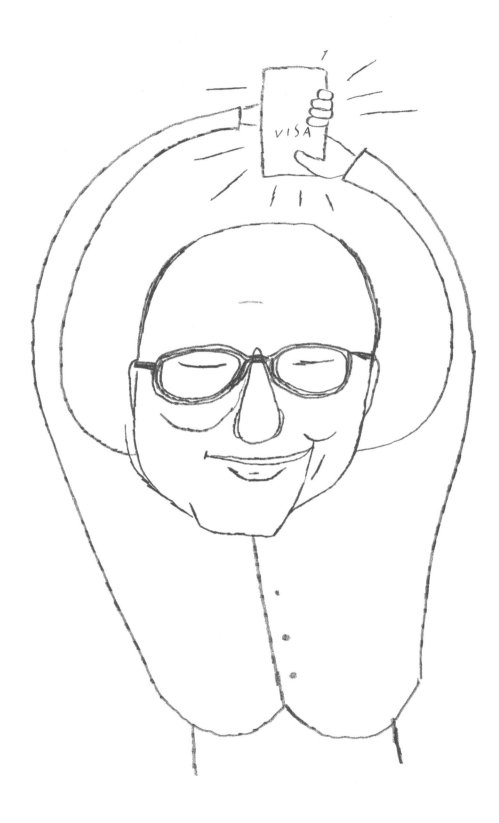

"I
was
one
of
the
last
people
in
Beirut
to get a
visa
from the
American
Embassy
before the gate closed."

Rawi

1964 Born in Beirut, Lebanon

1984 Moved to New York, taking on a series of
 odd jobs, including taxi driver

1992 Moved to Montreal to study photography
 at Concordia University

2006 Published his debut novel, *De Niro's Game*,
 which would win the prestigious IMPAC
 Dublin Literary Award

2008 *Cockroach,* a darkly comic novel about a man
 who thinks he is one, was shortlisted for the
 Scotiabank Giller Prize

2012 His third novel, *Carnival,* was awarded the
 Hugh MacLennan Prize for Fiction

FUTURE Continuing to work outside the conventional
 and returning to his practice in photography and
 visual art.

1974 Born in Vancouver, BC

2001 Published her first book, the short-story collection *Simple Recipes,* which would win the City of Vancouver Book Award

2011 Published *Dogs at the Perimeter,* her second novel, about the aftermath of the Cambodian genocide

2015 Wrote critically in the *Guardian* about the Chinese government's decision to close the creative writing program at City University of Hong Kong, where Thien served as international faculty for five years

2016 *Do Not Say We Have Nothing,* her third novel, won both the Scotiabank Giller Prize and the Governor General's Award for fiction. It was also shortlisted for the Man Booker Prize

FUTURE Grappling with how her writing contributes to our understanding of the world.

Body as Canvas

Tattoo artist

Steve Moore was working on the cheap at
a convention in Moscow when a man came
in asking for a full chest tattoo. "You know how
people, they take out their keys, they take out
their wallet and phone and they put them on the
shelf? So this guy also takes out his handgun."
Steve played it cool—at the age of twenty-two
he had just recently got started in the tattooing
business, and his boss (a guy called Crazy
Ace) was a biker, so he had been around some
interesting people. The man's chest took four
hours to paint, and as Steve was finishing up
by applying bandages, he felt a blow to his foot.
He looked down into the barrel of the handgun.
"I was all like, 'Uh … your gun hit my foot.'
And the guy's all, 'No problem, no problem.'"

Nanaimo, BC

Steve Moore

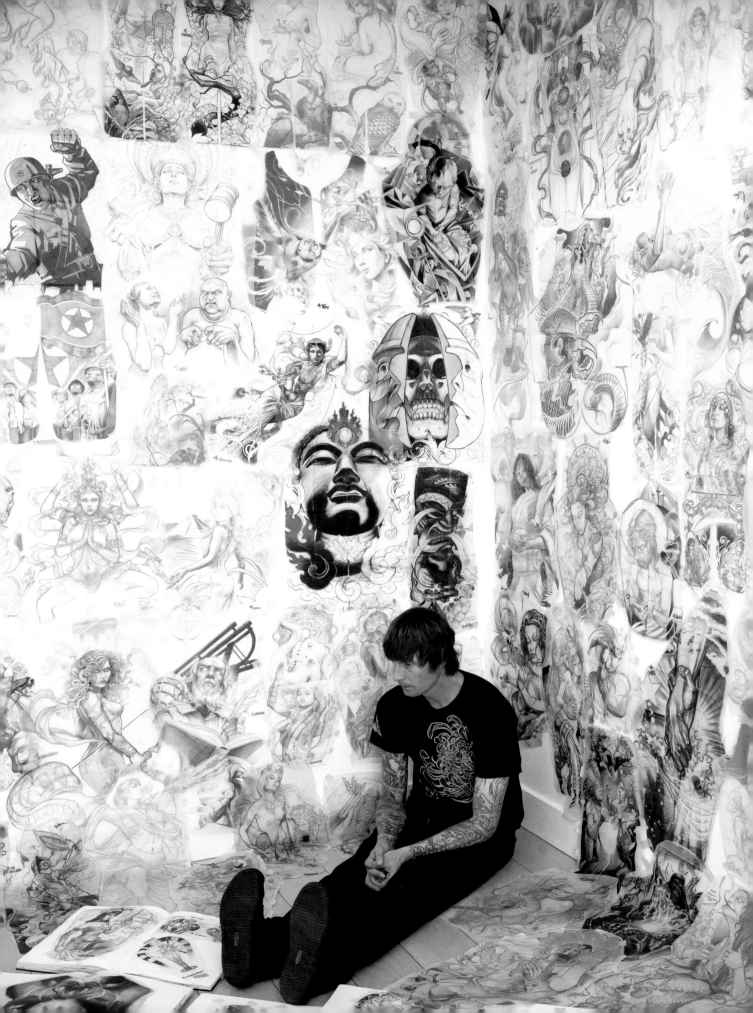

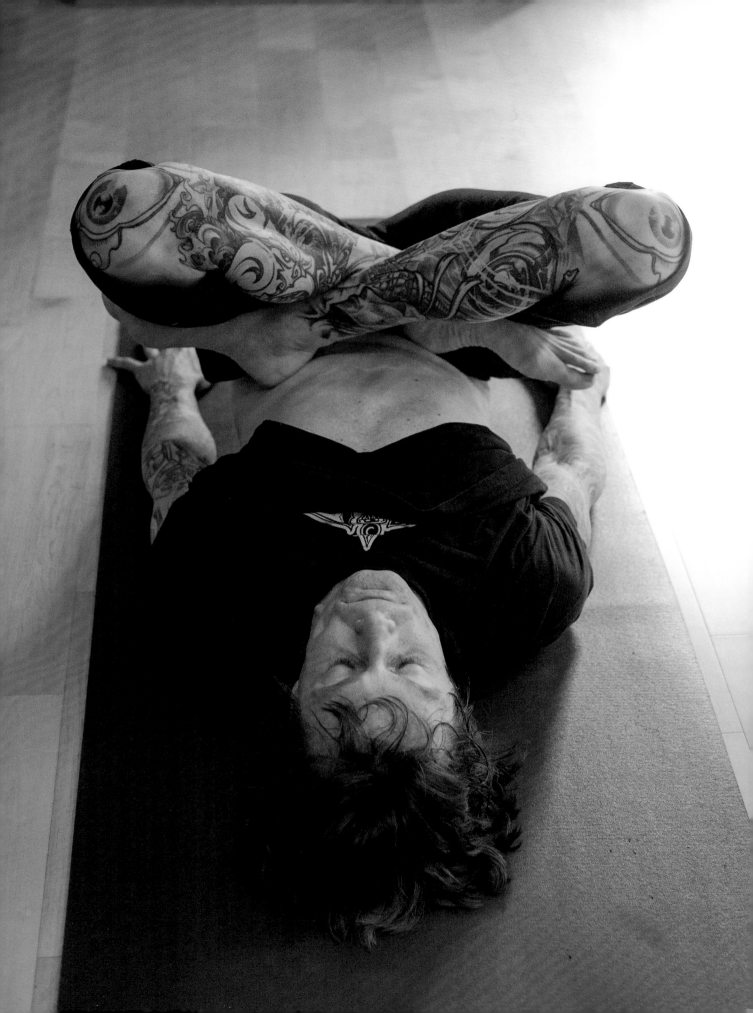

That was 1995, and today clients flock from around the world to Steve's small studio in Nanaimo. As a skater kid growing up in suburban Mississauga, outside Toronto, Steve drew constantly, though he would prove to be too restless for art school, dropping out of the Ontario College of Art after just a few months. (He went snowboarding instead.) Largely self-taught, Steve, like many tattoo artists, cut his teeth on small drawings his friends asked for. "It was Canada flags, maple leafs all the time! Or someone wants a tiger because they were born in the year of the tiger."

But even then he enjoyed the thrill that he got from helping people express themselves with something so permanent as a tattoo. Now Steve's specialty is large, intricate, custom-designed pieces that speak to a client's personal story while bearing his own signature style—more artful work that puts him in the role, he says, of interpreter or storyteller.

As an example he mentions the client who came to him recently requesting a back tattoo—from neck to knees—around the theme of time. Steve asked for a list of images that the client was fond of, before sitting down to research, conceptualize, and sketch. "In the end, I came up with this idea of a woman walking through life, kind of carefree and looking forward. She has no idea that underneath there's this character of Death. But rather than being something to fear, he's supporting her every step." Steve added other touches, such as hourglasses intended to represent each day of her life. "It's a story of life and time," he says. "She's totally oblivious to the eventuality that she will meet Death. One day she'll fall and they'll be together."

Designing and inking each tattoo can take up to a hundred hours to complete, spaced over days, weeks, or even several months. But the necessary attention to detail, Steve says, suits his obsessive personality.

"Happiness for me is when I'm not aware of time anymore. Often I get immersed in a drawing, and I can lose hours and hours and hours on the clock." Sometimes he wakes up in the night with a new idea and gets out of bed to sketch right away. Other times, he'll be in the middle of a vegetarian dinner with his family when his surroundings just seem to melt away. "My wife calls it 'space eye.'"

Steve admits that the obsessive nature of his work—not to mention the long hours spent in deep concentration, the pressure to execute—can at times be debilitating, so he makes a conscious effort to maintain a healthy balance in his life. He uses a symbol to help him visualize what matters most: a triangle, with one point representing family; another, art; and the third, a physical activity—yoga or snowboarding. Every night he reads to his eleven-year-old son, Walker, in whom Steve sees some of his own obsessive tendencies. "People who are OCD," he says, "that's supposed to be a bad thing. But almost every artist I've met is obsessive. I'm obsessive, and I'm so happy I have something to apply it to. Walker just has to find his thing—whatever it is, music or motocross biking—and once he does he has the potential to be good at it."

From his Vancouver Island home, Steve can see both mountains and sea, and he's inspired by the environmental activism of figures like David Suzuki. Even more than his vision for a more harmonious relationship with nature, it's Suzuki's sheer tenacity that Steve finds appealing. "I'm sure he comes up against things where he's thought, 'I quit.' Yet he follows through and continues his work. To have that kind of life mission and legacy is inspiring." Steve tries to frame his life in similar terms, preoccupied with the legacy he will leave behind. It's what attracted him to tattooing in the first place. As he points out, it's the one art form that no one can sell, lose, or have stolen. "I found a way where, if all of a sudden I disappeared, there would be these pieces of me spread all over. I couldn't totally disappear."

"The only way
to excel is by
applying yourself
fully. Luck is
something people
tell themselves
so they can
hold back."

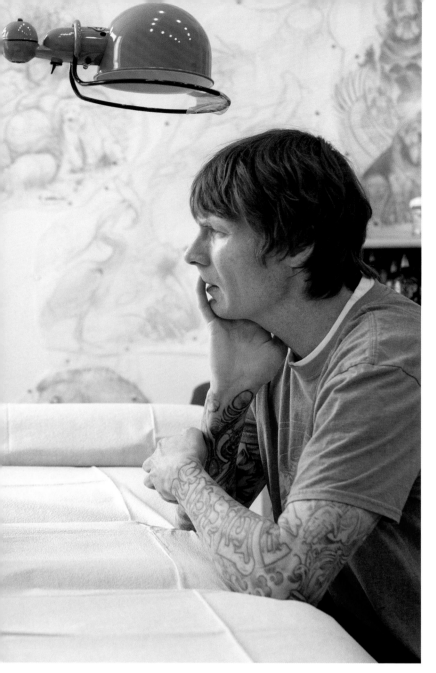

Scenes from Steve's workspace: his inks, tattoo station, and favourite chair. The body art he creates to tell his clients' stories can be months in the making, from research and sketching to the multiple tattooing sessions it can take to complete larger pieces.

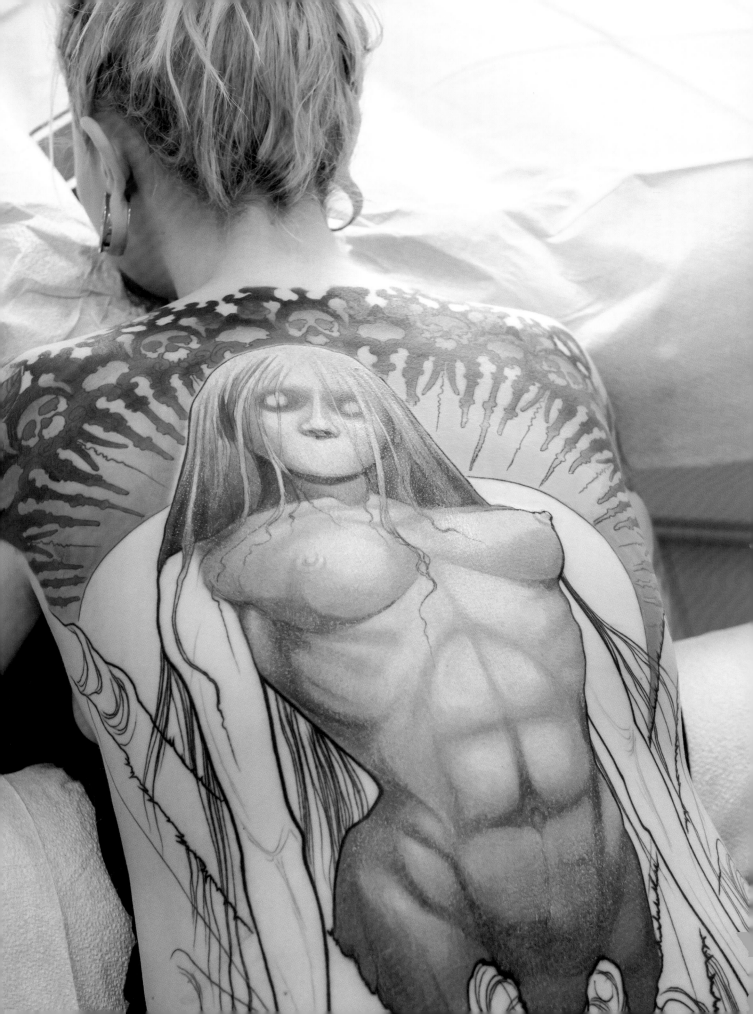

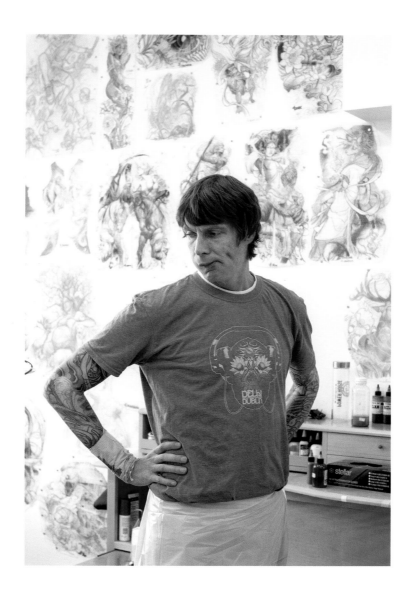

"I feel weird about winning awards. Tattoos shouldn't be judged that way. If somebody comes along and decides which one is better than another, does that mean that what the other people are wearing is less important?"

1972	Born in Mississauga, ON	2005	Opened his own tattoo studio in Vancouver, BC

1972 Born in Mississauga, ON

1993 Inked his first tattoo in his parents' basement and began an apprenticeship the following year

1998 Moved to Vancouver, BC, to work at Sacred Heart Tattoo

2005 Opened his own tattoo studio in Vancouver, BC

2010 Opened his current studio in Nanaimo, BC

FUTURE Aspires to waking up the next morning and being better than he was today.

"What do I think is beautiful? So much, it's different day to day, but I think nature is beautiful, I think my son, I think he's beautiful."

When the World Trade Center was attacked on 9/11, Maria Qamar was in the fourth grade in Mississauga, Ontario. She went home afraid of the terrorists everyone was talking about. "The next day and the weeks following, all these kids were saying, 'You're a Paki; you're a terrorist,'" Maria remembers. "What? I didn't do this," she responded. "What are you talking about?" Maria and her family had arrived from Pakistan only a few months previously. Her classmates there had been excited to hear she was moving to Canada, a place where corporal punishment wasn't used in schools. "So I came here, and the teachers didn't hit me, but the students definitely did." Other kids told her she smelled like curry, that she didn't belong here, that she should go back to her country.

Artist

26 years old

Maria Qamar

Toronto, ON

Pop Goes Desi

Maria started keeping visual diaries in elementary school. She'd draw what had happened during her day and then add fabulous elements to explore the might-have-beens. At the same time that she was bullied in school for being brown, her family worried that she was becoming too assimilated. She wanted to be an artist, but her parents couldn't understand how drawing pictures could be a career. "To them, when they think of art, it's da Vinci or Picasso or whatever," Maria says. "'All these people are dead,' they said. 'They never made money or they got famous after they died, so what is your life going to be? Besides, they're all men—women don't go into the arts.'" Maria's parents are both chemists, and they expected her to choose something practical. "Culturally we Indians and Pakistanis are always pressured to be doctors, lawyers, and engineers."

As a compromise, Maria went into advertising. Her artist name, Hatecopy, came out of her frustration with that field—"I genuinely did not want to do copywriting." After a few years she was laid off. "So I just got up one morning and decided I was going to do what I had really wanted to do the whole time—draw." The first of her creations to become an Instagram sensation was a riff on Roy Lichtenstein's 1960s pop art comics—Maria's drawing featured a glamorous woman with a bindi, her eyes leaking soap-operatic tears, and the speech bubble: "I burnt the rotis." As the likes multiplied, Maria kept drawing. "My friends were all dying of laughter, saying, 'This is hilarious! I don't even know why you're doing this, Maria. You need to find a job, but this is fucking hilarious.'" Maria opened an online store and started selling her drawings as posters and as punk patches for jackets.

These days Maria is exhibiting her acrylics—all pop art takes on life in the West for kids of South Asian immigrants—from Toronto to London. Her work has even had a cameo on the hit television show *The Mindy Project*. Mindy Kaling, the show's star and executive producer, and a first-generation South Asian American, is a personal hero for Maria. The day Kaling began following her on Instagram ties with the time Maria was on the cover of *Elle* magazine for the "craziest day" of her career. The London show was another milestone—in some ways a difficult one because it meant relinquishing her artwork to buyers. "My proudest moment was when I sold my last painting and I had nothing left. It was also my saddest moment."

Maria is branching out: her newest projects are a book called *Trust No Aunty* and collaborations with fellow Toronto artist Babbu (Babneet Lakhesar). She also loves the work of Toronto spoken-word artist Rupi Kaur. Having grown up without seeing brown women reflected in Canadian popular culture, Maria has learned to embrace the dual nature of her cultural identity. "I can listen to metal on my way to an Indian wedding; I can wear a half part of a lehenga with high-waisted denim and still look hot; I can still wear a bindi with any sort of Western clothing—it's all fine."

"That's the message I wish I had heard when I was growing up," Maria says. "You shouldn't be bullied for things like this; it's okay to embrace your Indianness; and it's also okay to embrace your Canadianness."

"I care about boys too much; I should stop caring about boys so much. It's very distracting. Because right now my body is going through this thing where it's telling me to have a baby. Biologically, I just really want a baby, to get married, have stability."

"In school I drew what had happened that day and added how things could have been different. They were a mix of documentation and storytelling. That's still what I do — take things that are somewhat real and exaggerate them in a way that Indian soap operas do."

Maria's early years in Canada were marked by feelings of alienation, both from her own community and mainstream society. "I tried to embrace them both, but it produced this weird sense of loneliness. Now people like me and Lilly Singh are talking about it openly, communicating through art and poetry. We're realizing we weren't alone: many kids are dealing with problems that were just like mine."

"My tip for success? Being transparent, honest, and consistent, so nobody can put you down."

1991 Born in Karachi, Pakistan

2000 Moved with family to Scarborough, ON

2012 Graduated from Seneca College and
 got her first job in advertising

2012 Created her Instagram account

2015 Began making art under the name Hatecopy

2015 Exhibited *Shame, Shame*, her collaboration
 with Babneet Lakhesar, in Toronto, exploring
 the feelings that young people from South
 Asia are made to feel for wanting careers in
 the arts

FUTURE To broaden her skill set, continue growing
 as an artist, and make herself proud.

The Healing Heart

43 years old

Soldier and entrepreneur

The mornings were impossible. Sleep had been so difficult, and now it was just as difficult to wake up, open his eyes, get out of bed. He sat there, staring at his muscular arms and hands, the parts of his body that had once operated—and neutralized—weapons. What would he do now with these limbs? If he couldn't hold a gun anymore, what could he hold? And if he was going to live, what could he hold on to?

After many weeks and months of mornings like this, he went to a tattoo parlour and had Maddie's name burned into his arm. It would be a reminder of his responsibilities, a reason to live. He needed to take care of his son. When he woke up and stared at his arms, he would now see Maddie's name. "It reminded me that I'm part of something bigger," he says. "I'm here to take care of him. I have a purpose."

Bruno Guévremont

Victoria, BC

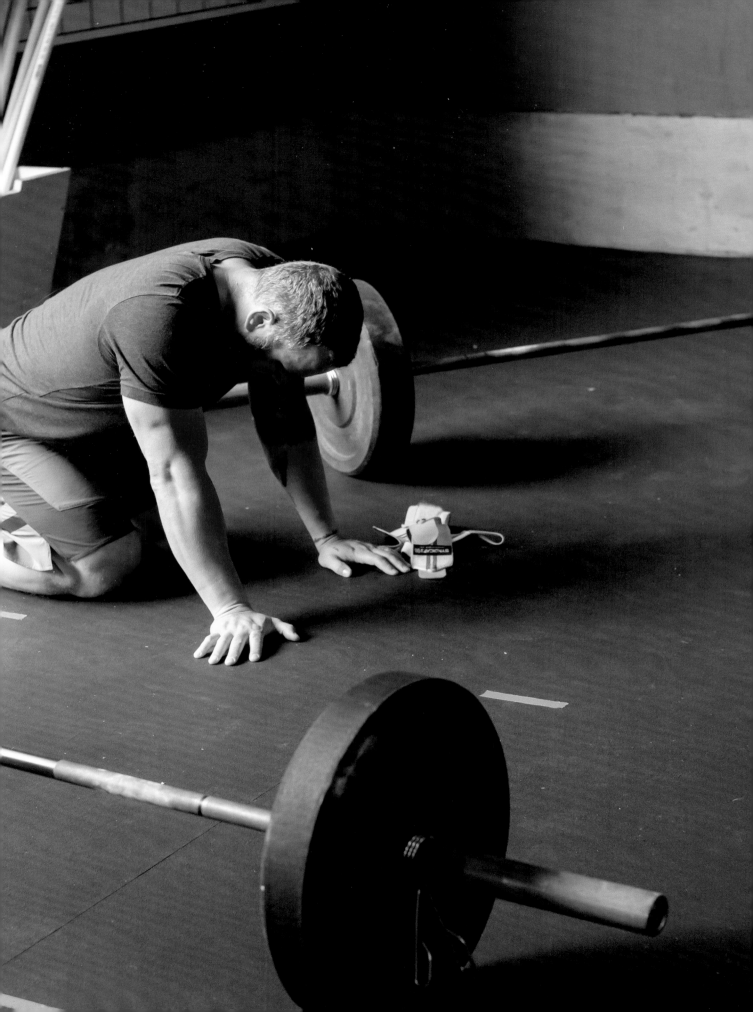

Bruno Guévremont had always wanted to be part of something bigger. That's why he joined the military in 1999, when he was twenty-two. Born and raised in Gatineau, Quebec, he had spent a year at the age of ten in Zaire, where his father worked as an electrician. It was a Damascene moment: "That trip to Zaire was a real eye-opener for me. It made me realize at a young age that we have such a great country. And I wanted to serve."

Becoming part of the Canadian Forces wasn't easy. At the time the military was in the midst of a force reduction phase, and Bruno applied three times before he got in. But he quickly became a kind of super soldier. First, he was a weapons technician in the army; then, after 9/11, he joined the Royal Canadian Regiment Parachute Company—the last arms tech to wear the coveted brown beret—and was deployed to Afghanistan. After that tour he wanted another challenge and transferred to the navy, where he became a diver, clearing underwater mines and rescuing submarines. He got injured, however, and went on to take a counter-explosive device course. In 2009 he returned to Afghanistan.

If Bruno's first tour was tough—in Kabul his company lost four soldiers—his second was even more arduous. His counter-improvised explosive device (C-IED) team was the busiest on the mission, taking over a hundred IEDs out of action during Bruno's time there (one day they did nine). Bruno himself disarmed a bomber wearing a suicide vest—the only Canadian ever to do so (and, along with an American and an Israeli, one of only three people anywhere in the world). His training was so good, he says, and his focus so nearly supernatural, that he felt no fear.

No matter how dangerous the work in Afghanistan, it was always supremely rewarding. "I had an incredible time in the forces," Bruno says. "I wanted to jump out of planes and I did. I wanted to blow up things and I did. I wanted to serve my country and I did." General Rick Hillier, former chief of the Defence Staff, called him "an awesome Canadian who has done awesome things."

Leaving the military, however, was a different story. When Bruno returned to Canada in November 2009, he had nothing to do, no orders to carry out. "There is no de-conditioning when you get home," he says. "At home you have time to get angry, and the body is taken over by the horrors of war that you relive." He became depressed. "Simple tasks are so difficult that you just want to end it. You can't read anymore, you can't fill out forms—not even ones you're asked to fill out to get help."

When Bruno finally acknowledged that he was suffering from post-traumatic stress disorder (PTSD), he treated his own health and recovery like another combat mission. Through the veterans' support organization True Patriot Love, he joined fellow broken soldiers on a gruelling, soul-soothing expedition to the North Pole. "It is the most therapeutic thing you can do for a soldier," he says, "to be put, like we were, in a challenging situation at a time when you're struggling with low self-esteem. And each one of us needed help from the other." The lessons he took away from that adventure later led to his opening a CrossFit gym near Victoria, where he continues to train both civilians and former military personnel.

Maddie is now eleven years old—around the same age Bruno was when he realized what a remarkable country Canada is. And the tattoo reminds him every day what he fought for. "War, genocide ... the human heart is very dark," he says. "The struggle is to keep your heart loving."

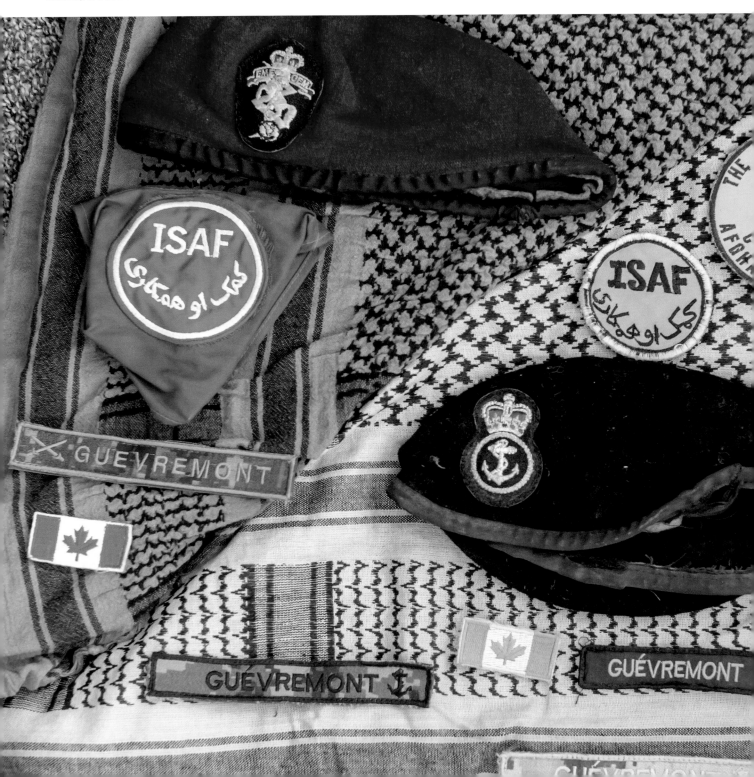

Mementos from Bruno's Afghanistan tours: badges, shemaghs, and berets—maroon as a paratrooper, and navy as a diver.

"When I took the live vest off the suicide bomber, he seemed to sigh with relief. The guy was mentally disabled. He had been fasting for two weeks. His family had been threatened so he would do this. I felt compassion for him. I would do anything to save my son, Maddie."

"At home you have time to get angry, and the body is taken over by the horrors of war that you relive."

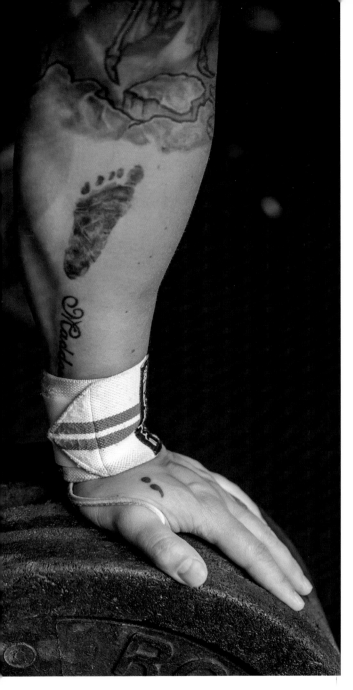

The tattoo of Maddie's baby foot reminds Bruno why he must always keep going. The semicolon shows that he chooses not to end the sentence that is his life.

1974 Born in Gatineau, QC

1999 Joined Canadian Army

2009 Completed second tour of duty in Afghanistan, as part of an anti-explosives team

2010 Diagnosed with PTSD a year after his return to Canada

2013 Opened his own CrossFit gym in Colwood, BC

2016 Named captain of Team Canada for the Invictus Games, an annual sporting competition for military veterans

FUTURE Managing his gym, the first of many he hopes, and creating a space where veterans and non-veterans alike can change their lives for the better.

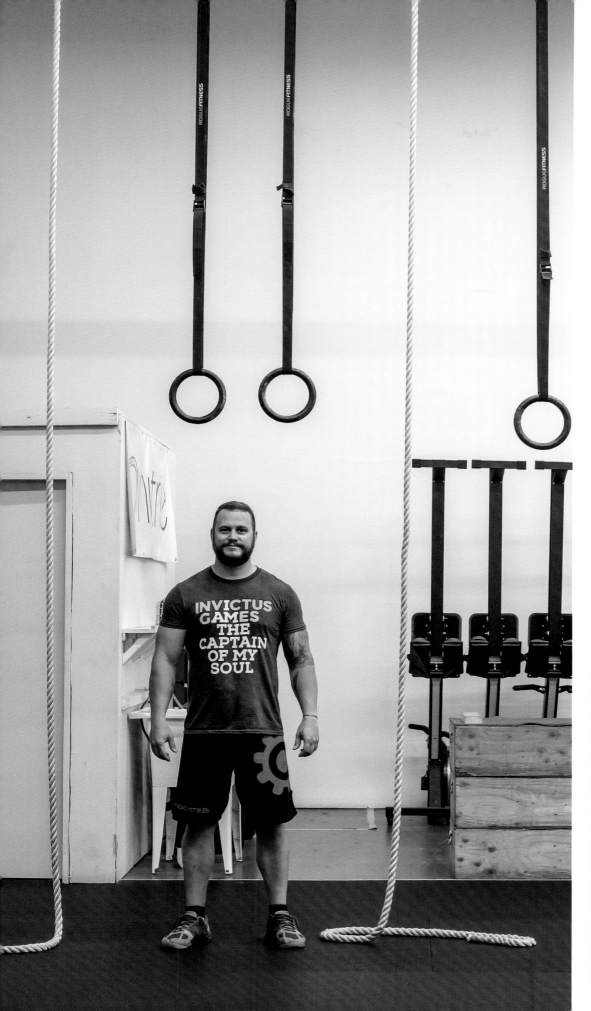

"Competing in the Invictus Games," says Bruno, "provides me and my fellow military competitors with the pride and confidence needed to push our minds and bodies beyond what we thought was possible—to represent our country shoulder to shoulder as we once did."

"When I was growing up in my small town," Bruno says, "we watched TV shows in English. Now those shows are translated into French. My hometown youth don't speak English as I did growing up. We grew up feeling the same as every Canadian. Now people feel separate."

Track Star

One of the most memed moments at the 2016 Olympics in Rio didn't come in a gold-medal race or match but in a semifinal heat of the men's 200-metre sprint. Usain Bolt, believing he's cruising to a comfortable victory, looks over his shoulder to see the Canadian Andre De Grasse suddenly closing the gap—smiling mischievously all the way. Finishing ahead by a hair, Bolt flashes a starry grin back at Andre, then wags a finger as though to say: "Not yet, my friend."

The media proclaimed a "bromance" in the making. Others commented on the symbolism: Andre making his claim as heir apparent to Bolt, the greatest male sprinter of all time, who will soon retire. In the 200-metre final the next evening, Bolt and Andre repeated their one-two finish, Andre capturing the silver with an astonishing show of late-breaking speed. Along with bronze medals in the 100 and 4 x 100 metres, Andre would return home as the most decorated Canadian runner ever at a single Olympic Games.

Andre De Grasse

"I'm really into fashion. A lot of people see me in sweats all the time, but I like to wear fancy things —jeans and suits and ties. I've been thinking about modelling or having my own clothing brand."

Few sprinters have arrived so suddenly, and with such dramatic results, on the international stage. Andre ran his first competitive race only four years earlier, when he was seventeen. Invited by a friend to see him compete at a high school track meet, Andre told him he'd rather race than watch. Wearing borrowed spikes and baggy basketball shorts, he took off from a standing start. He came second with a time of 10.9 seconds.

Tony Sharpe, a respected track coach and Olympic bronze medalist, was in the stands. He quickly took Andre under his wing, recognizing an extraordinary talent in someone he otherwise described as "a little, skinny, average guy." "I got to give it to Tony Sharpe," says Andre. "He's been with me since the beginning." Sharpe pointed Andre to the right junior college in the United States, from where he would eventually be recruited to run for the University of Southern California on a scholarship. At USC Andre came into his own, winning gold in the 100 and 200 metres at the 2015 National Collegiate Athletic Association championships, running both races within an hour. Three months later he won bronze in the 100 metres at the World Championships in Beijing.

"I didn't believe I could be one of the fastest guys in the world, right? But Tony made me believe it was possible, and it kind of inspired me to not let him down."

He may have come late to the sport, but running turned out to be in Andre's blood. His mother, Beverley, was a competitive sprinter in Trinidad before she immigrated to Canada in her twenties. When Andre was in the fourth grade she tried getting him interested in track, but he opted for basketball. Now it's Beverley, other family, and friends who help him stay grounded as he gets comfortable around all the cameras and autograph seekers. "At first I didn't know how to comprehend or handle all the attention," he says. The reaction to his winning double gold at the Pan Am Games in his hometown of Toronto overwhelmed him. "It was pretty crazy. I didn't realize how much of an impact I had made on my country." Now, he says, he is getting used to it and has learned to simply "go with the flow."

If Andre's quick ascent to Olympic medalist has turned heads, so has his unorthodox running style. At 5 foot 9, he's already shorter, leaner, and more compact than most of his rivals, but kinesiologists have focused on something else: his propensity to fully extend—almost fling—his right arm backward, while runners typically keep their arms bent at both sides. It's been dubbed "the Andre Arm" and is likely his body's way of compensating for an imbalance in his hips caused by an old basketball injury.

After Rio, Andre made good on a commitment he made to his mother and completed his sociology degree from USC, then returned to Phoenix, Arizona, where he now trains with elite coach Stuart McMillan. At twenty-three he's still three years away from the age at which most sprinters achieve their peak performance. And the biggest weakness in his race—his start—is something he's capable of improving through better technique. "During the season I practise from Monday to Saturday," Andre says, "and on Sunday I catch up on sleep. I know what improvements I have to make. I can only go up from here."

Away from the track he's working on creating his own charitable foundation. The value of giving back struck a chord with him during a recent trip to Chile, which was organized by his sponsor, Puma. Andre was shocked to discover that he has fans so far from home. "I hung out with these school kids in Santiago and I was really moved," he says. "I didn't realize what an influence I was out there. Seeing the fans in Canada support me was pretty big. But in Chile, that was an epic moment."

And what advice did Andre have for them? "You live and learn, right? It's okay to make mistakes. They're what make you who you are."

"I'm excited for the future. I'm nervous for the future."

"I listen to a lot of hip hop and
R & B. But once I'm on the track it's
about the slower beats, maybe piano
in the background, to help me relax."

Following spread: Raised Catholic by his mother, Andre's religious belief plays a big role in his life. "I pray every day—when I wake up, when I go to sleep, every time I eat meals. I give praise to him for where I'm at in my life."

Andre training in the hills around Los Angeles.

"There are times when I'm travelling alone when I'm kind of miserable. But I think that's just like everyone."

1994 Born in Scarborough, ON

2003 His mother tried to interest him in track, but he opted for basketball

2011 Competing at his first track meet, he came second in the 100 metres with a time of 10.9—from a standing start

2015 Inked a sponsorship deal with sports apparel brand Puma worth more than US$11 million

2016 Won silver and two bronze medals at Rio Olympics

2016 Graduated with a degree in sociology from USC

FUTURE "To be the fastest man in the world, to win an Olympic gold medal. And when my career is over, I want to be able to show kids that anything is possible if they work hard and have fun while doing it. I would be satisfied knowing I touched someone's life."

Kate Harris

35 years old

Atlin, BC

Explorer and writer

Modern Nomad

For great writers, borders are there to be blurred—borders between genres, between forms, between different kinds of voice. For great explorers they are meant to be ignored or, better yet, dissolved entirely. Kate Harris is that rare thing, both a writer and an explorer, and her entire adult life has been spent defying the limitations imposed on her by geography, governments, time, even her own body.

As a child, Kate aspired to become an astronaut —her father often said she'd be the first person on Mars—but, before she left for the University of North Carolina on scholarship, she had barely ventured outside her home province of Ontario. Once she did, she never stopped moving. UNC, where she studied biology and geology, was followed by Oxford (as a Rhodes scholar), then MIT.

At Oxford, Kate thought she'd study the history of science before becoming a scientist. Her first discovery, though, was that as much as scientific ideas intrigued her, she didn't want to test them in a lab. She wanted to observe their real-life impact, then think and write about them. "I love words and the world, and to me they're intertwined," she says. "I can't imagine exploring one without exploring the other." The expedition diaries that she'd been devouring, such as Darwin's *The Voyage of the Beagle* and Fanny Bullock Workman's *Two Summers in the Ice-Wilds of Eastern Karakoram*, became guidebooks for a possible life.

Always athletic—she jokes that at MIT she majored in mountain biking—she and a friend set out in 2006 on a four-month bike trip along Marco Polo's route through western China. Five years later, they embarked on a more arduous journey, cycling the entire length of the fabled Silk Road, from Istanbul to the Himalayas, testing the complex challenges of communication. In ten tough months they travelled 10,000 kilometres through ten countries and ate roughly 10,000 packs of instant ramen.

They also snuck into Tibet—twice. In defiance of a Chinese government that required foreigners to obtain permits to visit the region, they darted around checkpoints in the middle of the night and covered their faces to pass as local cyclists. It was here, in an inhospitable, nearly uninhabited corner of the country, that Kate became obsessed with borders.

As she has written, trying to determine or define the parameters of a place—especially a country as contested as Tibet—can be fruitless and damnably limiting: "Where on this spinning world was I? Ask a Chinese, and I was in China; an Indian, and I was in India; a Tibetan, and I was in Tibet. Ask me, and I was in paradise, no further names necessary."

Kate's travels didn't end there. She has skied the Hardangervidda in Norway and was part of the first all-female expedition to climb Lingsarmo in the Himalayas. She's a member of the Royal Canadian Geographical Society and the Adventure Syndicate, a collective of women adventurer-cyclists. She's written for the *Walrus*, *Sierra*, and *Arc Poetry Magazine,* and her travels along the Silk Road have been chronicled in a lyrical, expansive book, *Lands of Lost Borders,* which she says was almost as difficult to write as the trip was to make. "I want to go on other epic journeys," she says, "but the real part of the enterprise is coming home to write about the experience and share it with others so they can fall in love with the same places."

One of Kate's favourite places is a one-room, off-the-grid cabin in Atlin, BC, midway between Juneau, Alaska, and Whitehorse, where she lives most of the year with her partner and a rescue dog named Daniel. While some might regard this ascetic existence as a kind of ironic prison, for Kate it's entirely the opposite. She grows her own food and gets trout from nearby lakes. Her fair-trade, organic coffee comes from a neighbour 3 kilometres down the road. The cabin is insulated, sort of, by her large library. And every time she looks out the window, into a vast, borderless world, she's reminded, happily, of humanity's relative smallness.

"I'm obsessed with living as lightly on the planet as possible," she says. "We don't know where we came from; we don't know where we're going. I like to live in a way that honours that mystery."

"Growing up, I just wanted to be somewhere else."

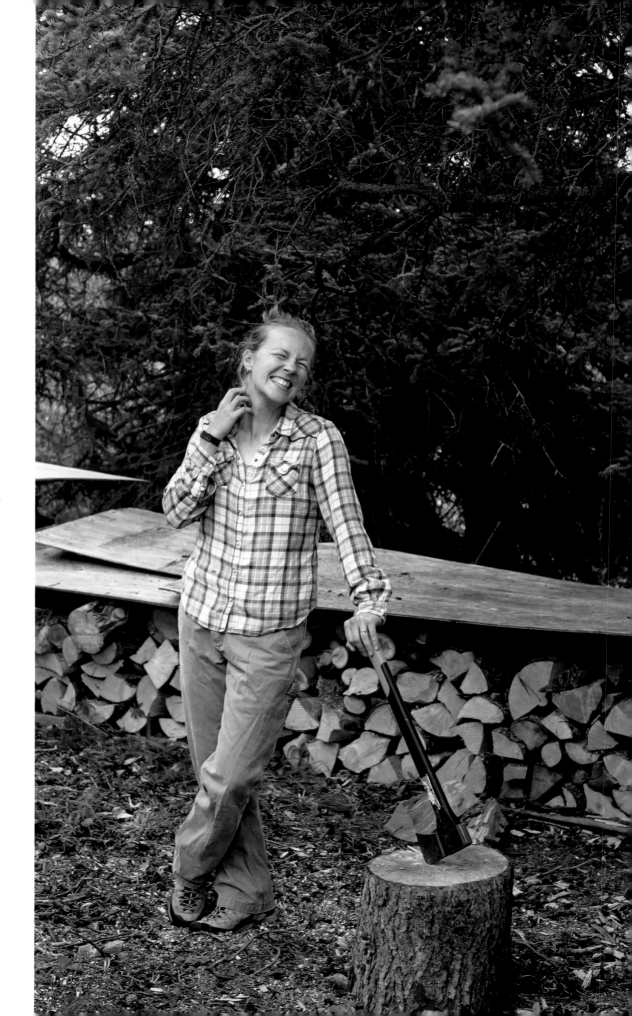

Kate chopping
wood outside her
cabin near the
town of Atlin, BC.

"What I aspire to do is very different from the nineteenth-century explorers. It's less driven by wanting to be the first, or planting flags on faraway continents, than by trying to wake people up to the wonder of life on earth."

"I love that reminder
of our smallness on a daily
basis. You look out the
window and it's just like...
we're visitors here.
This is where grizzlies live,
where caribou live, and
wolves, and we're just
guests for a little while."

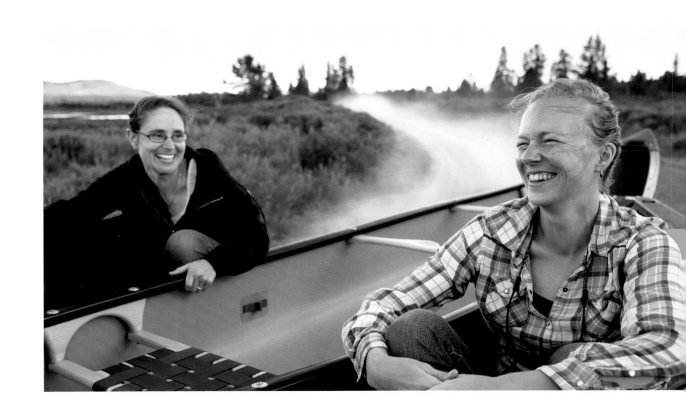

"I always leapt first and then built wings on the way down. You know, set an audacious goal and then figure out how to get there without knowing how to do it."

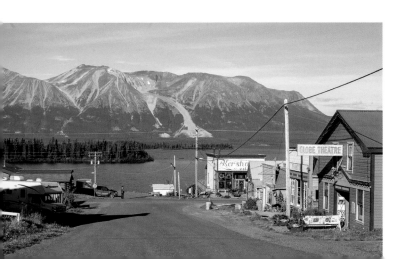

1982 Born in Guelph, ON

2006 Named a Rhodes scholar

2010 Skied the Hardangervidda, a mountain
 plateau in southern Norway

2011 Set out from Istanbul for a ten-month cycling
 expedition along the Silk Road

2012 Won the Ellen Meloy Desert Writers Award

2017 *Lands of Lost Borders* published by Knopf Canada

FUTURE Wants to build a writing shed next to the cabin
 in Atlin along with a garden and greenhouse
 to grow her own food. Also keen to improve her
 paddling skills and travel more by boat.

Forgive me, Canadians are at their worst when we talk about Canada—when we attempt to define who we are. It's like trying to give yourself a nickname; any appealing, colourful shorthand we'd choose for ourselves is unlikely to be convincing.

"Yeah, 'Canadian,' absolutely, I mean, on paper, but most people call us 'Fierce Loons' or sometimes 'Pilgrims of the North.'"

"No, no, they don't. They call you 'polite,' when they call you anything at all," the world will respond—if it responds at all. Next they'll tell us, quizzically, that they have a cousin in Montreal. They will tell you of this cousin in Montreal on every continent, in every corner of the world, and always in a tone that suggests they're opting not to question their cousin's lifestyle choice.

Most awkward of all, in our quest to stake out an identity, when Canadians try to tell us who we are, we immediately start sounding like Americans. Everything seems to go all liberty, mom, and apple pie, and the very act of defining ourselves feels like a rather American thing to do.

Canadians might as well spell out our national motto in fondue forks, or train a kangaroo to sing "O Canada" or "Bobcaygeon," as settle upon and broadcast a distinct national character to the rest of the world. The maudlin is the message, and so perhaps Canada is best expressed in the absence of self-conscious branding, indeed by absence in general, by vast space.

Canada is a big country. Toronto is about fifteen hours' driving time from Thunder Bay. Winnipeg to St. John's, you're looking at a five- or six-day drive, if the roads are good. And in doing that journey you're not even close to road-tripping Canada end to end. Canada is fortnight-sized, I'd say, a season-wide-and-tall if you include the Far North, which you should.

Visitors from other lands have often expressed frustration or at least bemusement to me over our national reluctance to say exactly how many miles or kilometres there are between point A and point B. Point B usually being the Eaton Centre or Niagara Falls in my experience, but then I live in Toronto, and was born in Vancouver, which is about four days away by rail.

No Canadian will willingly tell you how many mappable units of anything it is to anywhere else, but they'll happily tell you it's "six hours to my dad's cottage if you're going up on a Tuesday."

Tabatha Southey

Country

The Big

Canadians tend to measure distance in time, not space. It may partly be that the sheer number of miles we face is too vast to be expressed in anything as base as a "kilometre." Time is a more personal, arguably more subjective measure than distance, and the spaces between and around us, and the spaces many of us have crossed to get to this country, are such an intrinsic part of who we are that they demand this more intimate measure.

A measure in time factors in weather, the bumps on the road, and all the other travellers. It is a more accommodating measure for a large and often more accommodating country.

Canada: "Yes, we have room for you, but you may have to sleep in the Prairies."

I understand there was precious little resistance to metrication in Canada when it was imposed on us in the early 1970s, and I've sometimes wondered if that is partly because they left the hours alone. Nobody made the day divide by ten and messed with our inner odometers. So the nation let it slide.

Back in 2005 when CBC Radio asked listeners to vote for the greatest Canadian song of all time, they chose Ian Tyson's "Four Strong Winds," recorded in the early 1960s by the then folk duo Ian and Sylvia. It's a great song, but we have a lot of great songs in this country. I think it's no coincidence that we chose as our favourite a tune that is, at its heart, a break-up song about distance. It's about weather too, but mostly distance.

You don't have to live in Canada very long to recognize what "Think I'll go out to Alberta, weather's good there in the fall …" means in a relationship. A great divide is about to be crossed. It is, lyrically, one of the most taciturn songs in popular music. The man has some friends he "can go to workin' for," and he's off alone as she's staying put. There's some bordering-on-fanciful talk about him sending her "down the fare" if she changes her mind and if there's not an unreasonable amount of snow come winter. But mostly it's "I'll look for you if I'm ever back this way."

That is a singularly poignant expression of regret and, our distances being so vast, finality. Perhaps "Four Strong Winds" resonated with so many Canadians because even in the broad daylights of our increasingly, gloriously, crowded cities, it is still the space around us that defines us.

When I start to lose the thread of who we are, to feel like a stranger in this country or as if I am alone, I get in a car and drive and drive untill am far away. Eventually I find us all again.

—

Tabatha Southey was born in Vancouver and lives in Toronto. She is a writer and a columnist for the Globe and Mail.

Elegance in Motion

Fashion designers

While the most revered designers in fashion history may be the single-named, iconoclastic solo artists—Chanel, Dior, Lagerfeld, Prada—there's a lot to be said for collaboration when it comes to making clothes and accessories. In fact, fashion seems to benefit from the power in partnerships and, in particular, partnerships between siblings—think of the Rodarte sisters or, closer to home, the DSquared2 twins, Dean and Dan Caten. Or Byron and Dexter Peart, identical twins as well as the co-founders of the acclaimed Montreal luxury goods house WANT Les Essentiels de la Vie.

Byron Peart
Dexter Peart

45 years old

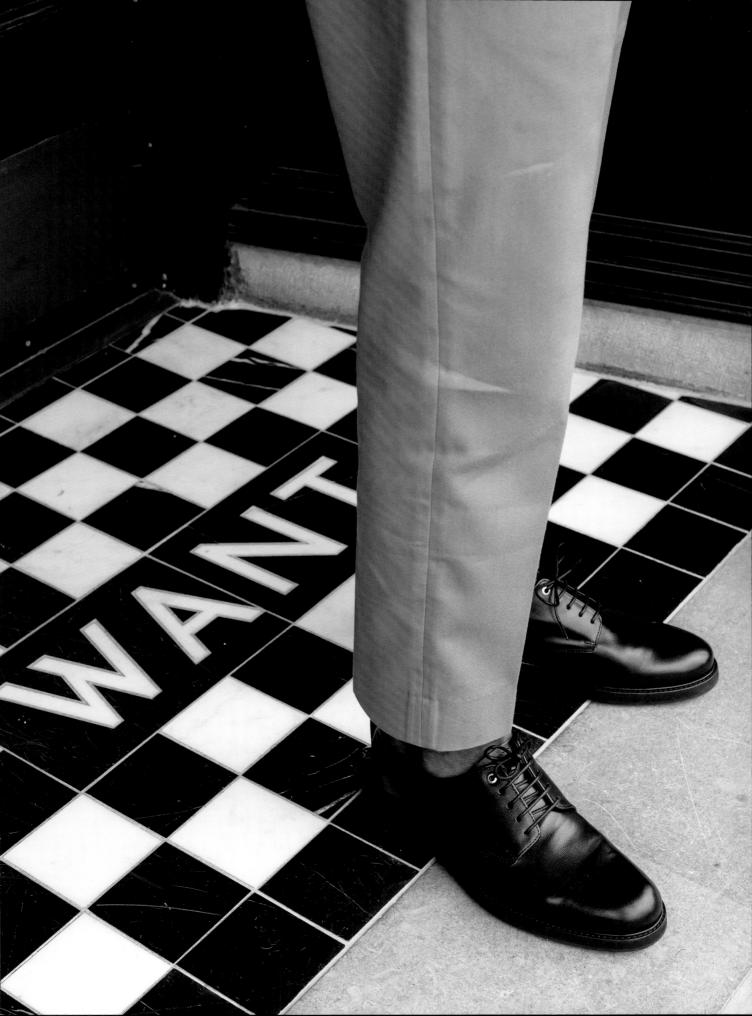

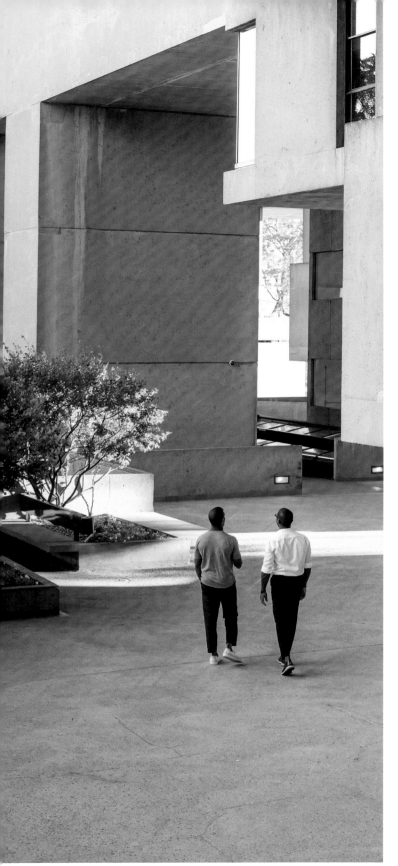

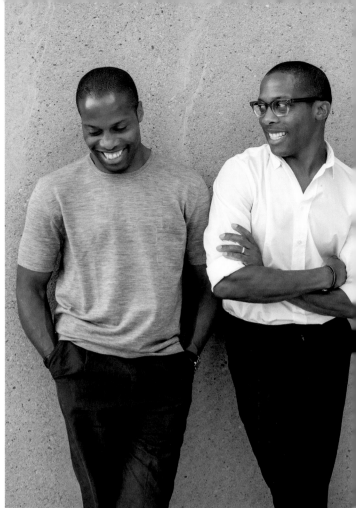

"In our business, being the entrepreneur and being creative are kind of separated—you have the creative director and the CEO. But we've really tried to harness the balance between both sides."

Byron

The two brothers, from Ottawa by way of Jamaica and based in Montreal for the last decade and a half, have been working together from the beginning. Rather than splitting responsibilities, they do everything together. As Byron says, their relationship is their "secret weapon," allowing them to bounce ideas off each other with an intimacy and understanding that few other people have. Dexter puts it this way: "The process, from the design to the labour, is really quite collaborative. There's a tremendous level of trust that goes on between the two of us—we're able to say whatever good or terrible idea we come up with—in order to ultimately make a better product or solution."

WANT itself began with a simple idea. Both of the Pearts were—and are—major travellers, routinely criss-crossing the globe for work, family, and pleasure, always curious about their surroundings. In the early 2000s they began to notice among their fellow airline passengers a disconnect between their fashion sense and the travel accessories they toted—men with great shoes carried their documents around in logoed conference bags, and women stuffed their (then-brand-new) iPods into ugly plastic cases. The Pearts, who had previously distributed high-end Scandinavian clothing lines out of Old Montreal, decided to translate their love of precise, minimal design into their own line of affordable luxury goods.

Their first two products, released in 2006 under the label WANT Les Essentiels de la Vie, were a thousand-dollar leather laptop bag called the "Trudeau" and, naturally, a sleek, leather iPod case. "When we design a bag," Byron says of their working methods, "there's so much discipline in the way we work that, by the time it's done, we feel really good about the product. We've invested so much time and energy into it." WANT was characterized by understatement and a harmonious fusion of form and function.

Soon enough, everyone wanted WANT. *Dwell* magazine wrote about the iPod case, and it quickly sold out. A few years later, as the Pearts expanded "les essentiels" to include handbags, footwear, and gloves, the line was being carried in about a hundred of the finest retailers around the world, from Barneys to Lane Crawford in Hong Kong. They opened their own shops in Toronto and Vancouver. As the *New York Times* put it on the eve of the launch of a Greenwich Village outpost in 2015, WANT "struck a chord among *Monocle*-reading, art-fair-attending globe-trotters who have a lot to carry … and want to look sharp doing it." That's a fair description of the Pearts themselves. The brothers constantly ping-pong between their home base in Montreal and Europe (Greece is a favourite vacation spot for Dexter), Jamaica, New York, and Japan (where they've just opened another shop). And now, when they get to an airport lounge, there's a good chance that some of their fellow travellers look as elegant as they do.

Rarely are the Pearts apart, and aside from a brief stint during their university days, they haven't lived more than a hundred metres from each other since they were born. Given their occupation and success, they could settle anywhere in the world, but they've stayed in Montreal. Today they live in separate apartments in that pinnacle of Canadian brutalist design, Moshe Safdie's Habitat 67: Byron with his husband, and Dexter with his wife and two little girls. "We were in Jamaica having dinner with a bunch of friends," Dexter says, "and someone asked, 'If you could live anywhere in the world, where would it be?' As the question went around, all these people were picking these wildly exotic places. When it came to me, I said, 'I'd live in Montreal.' I'd basically stay in the city where I already live. I'm excited about Canada right now. I feel like it's this bastion of hope."

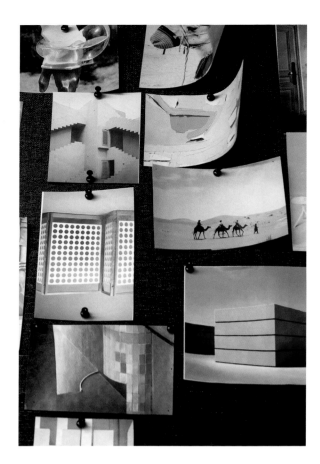

A wall pinned with images used as design research for the SS17 collection called "Global Nomad."

Below: Inside WANT's headquarters in the Parc-Extension neighbourhood of Montreal.

"The entrepreneurial side of us has always been there. As kids visiting Jamaica we would go sell sunglasses on the beach— it was like a couple of kids with a lemonade stand. We were already a couple of merchants when we were a very young age."

Dexter

"So Dex and I have this thing where I like to wear stripes, I don't know where it came from, and then Dexter wears polka dots. And we basically have this unwritten rule that I can't own anything with polka dots, and the same for Dexter and stripes."

> "I'm obsessed with time away with my family—my two young daughters and my wife."
>
> Dexter

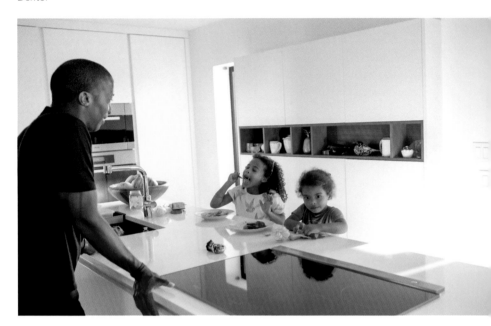

"We're inspired by the
designs around Expo 67
in Montreal—Canada
imagining itself at the
apex of what modern
society could be. It was
a time when Montreal
was thinking big, as the
city of the future. It's an
idea we're still immersed
in and see the beauty of."

Byron

1972 Born in Ottawa, ON

2000 Opened WANT Stil, a retail store in Old Montreal
 that was one of the first to introduce Scandinavian
 labels to the North American market

2006 Launched their own line of travel accessories
 under WANT Les Essentiels de la Vie brand

2009 During a challenging time for the company,
 WANT collaborated with J. Crew on a collection
 that would sell out in three weeks and help boost
 the company's fortunes

2015 Opened a WANT retail location in New York's
 Greenwich Village

FUTURE To be change agents with a profound influence
 on the way of the world, and to leave a legacy at
 home in Canada.

Will Gadd

50 years old

ice climber, paraglider

Canmore, AB

By any reasonable standard, Will Gadd should be dead by now. There was the time he climbed the spray-ice route up Niagara Falls in the dead of January. The time he paraglided 400 kilometres across the Rockies, setting a new world record. And the time he explored a series of Thai caves so far underground he had to carry in supplemental oxygen.

A twenty-first-century professional daredevil, Will's job is dreaming up risky undertakings no one has tried before. "My life is a continual kind of random creation act," he says. "Every day is creative in its own way." Right now he's working with Discovery Channel on a television series in which he visits some of the world's hardest-to-reach places. In 2014–15 *National Geographic* named him one of its Adventurers of the Year. Among his many other laurels are three gold awards for sport climbing at the Winter X Games and a World Cup ice-climbing title. At fifty, Will is still beating competitors half his age.

Climb Anything

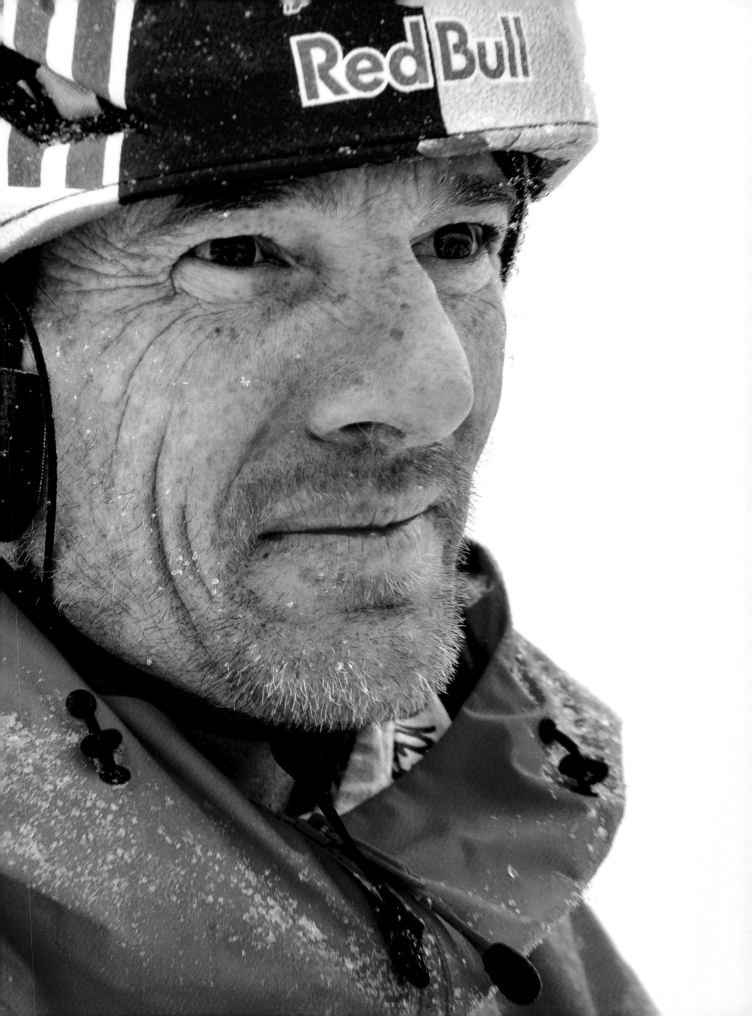

You could say that risk-taking is in Will's DNA—his parents met on a climbing trip, and Will spent his childhood in Calgary hiking, climbing, and doing stunts on his BMX bike. Meanwhile, his parents helped found the alternative elementary school he attended. "Many of my parents' life choices helped me see the world differently," he says. "Like, 'Hey, you can do things differently, you don't have to follow the standard path.'"

Though Will wasn't averse to studying hard, eventually earning a university degree in political science as well as a diploma in journalism, he believes the education system in North America could use an overhaul. "Here our rite of passage is to make people sit down in a room for eight hours a day and do nothing. Kids like me who are high energy, we need big events and interesting things going on or we're going to create them in less positive ways."

Will's two daughters are now nine and six; he makes sure their home life is orderly but with a dash of excitement. His house in Canmore, Alberta, is outfitted with indoor and outdoor climbing walls and swings in both child and adult sizes. The fridge is full of hot sauce.

Paradoxically, Will attributes his success to the power of negative thinking. "Positive thinking, that's for like getting a date," he says. "You want to actually get shit done, you have to think negatively." Will's trips can be extremely dangerous and sometimes take up to ten years to plan. Venturing into the world's harshest environments, often accompanied by a film crew, means taking other people's lives into his hands. "I have a very active imagination, and the way I survive in these environments is to think of everything that can go wrong in graphic detail. Then I break it down until I feel I have a reasonable answer to all those fears."

One of the qualities Will values most about Canada is the absence of things to fear. "When I travel in other countries around the world, I appreciate what we have all the more—freedom from violence and freedom from extortion, and latitude to live life relatively free of pain and suffering." Will was born in the United States to American parents, draft dodgers who resettled in Canada shortly after he was born. "Let's face it, I won the lottery on that one and I'm thankful for it, really lucky."

It's important to Will not to waste that good fortune. "I think it's almost an obligation to use this freedom that we've been given to go out and do meaningful things." For Will, that means testing the limits of how far, how fast, and how high human beings can go. But he insists that what drives him isn't setting records or establishing firsts for their own sake.

"It's not about me leaving my mark on the world; it's about constantly asking questions and learning." Most records are eventually broken anyway. "Everybody's always like, 'You must be driven to do these radical things!' But I'm doing them only because they're interesting to me, and they let me be creative. It's what I've been doing my whole life."

"My idea of misery is losing the ability to control the direction of life. Like when you get divorced. When you lose control like that, life kind of falls apart. I know my problems are really small compared to somebody who's a refugee or dealing with family trauma. There are people who deal with it every day of their lives."

"I guide people in the mountains all the time and I see the same thing happen: they show up, they're mentally scattered, and everything is a disaster. Then after a few hours of hiking they are present. You look into their eyes and there they are."

"I make a conscious effort to learn something new every couple of years.

One year it was how to log and use a chainsaw. Another year it was how to hunt."

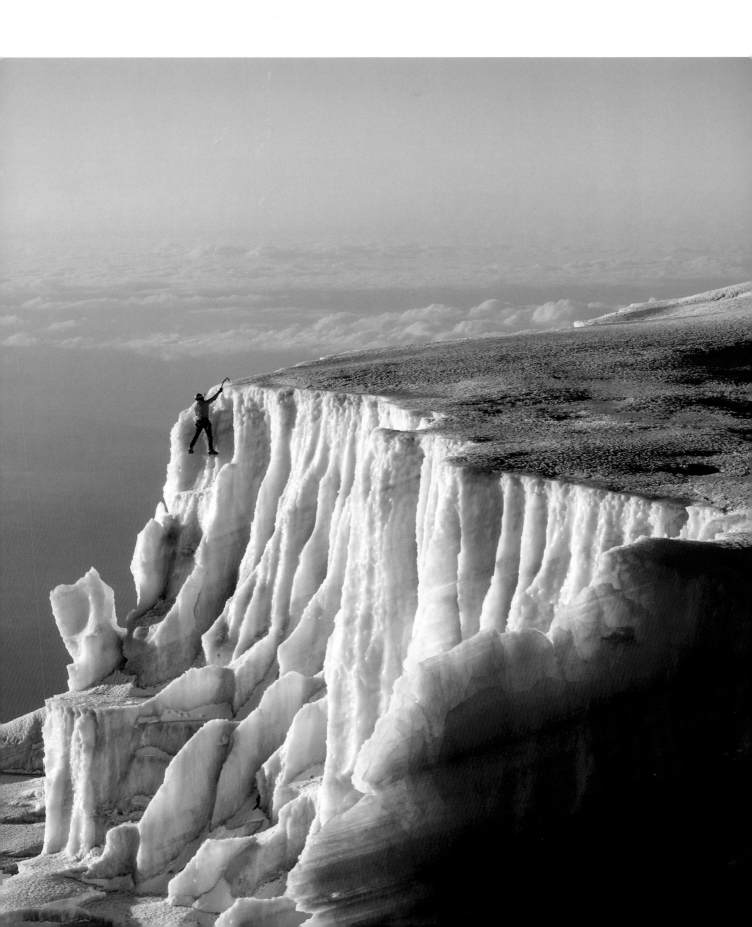

1967 Born in Colorado Springs, CO

1983 Bought his first climbing rope and completed
 his first new rock route

1998 Won his first Winter X Games gold medal
 in ice climbing

1999 Set his first paragliding world record
 for distance

2015 Became the first person to ice climb
 Niagara Falls

FUTURE Unknown—and that's the way he likes it.

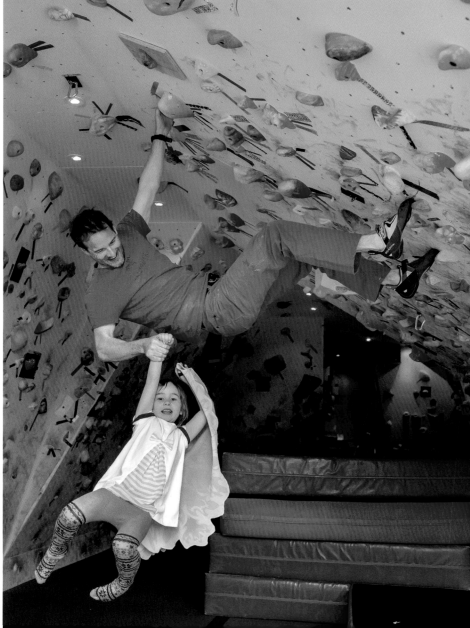

Will's well-used deck might be cluttered with toys, elk horns, and outdoor supplies, but the climbing gear in his garage could not be better organized or cared for. "I like my things neat and organized and in systems. When you are an ADD sort of individual, as I am, then systems and planning help."

Previous spread: Will ice climbing at Mount Kilimanjaro, Tanzania.

Mosha Lundström Halbert

30 years old

New York, NY

Fashion editor

In 2008 Mosha Lundström was on a bad first date. He was all nerves, dominating the conversation, and she could barely get a word in. When she finally had a chance to speak, she boasted that she was an editor at *Fashion Television*. He was impressed. The only problem … it wasn't exactly true. What she had was an interview for an intern position at the iconic program.

As the lie left her mouth, she knew she had to make it a reality—and, good thing, the internship came through. Then she got a job offer from *Flare* magazine. That turned out to be an auspicious start for the future style maven, now the fashion director at *Footwear News*, an influential publication put out by the same people behind industry bible *Women's Wear Daily (WWD)*. And that bad date? She ended up marrying the guy in a decadent wedding that was featured in *Vogue*.

Style That Travels

The story sums up how Mosha approaches most things in life: "Under-promise and over-deliver, though sometimes you've got to fake it to make it." Fortunately, she always has a detailed game plan to go along with an open mind and an inherent curiosity about the world around her. Likewise, Mosha's personal style reflects that of a driven woman with an innate sense of creativity—a look she describes as "elegance meets irony." "I really love something classic and super feminine that flatters my figure," she says. "But I like to add touches that are a bit more playful." A killer pair of shoes is another necessity, and she is rarely spotted in the same pair twice.

Fashion was a natural path for Mosha to pursue. Her mother is the designer Linda Lundström, most famous for the La Parka coat. Her father was CFO of the family business. "That was the best education," Mosha says, "growing up in a factory and seeing how clothing is made, having an appreciation for craftsmanship." She remembers having in-depth conversations with her father over issues of *WWD*, fascinated by the industry's movers and shakers behind the scenes. But she also learned to appreciate the struggles and sacrifices her parents had to make when the 2008 recession forced their thirty-six-year-old company into receivership. "My mom speaks about failures as a gift," says Mosha, emotionally. "She really encourages me to learn from them."

Mosha took several detours in her youth and returned to fashion in a roundabout way. She was captivated by movies as a child and dreamed of becoming an actor. "I had a hardcore Audrey Hepburn phase," she laughs, "though, looking back, what I really loved was all the Givenchy that Hepburn was wearing and learning who all the costume designers were." She tried theatre school in New York but was kicked out after only a year. "I was devastated; I thought maybe I'm not supposed to be what I've wanted to be my whole life." Next, she "ran away" to Iceland, her family's ancestral home, so she could focus on writing. It proved the perfect place to reinvent herself.

"When you're in Iceland you feel this tremendous surge of energy," she says. It was there, on New Year's Eve in 2015, that Mosha, dressed like a snow queen, married English entrepreneur Aidan Butler.

Footwear News, like *WWD,* is an essential trade magazine for fashion industry professionals. Its readers are shrewd and savvy, and it's Mosha's job to find new ways to capture their attention. "I approach feature writing similarly to the way I used to write scripts," she says. "I try to set the scene and maintain a strong point of view." She attends the four major fashion shows in London, Paris, Milan, and New York twice a year, and treks all over the world on shoots. "There's that Diana Vreeland expression, 'The eye has to travel.' It's important to see how other people dress. Even as fashion trends go global these days, I see enough that's new and original for my mind to explode with ideas."

One of Mosha's favourite places is the dream cottage her mother recently built on a small lake in northern Ontario. Scandinavian in design, it has charred cedar on the exterior and is filled with colourful First Nations art. After a brisk swim or paddle in the canoe, she likes to sit in the wood-burning sauna. "I'm a slow burner myself," she muses. "I don't want to be just another 'pretty young editor' with lots of stuff. As opposed to creating content for someone else's brand, I want to be making something that I have ownership over, that is completely from my own idea. I want to be contributing something, inspiring people to do something new that hasn't been done before."

"My husband is a Freemason;
I converted to be Jewish. If we have kids,
they need to figure it out for themselves,
explore their beliefs and not just inherit
them—we inherit enough in life."

Whatever she pursues, Mosha likes to learn on the fly. "I didn't study fashion," she says, "I didn't study journalism. My best education in journalism was working at *Fashion Television*, writing for the school newspaper, and learning from other people I admired."

"I'm commanding a team: the models, the hair, and makeup. I know I'm doing a good job if, by the end of the shoot, I look horrible. That means I've put all my energy into everyone else, which is how it should be."

"I think the 60s really was my era—mod fashion, clean lines but clinical. It captured the essence of beauty: feeling good in your skin, being confident."

Mosha at the Chelsea Market in New York; enjoying a Moscow Mule at the Bowery Hotel; Mosha with her hair and make-up team, Geo Brian Hennings and Daniella Shachter; Mosha's first Chanel shoes.

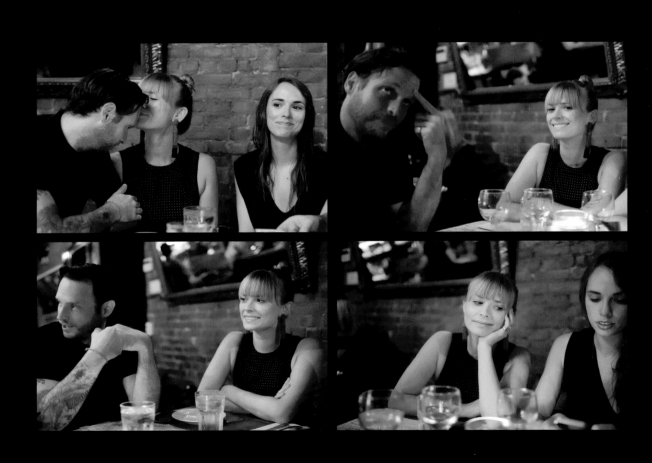

"I'm very uncompromising when it comes to my standards, and I fight for what I think is right and what I want, and that doesn't always make everyone like me."

1986 Born in Toronto, ON

2007 Interned at *ELLE Canada* magazine

2009 Worked at *Fashion Television*

2010 Moved on to *Flare* magazine to be its fashion news editor

2013 Appointed fashion director of *Footwear News*, part of the *Women's Wear Daily* family of publications

2016 Launched the Nordic luxury outerwear label Therma Kota with her mother and sister, inspired by their Icelandic and Swedish heritage plus the Canadian spirit of embracing the cold

FUTURE "I want to reach a lot of people as editor in chief of a major media brand."

"My idea of happiness is kind of where I am right now," says writer and documentarian Katherena Vermette. It's a deceptively simple statement that, like her poetry, contains a world of social, emotional, and historical meaning. On a literal level, she is talking about her office. Her "poet chair" is a plush light-blue armchair with a matching ottoman—the first thing Katherena ever bought from IKEA. "I felt like I had arrived because I could finally afford IKEA furniture." Her old cat is lounging on the chair's shoulder while her puppy sleeps in the corner. Outside her office window, a family of starlings has nested in the roof, and as she works she can hear them singing.

Writer and filmmaker

40 years old

Winnipeg, MB

Katherena Vermette

Red River Poet

Katherena at her writing desk at home.
Previous page: Katherena's favourite picture
of the neighbourhood where she grew up.
"In the late 1960s this kid got the best view
for the approaching Santa Claus parade."

Katherena is also in a pretty great metaphorical place right now. Her first book, the poetry collection *North End Love Songs*, won the Governor General's Award. She followed that with a novel, *The Break*, and then a National Film Board documentary she co-wrote and co-directed entitled *this river is a woman*. The river in question is Winnipeg's Red River, a historic meeting place for Indigenous and European traders. Katherena, whose family's Metis roots in the city go back to its founding, lives with her two daughters in a house she bought three years ago close by the Red.

Much of Katherena's writing is intimately tied to the community she was raised in—the largely Indigenous North End of Winnipeg. Both of her parents encouraged her education; her mom, somewhat prophetically, began reading when she was pregnant with Katherena. For inspiration, Katherena looked to her stepfather, one of the few people in her family to attend university. "I remember being really intrigued by all his textbooks and the research involved in writing his papers," she says. "I always wanted a little bit of that. That's kind of where a lot of my work starts: this base of research, exploring, and wanting to know more."

Katherena's process is evident in *this river is a woman,* which engages the ongoing horror of missing and murdered Indigenous women, many of whom have eventually been found by the Red River's banks. But the troubles of her home community haven't kept her from celebrating the natural beauty and strong human connections she finds there. "You get a lot of flack for being proud of where you're from when people don't think you should be."

It's part of the reason she wanted to be a writer, because she wasn't seeing her own experience reflected in Canadian poetry. "Mine is a very Indigenous perspective, but it's primarily an inner-city perspective," adding that most Aboriginal Canadian literature has focused on the rural experience. "I wasn't seeing anyone talking about the beauty in Winnipeg's inner city, the strength and resilience." In recent years, Katherena has been making her poems into short videos, juxtaposing her words with images of people and places that matter to her. One video, *Heart,* features a montage of adults and children working and playing in the North End's churches, diners, streets, and parks, accompanied by Katherena's voice reading these lines: "They say 'lost cause.' I say 'seeking.' They say 'beaten.' I say 'rising.'"

What Katherena loves most about her home is the way people care for each other. "There isn't a single Indigenous, professional person I know who doesn't also spend their time in some sort of volunteer capacity." In her career as a writer, it's not the big awards that have mattered most— it's making her own community proud. Katherena has been inspired by the tremendous energy she sees in the next generation of Indigenous youth. "I see so many beautiful, strong youth in my community," she says. "They're so far ahead of where people of my generation were twenty years ago. I think twenty years from now we're going to be so much better off."

"I'm really just an
opinionated bitch.
I've practised a Western
style of paganism
for many years.
I like the word 'witch'—
she's both a teacher
and a learner."

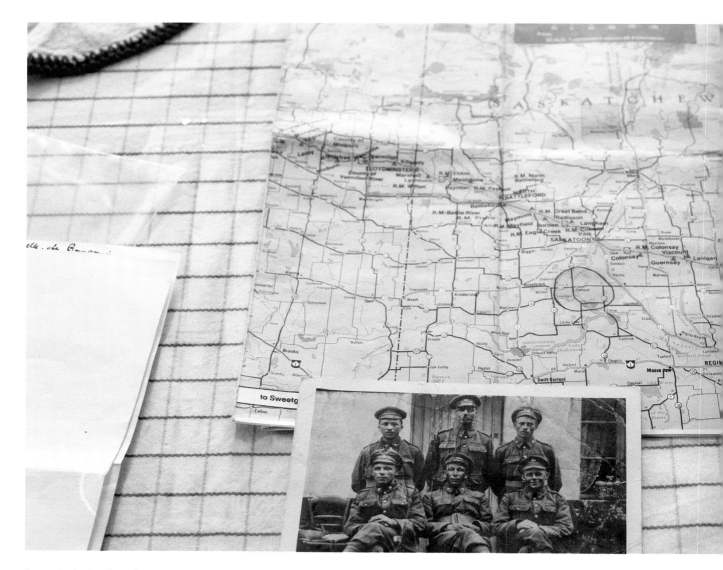

A map showing locations of
battles from the North-West
Rebellion of 1885—during
which a predominantly Metis
resistance fought government
forces in Saskatchewan and
Alberta—and an image of
Katherena's ancestral uncle,
seated at middle, who served
in the First World War.

At left: One of the dream catchers Katherena has made.

Below: A faded image, part of an art piece at Neechi Commons.

Following spread: The landmark Northern Hotel in Winnipeg's North End, which has featured in Katherena's writing.

"I just want peace. I want things to be resolved.
I want promises, for lack of a better word, to be honoured.
I want respect given to Indigenous people in this country."

"I take a lot of time to process things—what I see
and think about things. And writing gave me that time."

1977 Born in Winnipeg, MB

2013 Won Governor General's Award for Poetry
 for *North End Love Songs*

2014 Completed MFA in Creative Writing from
 University of British Columbia

2016 House of Anansi Press published her novel
 The Break

2016 Co-wrote and co-directed *this river is a woman*
 for the National Film Board

FUTURE "My proudest moments are when the community
 feels proud of my books—I want them to feel
 I have accurately represented them."

Bruce Poon Tip

Entrepreneur

All children are curious about something and, through it, begin to learn about the wider world. For Bruce Poon Tip, the future travel entrepreneur and founder of G Adventures, it was dogs. "I was into reading all these books about dogs," he says, "and I would see they came from a particular place—the Scottish terrier for one." Through dogs, he discovered the culture of the countries where they originated. His parents couldn't afford a dog, but he called up breeders anyway, pretending he was interested in buying one. All he really wanted was to ask questions.

Growing up in Calgary as the son of ethnic Chinese immigrants from Trinidad, Bruce often got into trouble for asking questions. When, in grade five, one of his teachers told him that Tibet didn't exist—it wasn't on the classroom map— Bruce produced his encyclopedia to prove her wrong. "I knew Tibet from the Tibetan mastiff," he says. "I even read about this living god called the Dalai Lama who had been reincarnated." He was sent home for being a nuisance.

Travel for Change

Toronto, ON

"Going to Tibet changed the way I thought about everything—business and life. It showed me the importance of emotional intelligence, that compassion could exist in business."

But Bruce also had a knack for starting businesses—three by the time he was fifteen — earning a Junior Achievement award for entrepreneurship in the process. When he was fired from his part-time job at McDonald's —again, for asking too many questions—he had his epiphany: "I came out of it thinking I'm successful only when I do things myself." A few years later, supported by maxed-out credit cards, Bruce launched a visionary travel start-up out of his Toronto apartment. Today, with over 100,000 annual customers and 1,300 staff stationed around the globe, G Adventures is the largest adventure travel company in the world.

One of the company's first trips was a home stay with an Amazonian tribesman in Ecuador —a venture that epitomized Bruce's unique approach to tourism. "People travel to some of the poorest countries in the world, but they stay at all-inclusive resorts," he says. "That money is being sucked out of the country." Bruce designed trips where his clients reside in locally owned accommodation and get around on local transport while also being mindful of social and ecological impacts. "My destiny is to prove that people can travel in a way that changes the world."

Bruce's trips anticipated the growing trend for more authentic, grassroots experiences— for seeing the world as it's really lived, beyond the walled-in resorts and cruise ships. But the company is now admired for more than its commercial success. Governments and international organizations such as the World Bank and UNESCO frequently consult Bruce on how sustainable tourism can help transform struggling communities.

From the beginning Bruce wanted to create a business that reflected his values: "My company is an expression of me—it's very personal." For him, entrepreneurs are the artists of the business world. Ask Bruce who he is inspired by, and he points to the symbol posted on his office door. "You know that's the Prince logo," he says. "It's not just his music but the way he fought for his independence and went against everything that was standard in this goliath music industry."

Not surprisingly, that maverick attitude complements Bruce's keenly competitive nature. "I know it sounds contrary to my big, happy business model," Bruce says, "but I absolutely love decimating my rivals." He relishes the competition of sports, particularly in basketball, and he carries that over into his business. The trick, he admits, is to find grace in losing: "I can't say I like it, but it gives me an opportunity to grow."

These days food provides his window on the world. At home with his wife and two daughters, Bruce does most of the cooking. His favourite food is Indian, and he's fascinated by the regional differences in the cuisine. "You can tell everything about a country through its food," he says, "and by making it you're telling a story about a culture."

Cooking is also a way of connecting with his children. By example, he mentions the Taiwanese film *Eat Drink Man Woman*, in which the grumpy widower communicates with his adult children through the elaborate Sunday dinners he prepares for them. Bruce confesses that he cried while watching the film for the first time as it made him appreciate his own father, with whom he had a chilly relationship growing up. But even then, family dinners were mandatory. "Never in my life was I allowed to say, 'I'm going to a friend's house for dinner,'" he says. "That film made me understand my father and what those meals meant to him."

Recently, when his wife was away on a trip, Bruce offered to take his daughters out for dinner. Instead they chose to stay in and find a new recipe to prepare together. "I was so touched," he says. "What is it that connects us all universally? The need for food—and to be loved."

"I'm a news junkie. There's no level too low for me when it comes to reading the news. I read The Economist, I follow global affairs... then you'll catch me reading something about, you know, Justin Beiber and something about a Kardashian."

This page and opposite: Bruce at the G Adventures offices—sometimes it's hard to tell whether staff is working, playing, or a bit of both at the same time. "Everyone wants to be part of a winner. If you want to be a successful business, you hire winners and build your company to win."

Opposite bottom: Bruce exercising with his two daughters.

"Being an immigrant gives you a fifth gear. Whether it's working hard, being creative, making a decision that's not popular, being able to reinvent an idea—it all comes from being able to push your limits."

1967 Born in Port of Spain, Trinidad

1970 Moved to Calgary with family

1990 Founded G Adventures

2003 Launched the NGO Planeterra, which was later
 contracted by the Inter-American Development
 Bank to create five major sustainable tourism
 projects in Latin America

2013 Published his bestselling book *Looptail: How
 One Company Changed the World by Reinventing
 Business*, with a foreword by the Dalai Lama

2015 Published his book *Do Big Small Things*

FUTURE Having recently taken up painting, he hopes to
 complete his certificate at OCAD University.

Golden Focus

Off the mark, she seemed to hesitate longer than her competitors before kicking off the platform —as always, with her right foot. By the 25-metre point, though, she was well ahead of the pack, a torpedo outrunning bullets. Her lead would never be challenged. When she hit the wall at the other side of the pool, just 27.37 seconds later, she had once again shattered a world record in the 50-metre freestyle. She broke into her familiar smile, and the smile would never leave her face. When she left Rio de Janeiro several days later, Aurélie Rivard, Canada's finest Paralympic swimmer, was carrying four medals—three gold and one silver, tying her for most decorated Canadian Paralympian at the 2016 Games.

Aurélie Rivard

Aurélie has spent her entire life swimming. Born in Montreal, she started lessons with the Red Cross before she was a year old and at thirteen was competing in international meets. The solitude of the pool offered a kind of solace. When she was eleven, Aurélie experienced a panic attack as inexplicable as it was devastating. Anxiety and insecurity plagued her thereafter—she couldn't go out with her twin sister, with whom she shared a profound bond, unless both were wearing dresses. "I had to do the same as her to feel comfortable," she says. But swimming took her out of her head, and swimming competitively gave her fresh focus and drive. Each stroke renewed Aurélie's confidence.

The anxiety never entirely abated. A typically confused teen, she hated sacrificing her social life, skipping sleepovers with her friends because she had to be up early the next morning to train. Even when she made her Paralympic debut in London at the age of sixteen—where she won a silver medal in the 400-metre freestyle—she felt conflicted. Every day she went to the athletes' lounge to gobble Skittles, wondering why she was there. "It wasn't a dream of mine," she says. "I didn't know what I wanted."

She soon faced another challenge. A year after the world championships, she changed schools so she could concentrate more on swimming (her days were split in two: mornings for school, afternoons for training). Separated from her sister for the first time, she was the new kid in a place filled with snobby kids who'd known each other for years. Aurélie had been born with an undeveloped left hand and, while the impairment never really bothered her—"I just thought it was part of me, like some people have blonde hair"—her new classmates seized on it. They talked behind her back, insulted her to her face, and threw things at her in the cafeteria.

One day at practice another swimmer tossed a water bottle at her, and Aurélie retaliated. She hurled the bottle back, hitting the girl in the face, and though she doesn't remember exactly what she said, the bullying stopped. "When I think about that year, I wouldn't want to go through it again," she notes. "But it really made me who I am today. It made me focus more on myself."

By the time Aurélie competed in the 2014 Commonwealth Games, the dream she had questioned in London had finally become hers. She took home a bronze from those Games, but she also gained fresh inspiration from Canadian swimmer Ryan Cochrane, who'd won two major races. "I felt so much pride," she says, "as though I was standing on the podium with him. Every time I felt like not training hard, I would think about that feeling. And that's when I started winning."

In the early part of 2016 Aurélie held the world record in the 50 metres, but in May that record was broken by the Russian para-swimmer Nina Ryabova. Aurélie was devastated and, for a month or so, thought about bailing on the 50-metre freestyle in Rio. Instead, she doubled her focus on that race, vowing to win—and she did, the record falling yet again. When she emerged from the water, she saw her parents in the first row of the stands, the people who had supported her for so long and made their own sacrifices. She kept smiling as the tears rolled down her face.

When Aurélie was in her early teens, she saw a therapist to help her navigate her debilitating struggles with anxiety. Now, like most elite athletes, she speaks with a sport psychiatrist to deal with the pressures of performance. "Being an athlete is very physical, but it's even more mental," she says. "It's really easy to overthink or doubt yourself. You have to learn to trust yourself, be mentally strong, or it's just not going to happen. I wasn't born that way—I had to learn it."

Like all competitive athletes, Aurélie occupies a singular kind of existence—on the one hand, living entirely in the moment, and on the other, focusing with laser intensity on the next race. She has dreams of other work and of starting a family, but for now all she can think about is swimming. To that end, she has advice for everybody: "Just trust yourself. It would have saved me so much stress if I had understood that concept earlier. Don't focus on your rivals but only on you. That's what's going to help."

"I was really lucky to be born into the family I have. After that it's the choices I make, the opportunities I create for myself. I always had a natural talent in the pool; the rest is the luck I've created for myself."

Aurélie training at the pool at Montreal's Olympic Park. Outside the pool, Aurélie says she tries to keep up with fashion trends. "People say I'm stylish. I wear my prosthetic hand when I'm out but not when I'm training or at home—but it's always in my bag. I guess you guys don't have that!"

"When I'm away I miss Tim Hortons—it's just part of my life. When I go to the train in the morning, I always get a coffee. It's where I go if I don't have time to cook or have a nice dinner or lunch."

1996 Born in Montreal, QC

2008 Began competitive swimming

2012 Won her first major medal, a silver, at the
 London Paralympics

2015 Won seven medals, including six gold, at the
 2015 Parapan American Games in Toronto,
 making her the most decorated female athlete
 in the event's history

2016 Named Canada's flag-bearer for the closing
 ceremonies of the Rio Paralympics, where
 she won three golds and one silver

FUTURE Using her failures to get even better: "After
 Rio, it's not the races I won that I want
 to work more on but the one in which
 I finished second."

Despite the extreme financial burden of hosting the 1976 Olympics, the Montreal Games left a legacy of sports infrastructure that younger athletes like Aurélie continue to benefit from.

Picturing
the Planet

Toronto, ON

Photographer and filmmaker

62 years old

According to a growing number of scientists, we now live in an epoch called the Anthropocene. For twelve thousand years, after the end of the last ice age, humans enjoyed the stable climate that enabled them to thrive and create complex civilizations. But that period, the Holocene, is over. The Anthropocene marks the shift to an epoch where the collective activity of humans is able to alter the planet's course as an ecological system. Think greenhouse gas emissions, mass deforestation, factory agriculture, and the reshaping of topography by massive hydroelectric projects.

"We've moved the planet into another state," says photographer Ed Burtynsky, "where humans are *the* event. The past event that created the kinds of changes and extinctions as dramatic as what we're experiencing now was when a meteor hit the planet sixty-five million years ago."

Ed
Burtynsky

Over the past three decades, no artist has chronicled humanity's profound reshaping of the natural environment so thoroughly—and beautifully—as Ed. His hyperreal, large-format images of mine tailings, quarries, ship breaking, and engineering megaprojects are shown in galleries and museums around the globe. They have also won him numerous awards, including the prestigious TED Prize—which he learned of winning on his fiftieth birthday. The 2006 film *Manufactured Landscapes* helped introduce Ed to an audience outside the art world, as director Jennifer Baichwal accompanied him on a trip to China to shoot its mammoth factories and the construction of the Three Gorges Dam.

Viewers often marvel at the uncanny beauty of Ed's pictures, their exquisite composition and painterly quality somewhat at odds with the destruction they depict. But it's within that tension that their unique power resides. As he says: "I'm looking at the world we're creating as if I'm sending a report to another species that's wondering what we're doing to this planet."

Ed found both his vocation and subject matter early on. Growing up in St. Catharines, Ontario, he liked to hang around the nearby Welland Canal and the decaying industrial sites around town. When Ed was eleven, his father bought the family a set of camera and darkroom equipment, and Ed intuitively turned his lens toward these landscapes. "Taking pictures just became a natural part of what I did as a kid," he says. "Creativity was somehow in my DNA. My father came from a village in Ukraine where everyone was an artisan—they'd been making crafts, painting, or woodcarving for centuries."

In other respects, his relationship with his father was terrible. "It was a difficult time," he says. "I was shy and had a bad self-image. But it left me with this feeling I had something to prove to myself and to others." By thirteen, Ed was already establishing his independence, running a small business shooting portraits at a Ukrainian community centre. Two years later his father died. "That's when I realized I couldn't depend on anybody; I had to make my own life." It was through his photography that Ed found he could create something of value, and, he adds, "I was willing to fight for it."

"We're living in a myth that growth can be infinite. With all the empires that have risen and fallen, history has proven that infinite growth is impossible. We can only grow to the limit that the environment will allow."

More than four decades later, Ed is one of a handful of Canadian visual artists whose work is instantly recognizable worldwide. In the past that's usually meant moving to London, New York, or Berlin—where Ed has gallerists representing him—but he's happiest with the life he has made in Toronto. "I like the size of it, the diversity," he says. "There's so much opportunity to invent oneself. After going out and exploring the world, it's always a great place to come back to." When he needs to recharge, he either retreats to his country home north of Toronto or takes a canoe trip. "I love being out paddling in this raw landscape, finding its rhythm."

Ed's current work-in-progress could be described as the culmination of his thematic preoccupations to date. Slated to launch in fall 2017, the *Anthropocene Project* follows a group of scientists as they collect evidence and make the case for a change in our understanding of how we relate to the planet. Multidisciplinary, the project will comprise a travelling museum show, a book, a virtual reality exhibit, and another film collaboration with Baichwal.

A keen supporter of Toronto's artistic community, Ed still finds time to teach and lecture, but when he does it's less about the practicalities of making good images and more about the importance of having a vision. "With today's technology, taking a great picture isn't hard to do anymore," he says. "But making a body of work that's cohesive, thoughtful, that speaks about your own life and the age that we're in, that explores new ways of telling stories to each other—those are things that an artist today has to be doing."

"I love Stanley Kubrick, and that probably shows in my work—his framing, the clarity and centrality of his vision."

Ed admires a quotation from E.O. Wilson: "We have paleolithic emotions, medieval institutions, and God-like technology." When you combine these three things, he says, "we're a dangerous species: we have the tools that can reshape the world, but we haven't yet figured out how to control our impulses."

Facing page: For years after Ed's poultry photograph was included in a National Film Board publication, he was known as the "chicken-packing-plant guy."

"It was so powerful the time I got to witness this burning of elephant tusks in Kenya, of elephants that were slaughtered for the illegal ivory trade. If you strung them together, tail to trunk, it would've been a 35-kilometre-long procession of elephants. And for what? Carving. It showed there is a reason to grieve for the things that we're doing."

1955 Born in St. Catharines, ON

1985 Founded Toronto Image Works, a commercially successful photo lab, darkroom rental, and teaching facility

1988 Toured his first major solo exhibition, *Breaking Ground: Mines, Railcuts and Homesteads*

2005 Won the prestigious TED Prize in its inaugural year, with co-recipients Bono and Robert Fischell

2006 Appointed to the Order of Canada

2013 Co-directed the film *Watermark* with Jennifer Baichwal, on the way water is used and managed

2016 *Essential Elements*, an overview of his work, published by Thames & Hudson

FUTURE To keep going into new places, breaking moulds, taking chances.

"I never feel like I'm working. I'm just following ideas and passions, and solving the problems of how to do what I want to do."

Fashion designer

Tanya Taylor's best thirty-first birthday present came in the form of an Instagram post—a photo from Michelle Obama's team showing the First Lady wearing one of Tanya's designs. The occasion was the Obamas' final White House holiday party, and Tanya had designed the dress specifically for her—a knee-length LBD ("little black dress" in fashion-speak) accented with red and purple embroidered poppies. Tanya was in a clothing store in New York with her family when the news came in, and the staff popped a bottle of wine to celebrate the landmark moment. "Seeing her wear our dress brought so much joy into my life. She has always inspired me to keep going."

Storytelling Through Style

New York, NY

32 years old

Tanya Taylor

Tanya at her company's design studio in the Soho neighbourhood of New York. "A lot of people come into the business saying they've 'studied fashion,' but they don't know what that means. They don't know if they want to market or make clothes and have the skills to do so. Toronto needs a great art institute to get young people interested and involved in fashion at a younger age."

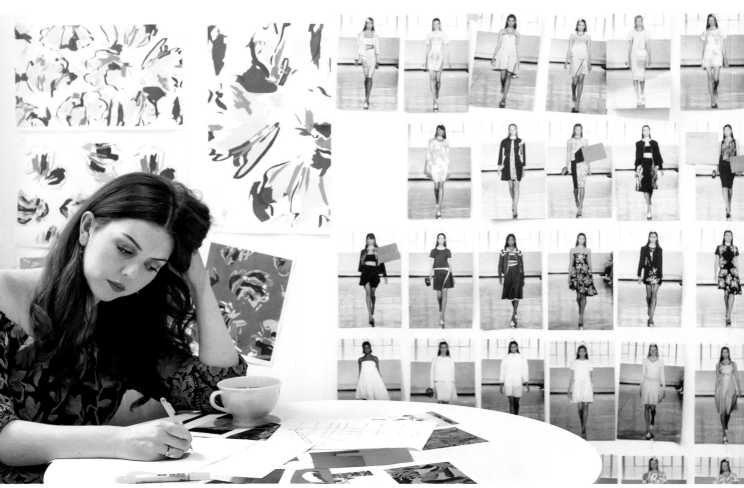

Though Tanya's parents divorced when she was four, both of them have had a marked impression on the person she is today. For years her father taught at universities overseas, before becoming a family therapist; she admits to sharing his analytical approach to understanding people. Her mother, Virginia Shaw, is the former chairwoman of the energy company ShawCor Ltd. Meanwhile, the women in this clan served as some of Tanya's earliest influences in fashion. "My whole family, they wear one colour head to toe. My grandma is a bright robin's egg blue, like ice. And then she puts a lot of little diamond bumblebee brooches all over her cardigans. My mom is 100 percent fuchsia; it's weird, she will buy anything that's fuchsia." Tanya's own signature colour is a fiery tomato red, which, she says, suits her energy and stubbornness. "Most people probably don't see their life in terms of colour as much as I do. I react very much to colour—I associate every single day with a different one."

Tanya initially studied finance at McGill University before going on to fashion school in London and New York. "I am not the most introspective person," she says, "so I never realized I could pursue what made me happiest—hence why I studied finance before fashion." In 2012 she was looking for a bold way to usher her new clothing line into the public eye. "I started working with a publicist who is a dear friend, and he said, 'The most important thing to do in New York in fashion is to stand out and do something that you're really excited by. Where's your favourite place in the city?'" "MoMA," she replied, and he said, "All right, good, have your show there." "Ha, that's hilarious," she said but figured she might as well try. Tanya didn't have any connections at the Museum of Modern Art, so she spent months calling its corporate sponsors, hoping to work out a deal. It paid off—her eponymous line's first collection launched, supported by JPMorgan Chase, with an installation in one of MoMA's lobbies.

Tanya's bold colours and intricate florals quickly caught the attention of high-end retailers, and her clothes are now sold in prestigious shops like Saks Fifth Avenue, Bergdorf Goodman, Neiman Marcus, and Holt Renfrew. Being Canadian has helped rather than hurt her prospects. "There are a lot of amazing Canadians in the fashion world, and it's like a secret code when you tell someone you're Canadian."

Tanya thinks of fashion design as emotional storytelling. "I'm definitely trying to tell a story. I think that designing is a way of talking to people, a way of connecting with them. I'm asking them to let me be a part of their lives. You have to be interested in people to be a designer." Her desk is always strewn with the flotsam of her practical concerns and eclectic interests: at any given time it may feature lemonade (her favourite drink), a wooden bird, hair products, books on Japanese kimonos from the 1890s, and manila folders full of pressing documents. Her best ideas come from travelling—a trip to Cuba yielded two thousand photos, mainly Tanya's attempts to capture the island's "unbelievable" colours. Another recent trip, to Utah, got her thinking about the high desert's natural palette.

All this travelling, looking, and collecting feeds into her creative process. "When I come back to the office with these photos, I'll start making stories on the cork wall in front of my desk. Some stories will be about colour, some will be about texture and details. Then I'll go on fabric appointments, meet with our mills in New York or in Paris, and start figuring out what fabrics might support the story I want to tell."

Michelle Obama is not the only political lady to sport Tanya's designs. Sophie Grégoire Trudeau is also an admirer of her style—she notably wore a Tanya Taylor creation for a much-photographed encounter with Catherine, Duchess of Cambridge. Tanya also designed a T-shirt in support of Hillary Clinton; her grey-and-white-striped crewneck with HRC in red, white, and blue was worn by celebrities from Emma Roberts to Demi Lovato. She believes one reason why her clothes have attracted women in politics is their optimistic, joyful feel. "In the US there's a bit of craziness going on right now. I hope people embrace colour instead of going into depression."

"I'd really like to grow
the brand internationally.
It already has such a
British sensibility, and
I love the quirkiness
and sense of humour
in Japanese fashion."

Tanya says that designing
is a way of connecting with
people: "To be a designer,
you have to be interested
in what they want."

An image board that
Tanya looks at for
inspiration. Below
is her cat Oscar.

"My grandma is one of
my design influences. She's
extremely stylish. Just
the level of polish that she
has, and the level of
respect she has for getting
dressed up each day.
There's something really
powerful and cool
about that."

"I have a hard time limiting my passion—I'm very into cooking, stickers, dancing, live music, movies, exploring cities ... I do poached salmon with a mean cauliflower and Brussels sprout salad side."

1985 Born in Toronto, ON

2007 Completed Bachelor of Commerce at
 McGill University

2009 Graduated in fashion studies from the
 Parsons School of Design in New York

2012 Launched her eponymous fashion collection
 at the Museum of Modern Art in New York

2014 US first lady Michelle Obama wore a dress
 designed by Tanya, the first of several
 occasions when she did so

2015 Won International Woolmark Prize
 for Womenswear

FUTURE "I aspire to build a fashion institute in Toronto
 and to be a good leader for my company."

Daniel
Saks

Nicolas
Desmarais

Digital Revolutionaries

Daniel Saks made his first sale when he was just eight years old, persuading an elderly customer to buy a cabinet in his family's furniture store in Niagara Falls. Daniel's great-grandfather started that shop, Saks Furniture, in the early twentieth century, and it provided the family with a multi-generational livelihood—his grandfather and father worked there too. But in 2008, right when Daniel was graduating from McGill University, the business came crashing down, yet another victim of the Great Recession.

"I was a smaller guy growing up, so I didn't make it onto the football team, but I joined the rowing team. It taught me leadership and dedication. I had to wake up every morning at five to get on the water and lead eight people—to be a kind of coach."

Daniel

"Growing up in Canada I was very sheltered from the darker impulses of our humanity. The longer we preserve innocence at a young age, the more it fosters empathy in adulthood. Perhaps this is why Canadians are renowned for effecting change by broad consensus through an inclusive discourse. The world needs more Canada,"

Nicolas

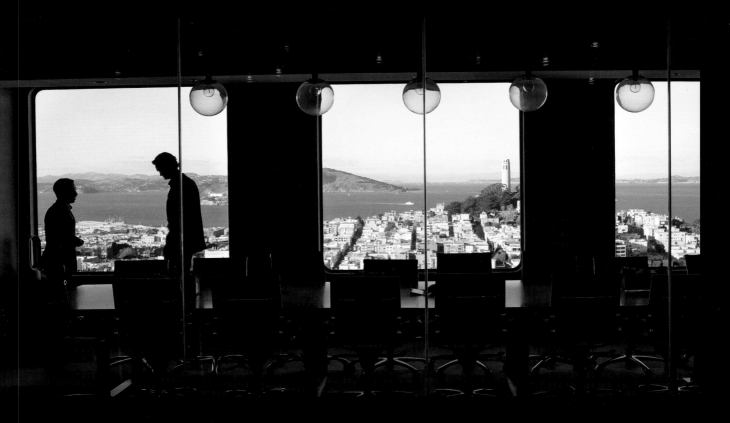

A sad day for the Saks family, but, for Daniel, a kind of inspiration. A year later, when he was twenty-four, the budding entrepreneur was living and working in San Francisco, brainstorming business ideas with his friend Nicolas Desmarais. It occurred to Daniel that, the recession aside, one reason Saks Furniture had faltered was that, as a small family-run business, it didn't have the access to technology that allowed it to compete with larger rivals. "We recognized the potential that the Cloud could have," he says. "Bringing software online could enable small firms like my family's to stay in business and compete. Even though the world around us seemed to be blowing up, we saw an opportunity to come out of this recession stronger."

Cloud-based computing was then just an emerging technology, with developers around the world racing to create shiny new apps for every aspect of business, from marketing to shipping. But many small companies, especially older ones with little interest in or knowledge of cutting-edge tech, had no clue such things even existed. Daniel and Nicolas's idea—which, with unerring clarity, they named AppDirect—was to bring these apps directly to small business owners via partnerships with the companies and telecoms they already knew. (For example, a barbershop's phone company would sell them an app to help manage appointments.) The start-up, which they billed as a kind of Facebook for business, got off the ground in 2009. By 2015 AppDirect had thirty million users and was valued at more than US$750 million. It now employs around seven hundred people in twelve offices around the world.

Like Daniel, Nicolas had sales in his DNA. Although part of one of Canada's most successful, entrepreneurial, and politically connected families, as a kid he went dumpster diving to scavenge items to clean and resell to neighbours. This initiative ended when he tried to sell an old flowerpot to the person who had thrown it out. His ventures grew as he did: lemonade stands became a rabbit-selling operation became a driveway-repair business. "The value propositions got more complex and the number of customers larger," he says, "but the concept remained the same: delight your customers with a better value-to-price proposition than what they had before."

Nicolas and Daniel became friends in 2003, but before arriving separately in California years later, they travelled on different but related paths. Born in Montreal, Nicolas received a BA in economics and political science at Amherst College in Massachusetts. Daniel, originally from St. Catharines, Ontario, got his degree in political science from McGill University. They both landed jobs in San Francisco soon after graduation— Nicolas as a consultant for Bain & Company; Daniel at an investment bank in Silicon Valley. Cloud computing was in the air, so to speak, and they began their conversations about its power and potential not long after.

Daniel credits the 2008 financial meltdown with fostering creativity and entrepreneurship in an entire generation. "With the recession, the people around my age who were graduating wouldn't get jobs in big companies," he says. "They were forced to think entrepreneurially, and that created an appetite for more risk. And now I think it's much cooler and easier to start a business than ever." Nicolas echoes that sentiment: "These are incredible times. A bit like living on the front lines of the Renaissance or the Industrial Revolution. The ever-accelerating pace of innovation and the role that AppDirect can play in this digital revolution keeps me up at night with excitement."

Daniel says they are "contrarians." Their ability to see fresh and different perspectives grants them greater empathy and a talent for catching opportunities that others miss. One such opportunity is Canada itself. He argues that, largely due to government policy and investment, the country now provides one of the best climates for business and tech development in the world. "When I speak to Canadian entrepreneurs," he says, "they often complain that there aren't enough investors in Canada. They complain that there's no opportunity. I push back and say, you're not thinking of big enough ideas. The one thing the Valley teaches you to do is believe in anything, even if it sounds crazy."

"Bill Gates answered
my email."
Daniel

Nicolas with his wife, Myriam, daughter, Olympia, and the robot he built. Still in its early stages of development, the robot is based on the InMoov design with the goal of controlling it by haptic bracelets and an Oculus Rift. Such technology could have dramatic implications for the economy, including the ability to work remotely more effectively.

Daniel swimming in San Francisco Bay—his favourite after-work exercise.

"With AppDirect, we want to affect digital distribution in similar ways to how railroads transformed hard-good distribution."

Nicolas

1985	Born in Montreal, QC	2009	Founded AppDirect with Daniel in San Francisco
2003	Met future partner Daniel Saks in Montreal	2015	Along with Daniel, named one of *Forbes* magazine's 30 Under 30
2006	Spent summer of his junior year interning at Bain & Company, a management consulting firm	FUTURE	"I would love to build AppDirect into an enduring tech company that powers the digital economy to improve standards of living for all. As it tears down barriers to entry for small businesses, it enables them to compete with large enterprises."
2007	Graduated from Amherst College in Massachusetts with a bachelor's degree in economics and political science		

Before Nicolas leaves for work,
he gives Olympia her breakfast
as they watch cartoons together.

1985 Born in St. Catharines, ON

1997 After writing an email to Bill Gates as a twelve-year old, Daniel was excited and surprised to receive a signed letter back

2008 Interned at Viant Group, a boutique investment bank in the San Francisco Bay area

2009 Completed Master of Liberal Arts in management, finance, and accounting at Harvard University

2011 AppDirect had official product launch to initially disappointing results

2014 AppDirect reached twenty million users worldwide, attracting a round of financing worth $50 million led by Peter Thiel, the influential Silicon Valley investor

FUTURE "To drive an entrepreneurial evolution and make it possible for any person around the world to start something they're proud of."

Daniel looking out over San Franscisco.

Jesse McCleery

38 years old

Galiano Island, BC

When Jesse McCleery was growing up in Winnipeg, he often spent time at his grandparents' house. His grandfather was Chinese, his grandmother, Polish, and one day Jesse found jars of pickles stored under the bed. He liked dill pickles and thought he'd enjoy these too. But they were different, more "fizzy" and "prickly," and it wasn't until Jesse was much older—and much wiser in the ways of food—that he realized he'd been eating fermented pickles. "It's literally just salt water and cucumber," he says, "and if you ferment it properly, it becomes as sour as vinegar pickles, with many different flavour aspects. When I was a kid, I hated the taste, but now I'd take that pickle any day."

In fact, McCleery spends time most days fermenting cucumbers and other ingredients. He is the head chef and co-owner, with his partner Leanne Lalonde, of Pilgrimme, a high-end restaurant nestled in the woods of Galiano Island. While it's been open for only a couple of years, its emphasis on wild and foraged foods and its innovative and surprising techniques have made Pilgrimme one of the country's most acclaimed restaurants.

Chef

Food Pilgrim

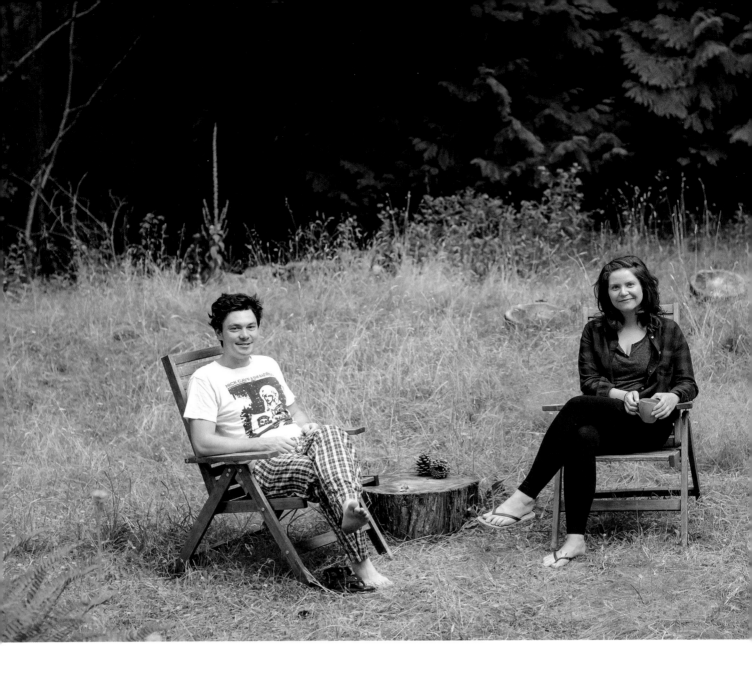

"The ideal dream for me was always
opening up a restaurant somewhere kind
of rural and remote, somewhere close
to farms with access to wild foods."

In retrospect, Jesse's path to this point has the inevitability of destiny. He first learned his way around a kitchen when he was seven years old, in the wake of his parents' divorce. Living with his father, who couldn't cook, meant that Jesse had to take the initiative "or else we'd be eating sandwiches for dinner every night." Barely into his teens he was already working in restaurants, mainly to subsidize his skateboarding habit. After a couple of years washing dishes and doing prep work—and by now firmly established at Civica, a gourmet pizza place—he realized that cooking had all but replaced skating. By sixteen he was a sous-chef. In 2000 he followed his older sister to Vancouver Island, where he got a job at Bodega Ridge, a wilderness resort outside Tofino. He immediately fell in love with the local bounty —the seafood, wineries, year-round growing season—and wild foods. In this pre-Internet time, before the foraging fad took off, local artists would turn up at the resort with bags of rare plants. "I'd never even heard of sea asparagus or tree tips," he says. "Back then, if you wanted to learn something, you'd have to work with someone who was doing it."

Meanwhile, in Denmark, another young chef, René Redzepi, had begun similar culinary explorations. His restaurant, Noma, pioneered the use of nearby seasonal ingredients foraged from the sea and forest. After earning two Michelin stars in 2008, it went on to become arguably the best restaurant in the world. Jesse became an intern at Noma in the winter of 2014. He stayed for six months, carefully observing the restaurant's distinctive fermenting techniques, working alongside chefs from all over the world, and watching, with awe, the sheer labour required to make Noma's singular dishes. "They're able to do what they do because they have fifty people working in the kitchen," he says. "They can process these things that take, like, eighteen man-hours in one dish."

When he returned to Canada, he wanted his own Noma. "You learn so much working with other people," Jesse says, "but I wanted to do my own thing and take risks." Which he did— repeatedly. With his girlfriend, Leanne, who had a background in hotel management, he leased a former restaurant space on Galiano Island, gutted the kitchen, and installed the $10,000 worth of equipment he'd stockpiled over the years. (They moved into the apartment above.) Bucking tradition, Pilgrimme ("pilgrim" in Danish) opened in winter, with no marketing budget, and survived that first season through local support. Now, during its busy summer season, Jesse doesn't leave the property for days on end, though he still hasn't taken a paycheque.

When Jesse talks about his cooking, he sounds like a gastronome with degrees in medicine and witchcraft. He spends time talking to local farmers, basing his vegetable-driven menus on recent harvests. He cooks fish and meat too, but will literally use the entire animal (duck feet in a soup, with the hearts dried, smoked, and shaved onto something else). Almost every dish has a living component in it, usually through fermentation. "There was a time when everyone ate a lot of fermented foods," he says. "Our bodies need that for a healthy gut and they crave it. I think it's one of the reasons why people like our food. It makes something taste even better, makes it memorable."

Pilgrimme at night. The restaurant's remoteness and poor reception ensure that the dining room is mostly smartphone free. "It's good," says Jesse; "it forces patrons to be present and live in the moment. Put your phone away and enjoy your dinner."

"Everything exudes
an energy and a kind
of frequency. That might
sound hokey. But I think
plants emit a frequency,
just like living animals—
and even dead wood,
a fallen tree."

"I love wearing a really good sweater and some nice leather boots."

This page: Lacto-fermented cucumber from Galiano Island with kefir and herbs; wild-yeast Red-Fife sourdough bread, accompanied by fermented plum juice and sea-lettuce butter.

Facing page, clockwise from top: Picking fir needles; yellow pea panisse with pickled Galiano vegetables and Persian star-garlic aioli; and charred Galiano summer squash glazed with nasturtiums and herring-garum caramel.

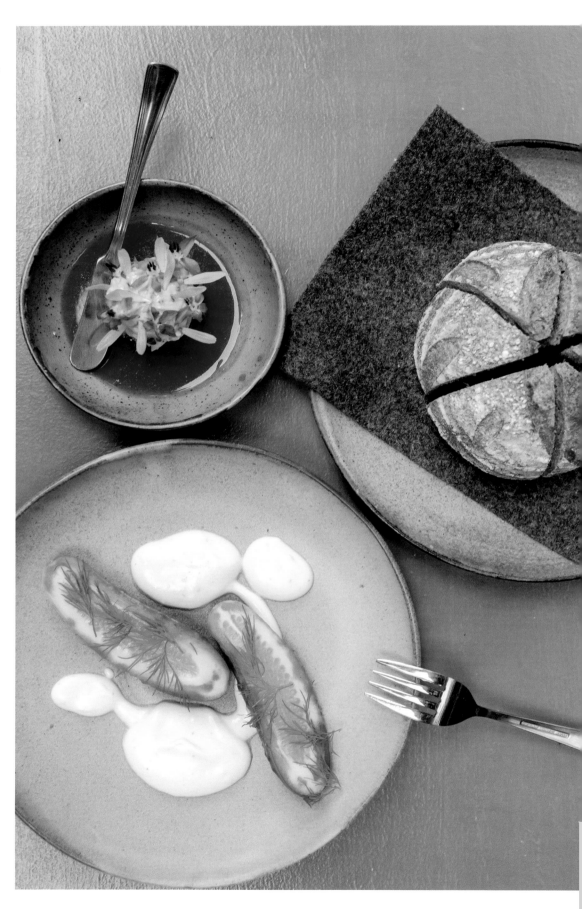

"When I turned thirty, I just wanted to make a kind
of pilgrimage, to travel and work somewhere for
as long as I could before I settled down."

1979 Born in Winnipeg, MB

1994 At fifteen got his first restaurant job

2000 Moved to Tofino, BC

2007 Met girlfriend and future business partner, Leanne Lalonde, at King Pacific Lodge in BC's Great Bear Rainforest

2014 Interned at René Redzepi's Noma in Copenhagen

2015 Opened Pilgrimme with Leanne

FUTURE Constantly come up with new ideas—and that means taking time away from the restaurant world to recharge.

Advancing Social Enterprise

40 years old

Social entrepreneur

Toronto, ON

In Vancouver in 2009, Roxanne Joyal was coordinating a massive show: a combination rock concert and conference aimed at children and youth. The event was put on by Me to We, the social enterprise Joyal runs along with her husband, Marc Kielburger, and his brother, Craig. Roxanne was in charge of shepherding celebrity performers and speakers from their hotels to the venue. "It was absolute pandemonium," she recalls. "We had both His Holiness the Dalai Lama and the Jonas Brothers at their peak." The Dalai Lama's entourage needed an eight-car procession but moved with stately calm; the Jonas Brothers convoy was a wild free-for-all. "I wondered how managing these two things could be so different but still part of the same job."

Roxanne Joyal

"I eat a lot of poutine. I don't even discriminate. Anything in Quebec would be the best—those cheese curds!"

Roxanne was born in a small town near Winnipeg into a French-Canadian family with some Metis roots. "My parents are very normal people," she says. "My mother works in Human Resources, and my father is a coach driver for Greyhound. So I was actually the first in the family to head out to university." At eighteen she moved to Ottawa, where she became a page at the House of Commons. "It's a lot of time to immerse yourself in the issues pertaining to Canada, so that was eye-opening for me. It was also 1995, the year of the Quebec referendum with Lucien Bouchard, who had an incredible charisma." One of the other pages listening to debates at this turbulent time was Marc Kielburger. "I found myself a husband, though that was not my intent by any stretch of the imagination." Roxanne then put her studies on hold to volunteer abroad for a year, spending six months in Klong Toey, a depressed area of Bangkok where she worked with mothers and children suffering from AIDS, and six months at a similar project in Kenya.

After she returned, Roxanne first studied international development at Stanford University and then law at Oxford, as a Rhodes Scholar. Over the next eighteen months she clerked at the Supreme Court of Canada and worked on an interesting arbitration case, but her mind kept going back to the time she spent with communities in Thailand and Kenya. "I realized my heart was in this social enterprise thing. So I packed up my legal skills and brought them over to this area."

When Roxanne and Marc met, his younger brother, Craig, was just fourteen years old, but he was already involved in international movements to abolish child labour. Over the next twenty years, Roxanne and the Kielburgers made the charity he founded, Kids Can Free the Children (now Free the Children), the centre of their lives. "Marc and his brother are like peanut butter and jam—they're just best friends—and the fact that he and Craig have brought me into their inner circle is a privilege. Thank goodness there are three of us, so we can get more done." The charity has since spun off a volunteerism, social engagement, and ethical business empire called Me to We that financially supports its sister organization, WE Charity.

The family, which now includes two young daughters, lives in Toronto, but Roxanne's role as CEO of Me to We takes her all over the world as she designs facilities, plans itineraries, and organizes events for the teenagers Me to We hopes to inspire. "What I really love most about my role is the variety," she says. "There's a creative aspect to what I do, but, even more exciting, I can work with teams and experts who take kernels of my ideas and make them so much better than I can. That gets me really jazzed." The foundation's "We Days," like the one attended by the Dalai Lama, attract tens of thousands of children and youth, and the charity partners with schools to organize learning and fundraising projects. The company runs group tours to India, Ecuador, Tanzania, Kenya, and other places where teens, adults, and families have the opportunity to participate in sustainable development projects.

Roxanne's main focus in recent years has been the corporate arm of the enterprise: Me to We gives half of its net profit back to its charity branch and reinvests the other half in scaling and growing its business. Me to We sells jewellery and handicrafts made by artisans in the countries it works with, currently employing about fifteen hundred women in Kenya and Ecuador. "A lot of it is home-based production, so they're able to continue their roles as mothers, but they can also be providers. And we've also been able to create groups that come together to do this work. So if someone's husband is out of line, he doesn't answer to only one woman but to nineteen others."

As for the future, Roxanne says her company is pioneering a new way of thinking about the relationship between business and charity. (To that end she would study for an MBA if she had the time.) "I would say this is consumer driven, and we're on the cusp of it right now. But I think social impact investing is becoming more and more of the norm." Her sense of responsibility toward others means she's always working, usually with Marc close by. The couple keep a notebook on their nightstand should an idea occur to them in the middle of the night. "My idea of happiness is knowing that I've served others well."

"I'm passionate about empathy and kindness in the workplace. We spend more time at work than we do at home, so it's got to be a good spot for you."

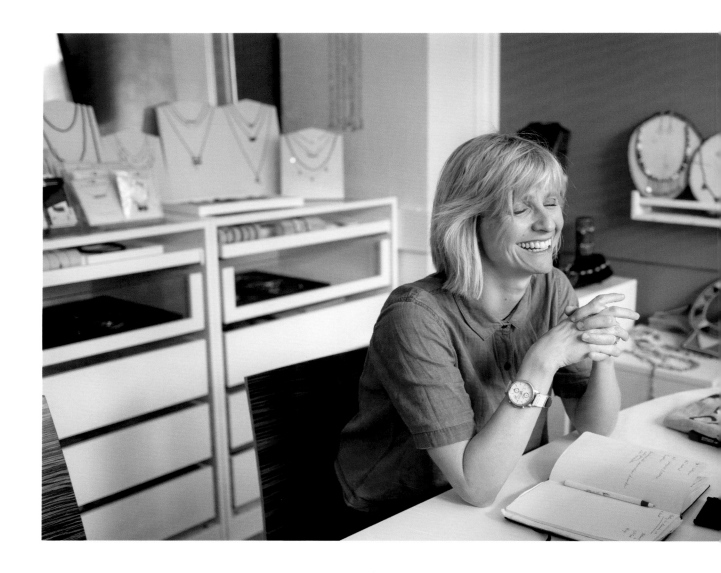

"I really have to give credit to my guidance counsellor from high school, Mr. Majeed Raman. Without his and my parents' support, and public francophone schools, I wouldn't be where I am today. It was very much a community effort."

1977 Born in Winnipeg, MB

1995 Served as a parliamentary page in the House of
 Commons, then went to Thailand for overseas
 development work

2005 A Rhodes scholar, Roxanne completed her law
 degree at Oxford and clerked for the Supreme
 Court of Canada

2005 Selected by the Women's Executive Network to
 be among Canada's 100 Most Powerful Women

2008 With Marc and Craig Kielburger, founded the
 social enterprise Me to We, where she serves
 as CEO

2012 Awarded an honorary doctorate by University
 of Nipissing for her work in education and human
 rights overseas

FUTURE "To keep growing our impact and make Me to We
 into a $100 million company."

Nathalie Bondil

Few professionals epitomize the virtues of our globalized culture better or more glamorously than contemporary art curators. They spend their days criss-crossing the world in search of fresh art, immersing themselves in cultures both ancient and new, carefully assembling exhibitions that seek to educate, enchant, and entertain. They are at once detectives and diplomats, teachers and students, administrators and party planners.

And few contemporary curators are better representatives of our globalized culture than Nathalie Bondil. The daughter of a French banker, Nathalie was born in Spain, grew up in Morocco, studied art history in France, and now lives in Montreal, where she is the director and chief curator of the Montreal Museum of Fine Arts. She arrived in Canada eighteen years ago and, in 2007, became the first woman to run the museum.

Empathy Through Art

The mixed media piece *Iceberg Blues* (1973–75) by
Edmund Alleyn at the Montreal Museum of Fine Arts.

Such a cosmopolitan background has given Nathalie a rare and valuable perspective. Educated to become a national curator in France, where she says working in a museum is essentially administrative and in service to the state, Nathalie was pleased to discover that the job in North America relates more to satisfying the public—and a diverse one at that. "I discovered freedom in America," she says, "the freedom to be an entrepreneur in a cultural institution. It's very easy to work and create here, to initiate projects. You can really make a difference for your society."

Nathalie can be evangelical on that subject. For her, art is neither frivolous nor a frill but the very lifeblood of civilization: "Art, and especially beauty, is linked to a psychological need," she says. "It's not a nice-to-have, it's really a must-have, because art helps you to be much more connected with yourself. Of course you can learn, you can read, you can write. But we know that humankind began to dance, to sing, and to have empathetic emotion before we were able to read or write or even talk. I think that empathy is very important."

Since becoming the director at MMFA, Nathalie has expanded its programming in many ways, hosting popular exhibitions dedicated to fashion (Jean Paul Gaultier) and music (Miles Davis), among other themes. She has also spearheaded the museum's dramatic physical expansion —adding a new building and educational facilities, restoring and reinstalling some four thousand works in the museum's collection, and transforming a former church into a concert hall. In November 2016 she opened the Michal and Renata Hornstein Pavilion for Peace, an architectural gem that heralded the start of Montreal's 375th anniversary celebrations. The MMFA now has more visitors and members than any other art museum in Canada.

Not surprisingly, Nathalie was first drawn to curatorial work by a love of travel. Curiosity and discovery continue to motivate her, even more than art itself. "I'm always learning something new about new civilizations," she says. "I'm very much interested in materials, anthropology, sociology, history. It's an endless library, and I love to read." Her personal style she likens to a "suitcase": when she gets dressed, she deliberately adorns herself with pieces and souvenirs that recall her travels—a jacket from Australia, say, or a Thai "kimono."

For someone who's travelled all over the world and whose job continues to take her to its most interesting corners, Nathalie remains in the thrall of her adopted home. "I love Montreal," she says, "because I think it's a very open-minded city—there are not too many things that can shock people. It's a very cool city, where culture is important." Her husband, a true Parisian, is happy here, and her eighteen-year-old daughter is studying at McGill University. She is no fan of the cold weather but argues that Canadian people are very warm, in the way French philosopher Claude Lévi-Strauss defined it. "A warm society is a society that is more open-minded," she says. "It's open to various differences and will catch those differences in order to make them its own. I think the fact that we are still building a new country makes things much easier."

"There's an expression in France, *Vous appartenez à la fonction publique*—'You belong to the public service.' But I think that in France, because it's so administrative, you can lose sight of the main mission, which is not just to preserve the collection for the next generation but also to make it as accessible as possible to the public. That means here I am free to do whatever I want to do, with just one restriction: I need to have success."

Scenes from Nathalie's home in Montreal, with her cats Picasso and Renoir. "I love cats. And I love to wear all kinds of souvenirs to remind me of great anecdotes and stories from my travels."

"I'm impressed by young people today because they are aware of major issues: they really want to think global but act local. They are completely different from previous generations, especially in France, and are not divided by old, conservative ideas. I am rather confident of the future, because they will have to face major challenges."

SIX EGGS

Figure 1

Figure 5

Figure 3

Figure 2

Figure 4

Figure 6

"My favourite food is eggs. Eggs are absolutely beautiful, and they are very good in terms of nutrition. They can be cooked with sugar or with salt. And they are the symbol of life. So, I love eggs. I can eat six eggs in the morning — I'm really a champion, and I'm proud of it."

1967 Born in Barcelona, Spain

1993 Completed graduate studies in museology
at École du Louvre

1999 Hired as curator of European Art (1800–1945)
at the Montreal Museum of Fine Arts

2007 Made director general and chief curator of
the MMFA, the first woman to hold the position

2015 Appointed a Member of the Order of Canada

2015 Under Nathalie's stewardship the MMFA
records its second straight year with attendance
over one million visitors—the first Canadian art
museum ever to do so

FUTURE "To continue to innovate and have fun."

Above: *Stuffed Animals* (2012)
by Claude Cormier.

Above right: Nathalie's cat
Renoir makes an appearance
as part of a mural at MMFA.

Poet, songwriter, performer

"When people started asking me where I was from, I wouldn't say Sudan or Canada but Regent Park," says Mustafa Ahmed of the inner-city Toronto neighbourhood where he grew up. "It's what made me the person I am more than anything else." Built as Canada's first public housing project in the 1940s, Regent Park would in later decades earn a reputation for gun violence, while the social needs of residents were chronically underserved. But where outsiders focused only on the negatives, Mustafa saw inspiration in the struggles of its people. "Yes, it did break me in a lot of ways—there are things I'm still healing from. But what strength and creativity I have I owe entirely to my community."

Mustafa Ahmed

21 years old

Toronto, ON

The Heart Is a Transmitter

> "Our dreams are so fragile. So many of the kids I know get caught up in the crime and negativity in the community. People who were once so pure-hearted face so much aggression that they feel they have to be on the defence all the time."

Mustafa began writing poetry at ten years old, as a way of sharing his thoughts with an older sister when he was having a difficult time at school. "She would write to me in poetry," he says, "and tell me to reply back to her in poetry. When I got suspended from school I explained what happened through poetry." At twelve he began performing his writing in public, at high school assemblies and other events, winning standing ovations from kids and adults alike. They were moved by his precocious way with words, by the compassion with which he wrote about his misunderstood neighbourhood. In a profile article from that time, the *Toronto Star*

When Drake reposted one of his love poems on his Facebook page, Mustafa woke up to twenty thousand new followers the next day. (The two would soon become friends and collaborate on Drake's clothing line.) Then along came The Weeknd, who recruited Mustafa to co-write the song "Attention" for his 2016 hit album *Starboy*.

Collaborating with The Weeknd may have seemed an unlikely choice for someone who describes himself as a devout Muslim. Mustafa's father, originally from North Sudan, is a social worker and president of the neighbourhood mosque. His

"There is too much policing of women, period. You're wearing too much, you're wearing too little. They need to be able to come to their own decisions."

1996 Born in Toronto, ON

2006 Began writing poetry

2009 Invited to perform his poem "A Single Rose"
 before a film festival screening of *Invisible City*,
 a documentary about Regent Park

2014 Released the spoken-word EP *Mustafa the
 Poet*. Awarded a TD Scholarship for community
 leadership, which enabled him to travel to Los
 Angeles and Paris

2015 Named poet laureate for the Pan Am Games
 in Toronto

2016 Co-wrote the song "Attention" with The Weeknd
 for the album *Starboy*

FUTURE To use his writing to touch hearts and minds,
 and to inspire younger people to be more active
 in the world.

Above: Mustafa with friends at
the mosque he attends regularly.

The Persian poet Hafez, Mustafa
says, "was a massive inspiration for
me. Growing up I had a quote by
Hafez in my room that read: 'Even
after all this time, the sun never
says to the earth, "You owe me."
Look what happens with a love like
that—it lights the whole sky.' That
used to be so inspiring for me to
read every day."

"You see these polls where some people say newcomers must do a better job of integrating into mainstream Canadian culture. It shatters me. It breaks my sister's heart. Sometimes all that serves to do is further isolate the Muslim community."

of Refuge

Raihan Abir

It was May 12, 2015, a Tuesday, early in the morning. My wife, Samia, then pregnant with our daughter, put on her motorbike helmet before going outside to check for suspicious-looking strangers lurking around our house. Thinking it safe, we left for our workplaces, biking a different route than the day before—what had become a routine act of caution for both of us. I was going to Dhaka University, where I was doing my PhD in biomedical engineering. Samia was on her way to the bank where she worked as an architect.

Three months earlier, my dear friend and collaborator Avijit Roy, the founder of the secularist blog Mukto-Mona (Freethinker), and his wife, Bonya Ahmed, a science writer, were attacked by assailants with machetes while on their way home from a book fair in Dhaka. Avijit had been viciously hacked to death. Bonya, critically wounded, managed to survive her injuries.

Religious militants claiming loyalty to al Qaeda had long been making similar threats against me, on account of my writings on atheism and freethinking, as well as my active involvement in secular causes within Bangladesh. Despite my fears, I was wary of going to the police; I worried that information about me could be leaked to the extremists. Samia and I took what few precautions we could, such us breaking up our daily routines. On the advice of a doctor friend, we resorted to wearing bike helmets as protection in the event of a machete attack —even while walking in public places.

When I arrived at the university that Tuesday, sweat-soaked from Dhaka's oppressive heat, I paused for a moment under an air vent to cool myself off. That's when the phone rang. It was a journalist calling to tell me that another friend, Ananta Bijoy Das, had been murdered while on his way to work that same morning. Witnesses said they saw four men with machetes attack him upon leaving his home. A fellow blogger for Mukto-Mona, Ananta had edited a book that Avijit and I co-wrote called *The Philosophy of Disbelief*. In the wake of Avijit's murder, Ananta had been trying to get a visa to go to Sweden, but his application was denied. We spoke frequently on the phone about how we could protect ourselves. I couldn't believe that now he was also gone.

It was already the third fatal attack on a secularist writer since the start of the year. I sat at my desk, bereft. As news spread, friends were calling to urge that I leave the country immediately. Despite the threats on my life, I hadn't yet considered fleeing; Samia was pregnant and my family was still grieving the loss of my brother in a recent accident. But now it was different.

Fortunately, I had what suddenly felt like a lifeline—an invitation to attend a conference of biomedical engineers, in a few weeks, in Toronto. I decided I must go. In the meantime, I deactivated my phone and hid. I stayed away from my home and the university, a friend providing me shelter at his office.

I landed on a June day in Toronto feeling relief but unsure what to do next. Should I go back to my pregnant wife after the conference or should I stay? Could I still write while ensuring our safety? Where would we live and how would we eat? An article about me that appeared in the *Globe and Mail* noted how nervous I seemed while being interviewed.

Soon fear gave way to hope. In Canada, I experienced a place where people were free to express themselves while also valuing diversity, tolerance, and inclusiveness. Here, differences weren't addressed with violence but with reason and by listening. I saw the whole world in one country; I felt accepted from the very first day.

In August, thanks to the help of many supportive new friends, Samia was able to get a visa and join me in Toronto. A few days later we applied for refugee status. And a few days after that, our daughter, Sophie, was born. In November we were granted asylum. Our acceptance came, however, just as I was processing more bad news from home: now it was my publisher who had been killed.

Today, Sophie is two years old. Her sweet and innocent smile fills our hearts with joy, almost making us forget all the trials and tribulations that we've faced. Samia and I have lost so much already. Friends that we worked and shared life with lost, because of their meaningless murders. But we never give in to hatred. We hold on to the idea that darkness of the sort we've faced can only be beaten back by shining the light of knowledge and reason.

From Toronto, I continue to help run Mukto-Mona, now the face of Bangladesh's secular humanist movement. It's under near constant cyber attack. My name still appears on an al Qaeda hit list. But I take heart from Canada's example of a peaceful, multicultural society, where one can speak and write freely. Sometimes I think back to something that Avijit said to Ananta and me only a few days before he was murdered. "I'm just a writer. Who would want to kill me?" Avijit, to my infinite sadness, is gone. But no matter how many hands may reach for machetes, his words—our words—can never be killed.

—

Raihan Abir is a writer and a scholar in exile living in Toronto. He continues to edit for Mukto-Mona, a bilingual English-Bengali website dedicated to freethinking, science, and reason.

257

"I get on bucking horses and I try to make money. I make a living at it," Zeke Thurston says. "It's all I've known my whole life. Ever since I could crawl, all I wanted to do was be a cowboy and rodeo like my dad." That's a characteristic understatement, but it's as pinpoint accurate as Zeke's roping skills.

Zeke Thurston

Everything Cowboy

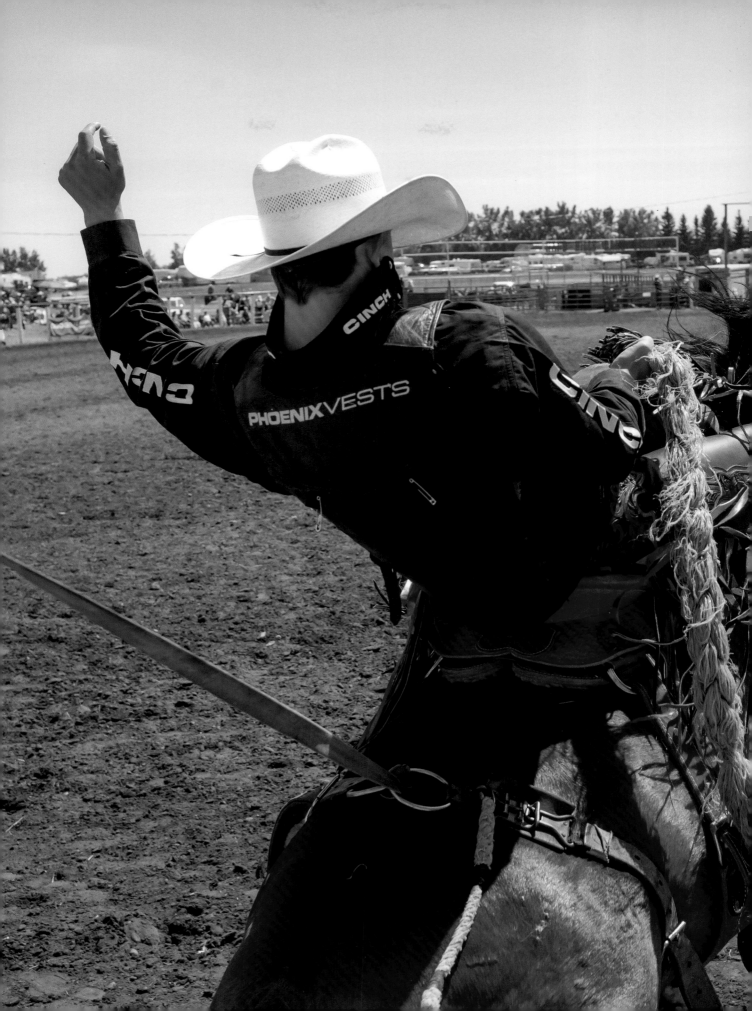

He was born, auspiciously, on the last day of the 1994 Calgary Stampede, to parents who themselves had met on the rodeo circuit—his mother, Lynda, a reporter; his father, the legendary Skeeter Thurston, six-time National Finals Rodeo qualifier. By the time he could crawl, Zeke's favourite toy was a miniature clown barrel and baggy pants made by his grandmother Sherry. When he was just seven, he rode his first bucking-bull calf, which stuck a budding horn through the face mask of his helmet, knocking out ten baby teeth. A year later Zeke and his two brothers became a rodeo act called the Thurston Gang, trick riding and roping across the country. At twenty he was a professional saddle bronc rider and had won championships in Calgary and Houston. His mom calls him the "Everything Cowboy." You can call him rodeo royalty.

When Zeke was growing up, a championship saddle that Skeeter won in Houston in 1986 hung in the living room. His dad was often on the road competing, leaving Zeke to help Lynda and his brothers and sister to run the family cattle ranch. It was gruelling, exhausting work—driving draft horses, milking cows, working cattle on the hottest and coldest of days. But the rodeo was always on the family's minds, dominating dinner-table conversations, and saddle bronc riding was the conversation topic that dominated most often.

Even a rodeo neophyte would recognize the event, but saddle bronc riding basically involves a rider trying to stay on a bucking horse for eight seconds while simultaneously spurring the animal. The horse is judged on how well it bucks, and the rider on the rhythm with which he spurs the horse. "When you make a really good ride," Zeke says, "you get a pretty big thrill from it. It's similar to a freestyle motorcycling guy doing a backflip or something. I love the challenge, I love the competition, I love to win."

And winning is pretty much what Zeke's done since he started competing. In 2015 he made his first appearance at RodeoHouston, one of the most prestigious rodeos on the continent. Riding a horse named Lunatic from Hell, he was a last-minute replacement at the invitation-only rodeo and walked away with the top saddle bronc prize: $50,000 in cash. (The trophy buckle he won there is still his favourite: "It's just real pretty.") That same year he spurred his way to a championship at the Calgary Stampede, picking up $100,000 in the process. A year later he repeated the feat. In December 2016 at the National Finals Rodeo in Las Vegas, he was named world champion saddle bronc rider and more than doubled his Stampede earnings.

Such early success would spin any athlete's head, but Zeke remains steadfastly grounded and unfailingly polite, peppering any conversation with "sir" and "ma'am." He used a rodeo scholarship to attend college in the United States, where he received a degree in farrier science (equine hoof care) that would help on the ranch. With his first Calgary purse, he set aside the money to build his own house. He recently married. A devout Christian (though with little time for church these days), he says, "It don't matter if you're doing awesome in rodeo or life, or you're having a hard time, it's always nice to have your faith to fall back on." If that sentiment doesn't stir your soul, maybe Zeke's competitive mantra will: "If you want to be the best, you better get with it."

Scenes from a saddle bronc
competition in Wildwood, Alberta.

Opposite page: Zeke competing.

"I've worn some kind of belt buckle every day since I was three years old. It feels foreign not to have one on."

Scenes from the ranch: left, Zeke; middle, Zeke and his wife, Jayne, on horseback, with his sister, Tess; right, Jayne. "I'm pretty easy to please," Zeke says. "So long as I've got some horses and cows and family and friends, I don't know what else I could ask for."

"We're a ranching family with a rodeo background," says Zeke, "a common western way of life. And we're close. Both my brothers ride saddle bronc horses, and my little sister barrel races."

" This sport is followed
only in the west. I would
like to see it become
a regular televised deal,
with a big fan base
all over the country. "

The image contains the handwritten text "Rodeo T.V." on the belt buckle.

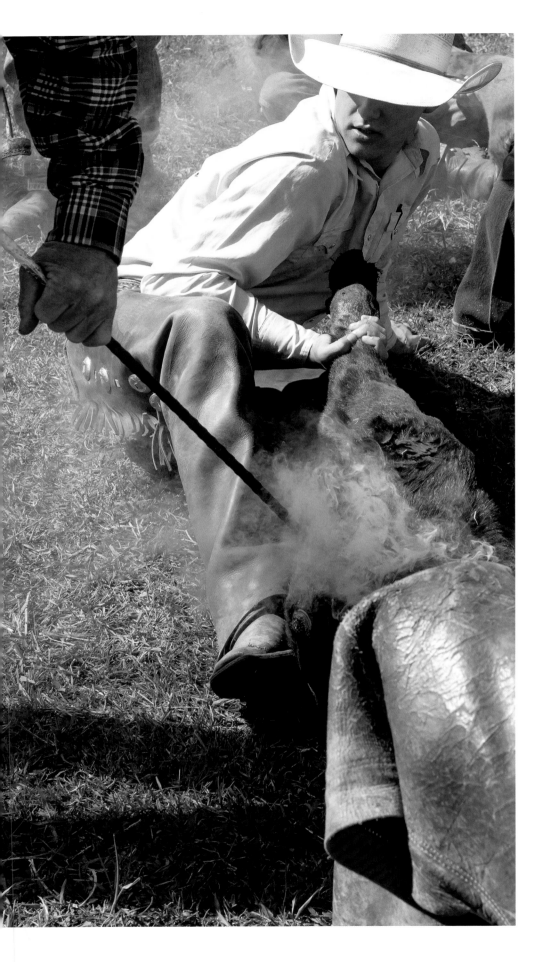

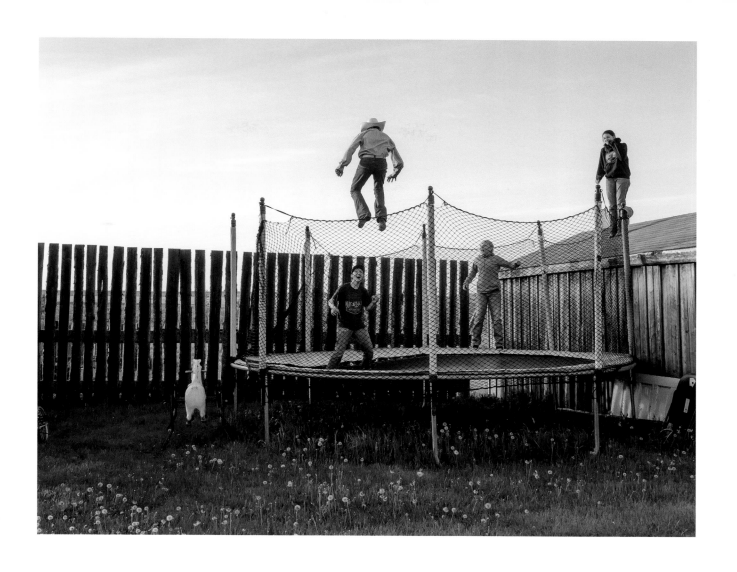

1994 Born in Calgary, AB

2008 Only fourteen years old, Zeke won a bronze
 medal at the Canadian Finals Rodeo in trick
 roping and riding

2013 Won best Canadian Novice title in bronc riding
 at Calgary Stampede

2015 Captured Saddle Bronc title at the renowned
 RodeoHouston

2016 Defended his title as saddle bronc champion
 at Calgary Stampede, making him the only
 Canadian to win at the Stampede that year

FUTURE "I hope to accomplish as much as I possibly can,
 to be the best that I can be in rodeo and life in
 general. Anything I do I want to do my best and
 take pride in it."

"Glorious and free—that sounds like my life."

The landing page for DJ Romeo's website consists of a grid of photographs, all featuring DJ Romeo: there he is with basketball legend Michael Jordan, with comedian Russell Peters, with former Blue Jay superstar Joe Carter. Keep scrolling and the Romeos keep multiplying— there he is posing with Drake, Kardinal Offishall, K'naan, Common, and, a bit more surprisingly, the late Rob Ford. Like some kind of club world Zelig, DJ Romeo seems to have met, and worked with, pretty much everybody. Ask him what kind of work he does, though, and you'll get an answer that's equally audacious and mystifying: "I make people happy," he says. "I teach people how to live."

Toronto, ON

26 years old

Matthew Romeo

DJ

Channelling Energy

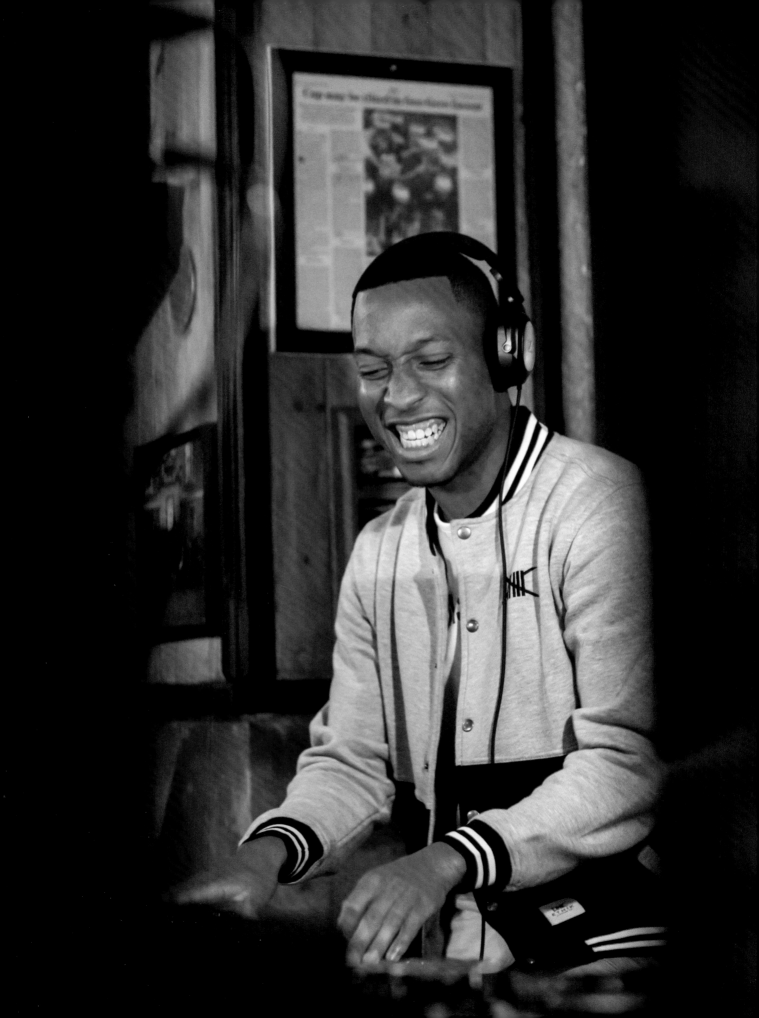

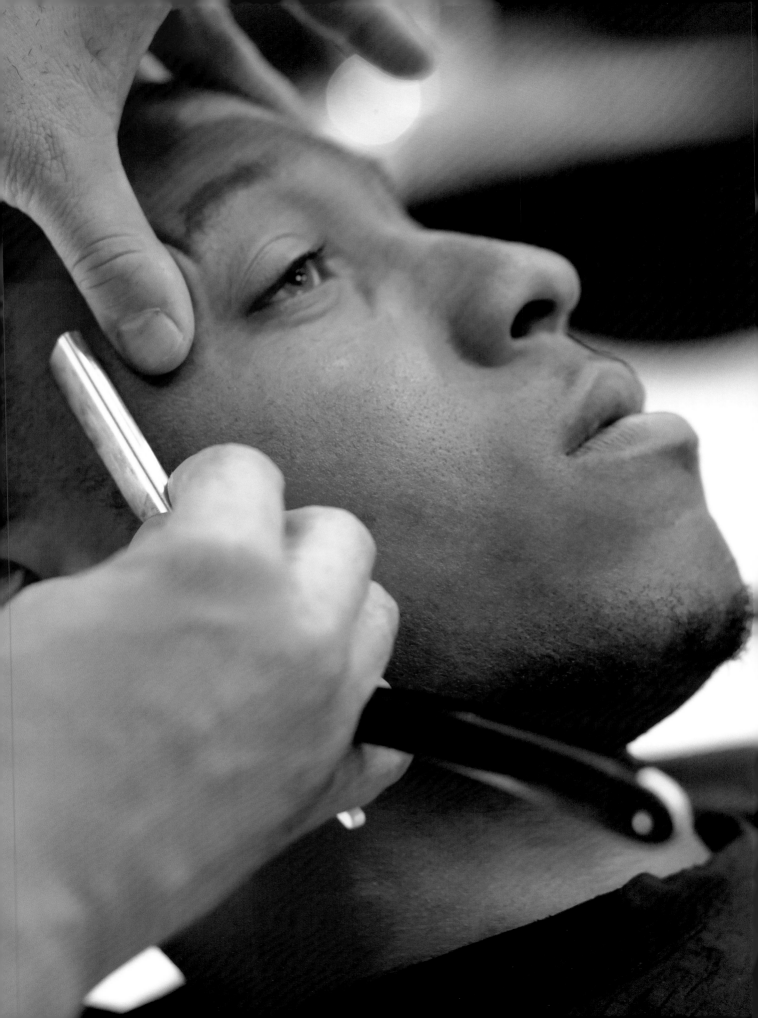

First, though, he had to teach himself how to live. Matthew Romeo was born in Toronto in 1991 and raised by a single mom from Trinidad in Windsor. He became a DJ, he says, at the unlikely age of nine, buying a pair of turntables at a yard sale and teaching himself how to use them. By high school he was DJing parties and school events. A guidance counsellor nudged him toward a skilled trade, but all two months of a metalwork class taught him was that he should really pursue what he loved. When he was sixteen he made a ten-year plan for his life from eighteen on: "By the time I was twenty-eight," he says, "I was going to be a world-renowned DJ. DJ Romeo."

He got there, eventually, but not quite according to plan. He moved back to Toronto, arriving with exactly a dollar and eleven cents and two bags of clothes. With nowhere to live and no job, he wound up spending his first three years in the city on the street. "I always thought the next day would be better," he says. "If I can make it through one day, then I can make it through the next. But then that turned into the next week, and then that turned into two months, and then that turned into a couple of years." Romeo never panhandled but managed to get by on food banks, credit cards, selling papers at the subway, and the occasional DJ gig. It was still incredibly tough, of course—on the street, he was confronting racism he'd never experienced before, and he was occasionally depressed. "I just didn't know how to ask for help," he says.

Fortunately, someone else knew to ask him if he needed help. Ricki Bekzadeh was the director of programming at the Remix Project, a Toronto-based non-profit that provides training and resources for disadvantaged youth looking to break into the creative industries, from film to music production. (Drake producer and OVO Sound co-founder Noah "40" Shebib was once on staff.) Romeo had heard about the organization and, though he was worried they might try to take credit for what he'd already accomplished, he gave them a shot: "I was going to kill myself, join the army, or check out Remix."

Bekzadeh's genuine interest in Romeo's well-being was revelatory—he asked him where he'd been living, what he'd been eating, whether he was in school. Romeo now credits Bekzadeh, who got him into a shelter, with basically saving him: "Ricki coming into my life and acknowledging me for two minutes—he helped me change my perspective on the world."

That perspective—high energy, optimistic, joyous, charismatic—became Romeo's brand. He began DJing at increasingly high-profile events, with increasingly high-profile celebrities. Corporate clients materialized: Samsung, Red Bull, United Way. He found he had a competitive advantage —he wasn't great at remembering the names of artists, but after listening to a song only once he remembered it. More specifically, he remembered how a song would make him feel. "When I DJ, I read the energy in the room," he says, "and I freestyle and I pick something that I feel is going to match it. It's a conversation, back and forth. I play a song and you dance to it—this is the energy you give me. We're communicating." By 2016 he was one of the most renowned DJs in Canada. The street suddenly felt far away.

What is Romeo listening to these days? His heart, mostly. When, as a teenager, he made his plan to become a superstar DJ, he also envisioned using a million dollars of his own money to start a foundation that would help get kids off the street. That sense of altruism guides him every time his agent books him a gig. "I could DJ anywhere, everywhere, but I choose not to. I only DJ shit that has a high impact, where I can reach a lot of people in a short time. No two days are the same; no two moments are the same. I don't live in time—I live in moments."

Romeo's motto, his slogan and catchphrase, the hashtag that follows him wherever he goes is DONT4GETtheNAME. Don't forget the name? How could we?

"Here's my tip for excelling as a DJ: Be better than I am."

"I don't have weekends,
I don't have holidays,
summer, winter, spring,
all that stuff. Every day
just keeps going, every
day has to be better than
the last day."

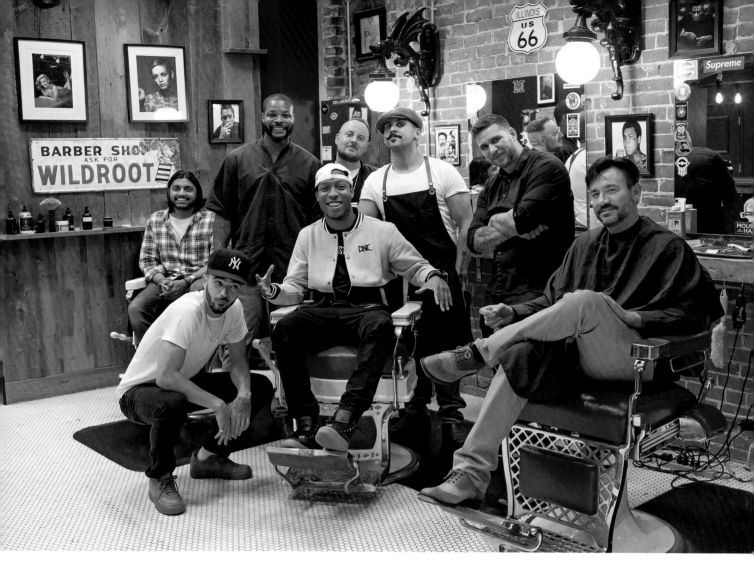

1991 Born in Toronto, ON

2000 At nine years old bought his first pair of turntables and taught himself how to DJ

2003 In grade eight, got his first paying DJ gig for a university house party in Windsor

2010 Moved back to Toronto and eventually joined Remix Project

2013 Became the official DJ for OVO Bounce, Drake's annual basketball tournament, and has been ever since

FUTURE To be a motivational figure.

DJ Romeo hanging out with his pals at the House of Barons barbershop in Ottawa.

"In a country full of opportunity,
there's really no reason why I should
have been homeless."

Running, Risk, and Reward

San Francisco, CA

Angela Strange

38 years old

Venture capitalist

In 2005 Angela Strange had just earned her MBA from the top-rated Stanford Graduate School of Business and been offered a lucrative consulting job in Toronto when she set her sights on an entirely different ambition—running an Olympic marathon. It wasn't a complete stretch—Angela was a serious long-distance runner and had won a couple of Vancouver marathons a few years before. But setting out to achieve something even more difficult than what she had already accomplished typified the aggressive aspirations that have always governed her life. "Regret for what you've done can be tempered by time," one of her professors once told her. "Regret for what you've not done is inconsolable."

It's quite possible that Angela regrets nothing at all. If her life's been a race, she's been a scrapper whose tenacity has taken her farther than simple ability ever could. She grew up in Ottawa, where her mother taught English and gym, and her father, who got his PhD in physics at Caltech, worked in government. Angela liked playing accountant and spent weekends balancing the family's cheque book with her father—"You wonder why I didn't have many friends," she jokes—but went on to study mechanical engineering at Queen's University in Kingston. Queen's was followed by three years at a top strategy consulting firm in Toronto, which sponsored her to attend Stanford Business School. After that, rather than return debt-free to her high-paying job, Angela took on six figures of debt and moved in with three other students, got a part-time job working for a Stanford professor, and ran, full time, in the hope of joining the Canadian Olympic team. "I didn't make it," she says, "which is not a happy end to the story. But what I discovered is that it's really satisfying to set some high goal and go after it, even if you don't get there."

Risking her career, even temporarily, would lead her to a world that routinely rewards risk, first in venture capital (VC). She stayed in California, but it took many months, and about eighty informational interviews, to find a VC firm that would hire her. Her hard work and unrelenting optimism paid off—from venture, with little prior experience, she joined the founding team leading product management and business development for a start-up that was eventually acquired by Google. At Google she helped build the Chrome browser for Android and iOS. "Getting to build this super-creative, new product on one of the biggest platforms in the world was awesome," Angela says. "It kept me there almost five years —longer than I'd anticipated."

In 2014, armed with this entrepreneurial and enterprise experience, Angela returned to the VC world. She became a partner at Andreessen Horowitz, the legendary firm whose investments in Skype, BuzzFeed, Airbnb (not to mention dozens of other start-ups) have made it a VC powerhouse. VCs, Angela says, are an enthusiastic, even utopian bunch who are privileged to work with incredible entrepreneurs—and that's what attracted her to the field. "I feel blessed to work with people who think really differently, who are developing new products that are going to fundamentally improve how we live, how we do things, how we make our lives better."

Meanwhile, Canada has never been far from her mind—she co-founded and co-chairs C100, a non-profit member-based organization that connects Silicon Valley to Canada with the goal of supporting entrepreneurship and accelerating innovation in Canada. Angela also keeps her hand in Canadian policy by serving on Finance Minister Bill Morneau's Advisory Council on Economic Growth.

Angela can be as evangelical about Canadian ingenuity as she is about tech innovation. "I'm excited about all the products that we're going to be using in the future, which aren't invented yet," she says. "And how that's going to come to be, and who's going to make them, and the part I'll be able to play in it." Canadians already have leadership potential in one of those areas— artificial intelligence (AI). "Its applicability across all industries is going to be tremendous. And some of the founders and the brightest minds in AI are Canadian."

Angela lives with her husband, originally from Bangalore, in the San Francisco neighbourhood of Pacific Heights. She continues to run, clocking around one hundred kilometres a week, usually in pre-dawn runs along the ocean. A passion and a habit, it's also a sport that never loses its motivational value: "Running has a meditative quality that helps focus and generate ideas. It's also a good reminder that you can often win on pure grit."

Since buying a Tesla electric car, shown here plugged in, Angela says she's earned back an hour and a half of every day. "I get on the highway, hit autopilot, then respond to emails and read the news on my way to work. It's the most life-changing purchase on the planet."

"I couldn't live without my favourite things: my Birkenstocks, running shoes, Kombucha gingerade, Brussels sprouts, and NPR radio."

"My first career aspiration was to be in Cirque du Soleil. In junior high I joined a trampoline club — then it went from casual practice to every single day after school and every weekend. My summer job all through high school was to load the trampoline on the back of a pickup truck, drive around to busker festivals in eastern Canada, do trampoline shows on the street, and then pass the hat. It was awesome."

1979 Born in Ottawa, ON

2000 Graduated with a BSc, first-class honours,
 from Queen's University

2000 Strategy consultant at Mercer Management
 Consulting, Toronto

2002 Finished first at Vancouver Marathon,
 a feat she'd repeat the next year

2003 Completed MBA at Stanford Graduate
 School of Business

2003 Ranked as Canada's seventh-best
 woman marathoner

2006 Associate partner at Bay Partners

2008 Director of product management and
 business development at Ruba travel guides,
 which was acquired by Google

2010 Product manager at Google; worked on
 Chrome browser

2014 Partner at Andreessen Horowitz

2015 Co-chair C100, and serves on Finance
 Minister Bill Morneau's advisory council

FUTURE "I will eventually start my own venture
 fund and look forward to creating a firm
 that start-ups seek to work with."

"Don't always follow your
passions. Rather, find what
you could be uniquely
good at, so you can really
contribute to the world. You
must love what you do, but
be smart about it. Where
can you have good mentors?
What has momentum?
Where can you be creative?"

"Only 15 or 20 percent of Canadian businesses think that innovation and globalization are really important. Let's focus on helping those high-potential firms to scale even faster. Canada should push where we've already got momentum and the potential for global leadership. We've got people who are ambitious, and that's really important in driving the economy."

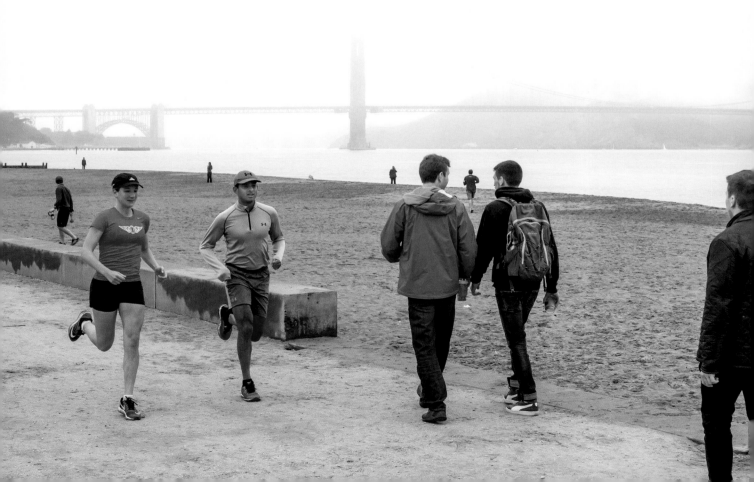

Cazhhmere

Roots and Rhymes

In the eighties and early nineties, no person touched more kids' lives than Michael Jackson. His style, songs, and quicksilver dance moves made him the world's first truly global pop star. For countless teens with artistic streaks, MJ was the singular inspiration to dance, sing, or write music. But for a shy, quiet type like Cazhhmere, the goal was to create the sorts of videos that made Jackson such a phenomenon. "When my mom bought me that *Moonwalker* VHS tape, I watched it all day, every day," she says. The videos' energy, spectacular choreography, and visual ingenuity elevated the lowly pop star promo clip into a new kind of art form.

"MuchMusic and MTV played a part in why I chose to be the type of storyteller I am. In my young teenage years they played those 'making the video' type shows where they went behind the scenes. And at some point I said, 'Oh, I could do that.'"

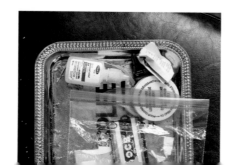

"Michael told stories, not just with his music but with his visuals—and he showed you all these different ways you could tell a story." While other kids might have been copying his dance moves in the mirror, Cazh, an only child until age ten, entertained herself by thinking up "MJ-like storylines and images" to accompany the music of other singers she listened to.

Cazh's dream was to work in entertainment, but she had no desire to be in front of the camera or the microphone. Luckily, it was a high school teacher named Mr. Reid who saw Cazh's creative potential and put a camera in her hands for the first time. "He suggested I make a documentary on something based on music," she remembers. Cazh shot a video about how corporate America was co-opting hip hop and compromising its authenticity. "Mr. Reid made the effort. He took one person, me, and got me to think more about the things I was into. And then used that as a way to get me to open my mind."

Fast-forward a couple of decades—including a stint interning at MuchMusic—and Cazh is among Canada's most sought-after directors of music videos, producing clips for the likes of Kardinal Offishall, Snoop Dogg, and Classified. She's the only director to be nominated for a Much Music Video Award six years straight. Not that you'll see her at many VIP parties or events or find much about her on the Internet. "I don't want to be seen," she says. "I shouldn't have to go to all these parties and drink. I just want people to see my art."

As a successful black woman in an industry that's still predominantly white and male, Cazh is often asked about the obstacles she's had to overcome—a position she finds uncomfortable. "I guess I've made an effort not to draw attention to any of those things," she says. The real trailblazer in her family, she'll tell you, is her mother, Terry. A twenty-one-year-old single mom when she had Cazh, Terry put herself through a BA at Dalhousie University in Halifax before taking a job in Toronto with the Ontario Human Rights Commission. "She's the hardest-working person I know," Cazh says. "She's been a champion for the working class, and I don't know anyone who cares more about equality." It helped, too, that her mother made sure that a steady diet of classic soul and R & B was always playing around the house.

Though Cazh was eight years old when she moved with her mother to Toronto, she never lost touch with her roots in Nova Scotia. Unable to afford camp, Terry sent Cazh to Halifax every summer to stay with her grandfather. There she became deeply immersed in the family's history, which went back in the province more than two hundred years. Her ancestors were among Canada's earliest black settlers and later fought in the First World War as part of North America's first all-black battalion. Subsequent generations would be active in politics, sports, and the arts.

But pride comes with a sharp awareness of the racism they suffered. "When I was a kid we would visit my grandmother's gravesite," Cazh says, "and I was always asking why she was buried so far away in the back." Later, Cazh learned it was because the cemetery had once been segregated.

The experience of black Canadians has long been obscured by the separate, more prominent narrative of African-Americans, especially as seen through the lens of popular culture. It's a gap in our understanding that Cazh hoped to address in *Deeply Rooted*, her 2016 documentary for the CBC. "It's me introducing Canada to a family —my family—that maybe they've never seen before. You look back at our history, and we're the most Canadian of families, contributing a lot to society. But people look at the colour of our skin, and Canadian is sometimes the last thing they assume we are."

Cazh's personal and family's experiences are the basis for a number of the film scripts and documentary treatments she is now working on. In a way, that connection to her past is also there in the music videos she's hired to make. "When I'm thinking up ideas, it's still like when I was a little girl listening to songs," she says. "I would just close my eyes and see the song on the TV in my head."

Cazh shooting a video for the song "Rebellion" by EMP in Toronto's Kensington Market.

"For me, Mr. Reid was the perfect teacher. Before him I never thought learning was interesting, but once he became my teacher I looked at things differently. I actually went from not caring about school and having mediocre grades to graduating a year early. I just wanted to get out there to see what else I could do."

"Slavery lasted for over 300 years, then ended over 150 years ago, but no one ever lets people know what has happened during these 150 years. We've done incredible things, yet in both Canada and the United States the only thing they want to remind us is that we were slaves at one point."

1982 Born in Halifax, NS

2000 Attended St. Mary's University, Halifax

2003 Interned at MuchMusic in the urban
 music department

2003 Directed first music video

2006 Nominated for her first Much Music
 Video Award

2016 Her personal documentary *Deeply Rooted*
 aired on CBC

FUTURE "I want the world to know I was here. And how
 they will know is through my stories."

"Although I live in Toronto, I regard Halifax as my home—it's not just my family roots, but I miss the clean Maritime air, the food, the slow pace of change."

Ilya Sutskever

"I believe that a computer can do anything that a human can, if programmed appropriately," Ilya Sutskever says from his new home in San Francisco. At a time when advances in technology are transforming our world, Ilya is at the vanguard of one of Silicon Valley's most exciting projects. He is the co-founder and research director of OpenAI, where he and his colleagues are dedicated to bringing about a breakthrough that generations have dreamed about—artificial intelligence.

Ilya was born in the Soviet Union. His parents —an English teacher and an electronics engineer—immigrated to Israel when he was five, settling in Jerusalem. When he was a teenager, his family moved again, seeking greater opportunities for Ilya and his younger brother, Noam, who were both into computers. The family chose Canada and arrived in Toronto when Ilya was sixteen. "Canada is simply a wonderful environment that allows people to succeed. It doesn't stand in your way. If you want to do something, there are many opportunities to do it."

Deep Learner

"If you take a computer and you program it the right way, it's going to be just as smart as a human, and I think that it could also have all the same feelings that a human can have. And I think in all important respects it could be indistinguishable from a human."

What Ilya wanted to do was study machine learning. And he had a lucky break—Geoffrey Hinton, one of the world's leading experts in neural networks, was his adviser at the University of Toronto. "The ideas that I helped develop in his lab," Ilya says, "ended up being the basis for all the machine learning applications you see today in tech companies." Speech recognition software, Google Street View, image search, machine translation, and self-driving cars all make use of the U of T lab's innovative work. Hinton, Ilya, and Alex Krizhevsky, another graduate student, then developed a visual recognition system notable for its unprecedented accuracy and spun off those efforts into a start-up called DNNresearch.

Neural networks (also known as "deep learning") look to the human brain as inspiration in crafting computer programs that can learn. "Learning is interesting because it feels like such a mysterious process," Ilya marvels. In 2011 he was the first Canadian to receive a Google PhD Fellowship. In 2013 DNNresearch was sold to Google—the deal was hashed out in a hotel room over several nerve-racking days—after which Ilya and Krizhevsky were invited to California to work on a team named "Google Brain." Recently, Ilya left Google to co-found OpenAI, a non-profit backed by tech luminaries such as Elon Musk and Sam Altman. Drawing on an international network of researchers, its mission is to advance digital intelligence in a way that is most likely to benefit humanity as a whole, unconstrained by a need to generate financial return.

Ilya believes his work at OpenAI can play a crucial role in developing artificial intelligence that will help and not harm. One major risk is that advances could become too concentrated in the hands of powerful unelected groups. The other is a bit more *Blade Runner*—that thinking machines could pursue interests that are counter to the interests of humankind or become so powerful they are difficult to control. "It's not an easy thing for governments to think about because right now it's really hard to predict exactly how the future will play out with artificial intelligence," he says. "There's disagreement among experts as to how quickly this technology will develop." All the more important, he adds, that AI researchers think deeply about these issues to help shape the foundations of policy and foreground the potential benefits to society.

"Machine learning is so much more than the algorithms big companies are deploying," Ilya continues. "An algorithm doesn't care what problem you're asking it to solve; you just give it the data. Machine learning is never about solving just one specific problem; it's about developing the ability to solve a huge variety of difficult problems. You have these ideas and philosophical thoughts you can formalize through code and investigate through experiments, and then, if the ideas are successful, the whole field advances by becoming more capable at solving problems."

With such a heavy responsibility on his hands, Ilya doesn't have a lot of time for the inessentials—or even the essentials. "Most of my food is at work, so my fridge is chronically under-stocked." He doesn't watch movies or TV or take vacations because they absorb too much time, but he spends a few hours every week reading, painting, playing the piano, and watching YouTube. What keeps him awake at night is mostly excitement about the future of his field—every day, he can see his and his collaborators' research at OpenAI finding new applications and inspiring new inventions. "I hope we manage to make great discoveries. I hope we can convince the community to think and worry about how this technology will work in society. And then ... not mess it up."

"The good thing about YouTube is that you don't have to watch it for a long time — you can spend ten minutes. I like to watch popular science videos, documentaries, reviews of gadgets, videos about cars, about psychology. There's also great comedy."

1986 Born in Gorky (now Nizhny Novgorod), USSR

2002 After living in Israel, Ilya's family moved to Toronto

2007 Earned his MSc (and later his PhD) from the
 University of Toronto

2011 Became the first Canadian to be awarded
 a Google PhD Fellowship

2013 DNNresearch, the company he co-founded
 with Geoffrey Hinton and Alex Krizhevsky,
 bought by Google for its pioneering work on
 visual object recognition

2013 Joined the "Google Brain" team, a research
 group focused on deep learning

2015 Co-founded OpenAI, currently serving as
 research director

FUTURE Applying artificial intelligence for the betterment
 of society.

A scale model of the human
brain. "Recently I learned that if
people browse the Internet for
too long," says Ilya, "it affects
their understanding and their
attention span in a very negative
way—especially if there are a lot
of hyperlinks. And this in turn
hurts our ability to achieve the
tasks that we set out to do."

"When we can say that artificial intelligence has been realized, it will mean computers can do pretty much anything a human can do—do my homework, build this house, convince this person to do something. I think they will be able to make moral judgments."

Coco
Rocha

28 years old

Model, entrepreneur

New York, NY

At the grand finale of Jean Paul Gaultier's couture show in early 2017, following a tradition every fashion fan knows, Coco Rocha appeared in a stylized white wedding dress. The garment was classic Gaultier, equal parts angels' robes and spacesuit, but it was also a Coco-perfect outfit. Ever since the supermodel started appearing on international runways in 2006, she's seemed like an ethereal, radiant extraterrestrial, the woman who fell to earth maybe, an impossible blend in charisma and the bone structure of David Bowie, Tilda Swinton, and *Alien*-era Sigourney Weaver. In keeping with her image, she arrived standing on a swing, then leapt to the runway, prancing down its length with the uncanny bearing of a praying mantis.

Redefining
the Supermodel

Like many models, Coco arrived at her profession accidentally. Born in Toronto, raised in British Columbia, she was approached by a model scout at an Irish dance competition in Vancouver when she was barely in her teens. Within a year she was modelling internationally and, at sixteen, living in New York and working with the most renowned photographers and designers. In 2006 she opened the Christian Lacroix show in Paris, and that breakthrough led to work with virtually every top designer in the world, from Stella McCartney to Marc Jacobs. That same year she signed an exclusive contract with the legendary photographer Steven Meisel, who shot her for a *Vogue Italia* layout conspicuously titled "Organized Robots." After that shoot, a still-uncertain Coco turned to another model she admired, Sasha Pivovarova, and said she didn't know what she was doing and worried she'd never work with Meisel again. Coco recalls: "In her confident Russian accent Sasha told me: 'Don't worry, you've done this job, now you won't need to worry about finding work again.' She was right."

You'd now be hard pressed to name a magazine whose cover Coco hasn't graced or an advertising campaign she hasn't been the face of. Most recently, she dyed her hair platinum blonde for a star turn in Balmain's latest ads. "I feel incredibly lucky to still work in this industry," she says, "and to be able to surround myself with some of the most creative people of the twenty-first century. To observe them working and learn from them is one of the unique privileges of my trade."

In those early days, Coco was a throwback to an earlier supermodel era, when the public was on a first-name basis with the most beautiful women in the world: Naomi, Linda, Christy. But she was also called the world's first digital supermodel, an early adopter of Twitter and Instagram, hyper-conscious of the construction, control, and dissemination of her image in a way no other model had been before. (In 2012, she became the first model to have more than a million followers on Google+.) The one thing she can't leave home without is her iPhone.

She hasn't kept her keen sense of brand awareness to herself. Coco's long been a mentor to other young women in her field, and she's now the mother of a young daughter. She was also co-host of the modelling reality show *The Face* in its first season, and last year became a director and co-owner of New York's Nomad Management modelling agency. "The big sister role is one I really enjoy," she says. "We founded the agency with agents who have been a part of my life from the start of my career. They literally watched me grow up." Not surprisingly, her goals with the agency are progressive, even noble: to ensure the ethical treatment of underage models, to increase the transparency of accounting practices, and to ameliorate the unhealthy expectations that can characterize the fashion world. "Looks are only part of it," she says of her work. "A good model must be professional and willing to work hard. But she also has to be someone who knows who she is and what her values are."

"I've read Jane Eyre
I don't know how many
 times. That era fascinates
me. I think I was probably
 born a couple hundred
 years too late."

"I'm perfectly content on a plane when I have my drink and my movie all lined up, my phone is off, and I know we don't land for at least six hours."

STUDY OF POSE

SEBRING/ROCHA

Coco at home. "I'm lucky that my work often involves dressing up in some unique and beautiful pieces. But if I'm staying at home, my uniform is comfy pajama bottoms and a T-shirt."

Coco works closely with
her husband on her career
and their business ventures:
"We have been married
seven years, but because
we spend so much of our
time together, I always
say it's more like twenty-
one years."

1998 Born in Toronto, ON

2002 Spotted at an Irish dance competition by agent
 Charles Stuart—the first person to suggest
 modelling as a career

2006 Modelled in Christian Lacroix's couture show
 in Paris; photographed by Steven Meisel for her
 first *Vogue* cover

2010 Awarded Prix d'Excellence as model of the year
 by *Marie Claire* magazine

2011 In her role as a philanthropist, put together
 a special collection for Senhoa, an organization
 that supports Cambodian survivors of
 human trafficking

2014 Guest edited an issue of *Flare* magazine, the first
 person ever asked to do so

FUTURE To continue working with the professionals and
 creatives she loves to collaborate with and try
 her hand at different entrepreneurial ventures.
 "As long as there are doors open to me, I am
 going to try to use them!"

"There have been days I've done a shoot in New York, boarded a plane for Paris, walked a runway there, then got back on a plane to shoot in New York—all within twenty-four hours."

When Stéphane Tétreault was seven, his parents went for a parent-teacher interview at his Montreal school. "My teacher scared my mom a little bit when she said, 'You have to do something with that child.' My mom was like, 'What? What did he do?'"

Stéphane's teacher saw in him the beginnings of a prodigious musical talent. He started playing the cello that year, and by the age of nine was studying with Yuli Turovsky, a Russian master who taught at Université de Montréal. "At ten years old, maybe eleven, it was already very clear to me that I wanted to be a cellist for the rest of my life." As Stéphane grew into his teenage years, he and Turovsky would stay up until two in the morning discussing music and life. "He was really like my cello grandfather—he completely formed the style of my playing."

Montreal, QC

24 years old

Stéphane Tétreault

Cellist

Hands of Stradivarius

In grade nine, Stéphane was home-schooled; and in his final years of school he came to class once a week and spent the other days on practice, concerts, and competitions. At sixteen, he attracted the attention of Yannick Nézet-Séguin, then the legendary conductor of Montreal's Orchestre Métropolitain. Stéphane began playing with the orchestra and is now its soloist-in-residence. Though Nézet-Séguin would eventually move on to become music director of New York's Metropolitan Opera, he remains an inspiration to Stéphane. "Yannick has this way of getting the most out of musicians," he says. "You have a lot of big egos in the music world, but he's the nicest guy—he's unpretentious, he never gets angry in rehearsals. To have all his success and still stay so humble is exceptional. With Yannick you want to be the best you can be."

Despite earning raves at such a young age, Stéphane doesn't consider himself a prodigy. "I consider myself someone who worked quite a lot and practised a lot." Stéphane believes success lies in finding an emotional core to a performance rather than in technical proficiency. Onstage, he'll delve into the music by calling up memories—perhaps personal experiences of heartbreak or joy, perhaps scenes from movies. "There's a Brahms sonata that at the end, for me, is very similar to the Italian movie *Life Is Beautiful.* I bawl my eyes out every time I watch that movie." When he is doing what he loves, it's as if he disappears entirely. "Without making it too spiritual, it's almost a sort of trance. Onstage, there's a sense of freedom."

Now twenty-four years old, Stéphane travels the world with his cello, a 300-year-old Stradivarius named Countess von Stainlein, ex Paganini, of 1707. The cello, once played by Nicolò Paganini, was bought at an auction in 2012 and loaned to Stéphane by Jacqueline Desmarais—an event that made international headlines.

International air travel with such a noble instrument, however, lends the comedy to his life as a serious musician. "It's always crazy," he says. "You have airline people who ask you if the cello is male or female. Then they tell you it won't fit through the machine, even though you've made it fit about thirty-five thousand times before. Or they put it in the closet, which is business class, and you're in economy, so you can't protect it during turbulence." Once in a while an airline will decide the Countess deserves special treatment. "They've even put it on a bed, so it's more comfortable than I am."

When Stéphane and the Countess are at home, they live in the house where he grew up—his grandparents still live downstairs. In some ways, he's like any other young Montrealer—his kitchen is stocked with poppy-seed bagels from Fairmount, he's obsessed with *Homeland,* and he knows where the bartenders make the best vodka martinis. He's a hockey fan, loves to bake, and enjoys expressing himself through fashion. He used to roll his eyes at the music his dad, a rock bassist, listened to, but these days he has grown to love pop music—"Adele, that voice is very, very special." He devoured all the *Harry Potter* books and he's hoping one day to write an adventure novel of his own. "The problem is that I have only one life to live—for now at least."

"The worst reaction
I could get after a
concert would be,
'Oh yeah, it was okay,'
something lukewarm.
I detest lukewarm."

"I like to be moved or shocked — and to do that with music you have to be immersed 100 percent in what you're doing."

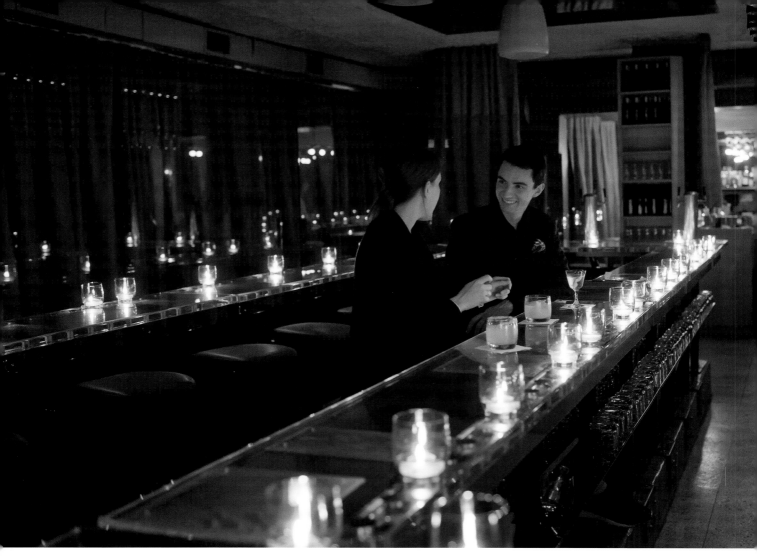

"The word 'prodigy' is flattering, but you need to go past it and try to become a well-rounded musician."

1993 Born in Montreal, QC

2012 Loaned the Countess von Stainlein,
ex Paganini, Stradivarius cello

2013 Won the Choquette-Symcox Award
presented by Jeunesses Musicales, Canada

2015 Received a master's degree in music
performance, Université de Montréal

2015 First winner of the Classe d'Excellence
de Violoncelle Gautier Capuçon from the
Fondation Louis Vuitton

FUTURE To be a globe-trotting soloist with a well-
rounded personal life.

Liane
Thomas

Executive producer

The proudest moment of Liane Thomas's career came recently: she was invited to Toronto's SickKids hospital for the unveiling of a daring television and print campaign that her company, Skin and Bones, produced with the ad agency Cossette. The campaign, called VS for "versus," features children who are real patients at the hospital recast as warriors and superheroes: accompanied by a pulsating hip-hop track, a boy destroys a dialysis machine with a baseball bat; a girl in a Mexican wrestler mask leaps into the air; a fleet of small children in hospital gowns sprints across a field with a platoon of charging cavalry. The words "Sick isn't weak" flash across the screen in block lettering. "Sick fights back."

Championing
Creativity

Toronto, ON

"Directors are quite selfish inherently—and there are far more men than women in that role. Women, because of their caretaking nature, are more likely to be producers."

It was a powerful theme that Liane could get behind personally. When she was twelve she overheard a doctor tell her parents she might not live past sixteen because of complications from chronic nephritis, a sometimes fatal form of kidney disease most often caused by an autoimmune disorder. But the condition—which would have her in and out of hospital for years—seemed only to spur Liane to pursue her goals with greater determination. "I won my high school science fair from a hospital bed at Toronto General," she remembers. "I think something in me said, the more I do, the more I achieve, and the busier I am, the more I'll prove to people that I'm okay, I'm going to be okay. That shaped me into the person I am today."

In her first year at McGill University, Liane's father advised her to take history classes as preparation for a career in law, and she accidentally signed up for an art history course. "I fell madly in love," she says. Her art history degree led to a job at Drabinsky's, an influential Toronto gallery. A turning point in Liane's career came at a gallery event for Celia Neubauer, then an up-and-coming artist, in which one of the artworks revolved around the suicide of Neubauer's brother. "Being in the gallery that night and understanding the premise of her art, and how it came from a really tough place, I right away understood that my role there was not to sell her art. My role was to protect this girl. I saw her vulnerability, how naked she was in a crowd of gallery goers."

Although the arena has changed, Liane still sees herself as a protector. In her late twenties she left the gallery world for advertising, first to work with Kessler Irish Films, then to start her own production companies: Sons and Daughters and, later, Skin and Bones. Around the same time she embarked on her new career, at twenty-nine, her brother, James, donated his kidney to her for a transplant operation. "For me, from twelve to twenty-nine I was dying, and from thirty until now I'm learning how to live."

Nowadays she might find herself shooting in Austria, Italy, and Slovenia within a single twenty-four-hour period. Or on top of a mountain in British Columbia wearing a mosquito net, supervising the shooting of a Ford commercial starring Lynda Carter (best known for her role as Wonder Woman). But Liane's priority is always to support the work of her directors. "My role is to communicate to the advertising agencies what makes these incredible, creative beings magical and to protect that by demanding respect for their process. Advertisements have the ability to move somebody, excite somebody, enlighten somebody. For me, advertising is the most amazing form of art today."

Not surprisingly for someone who says, "Working always made me feel healthy," Liane believes a strong work ethic is the most important virtue in life. Being in the high-pressure world of advertising, however, means it can be a struggle to find the right balance. "I'm a mom, but I have to tell you that being an executive is all-consuming. It can be hard to let go." As a single mom, she worries about giving her twelve-year-old son, Henry, the opportunities she has had.

After two marriages, Liane regrets not having found the right life partner. But she's grateful for how both relationships have shaped her life for the better. From her first husband, she acquired a love of fashion and learned to appreciate his "incredible eye for unique and beautiful clothes." Her second husband, a director and very capable chef, instilled in her a love of food. "It's amazing how these unsuccessful relationships have brought such rich diversity to my life." As for Henry, she says, "Getting pregnant was not an option before the transplant, so in many ways he is a miracle." Liane enjoys exposing his curious mind to new things and then getting his perspective on it. "We learn so much from each other, and what he has to say is often more enlightening than what you'd expect of a child. Henry is by far the best thing I have ever produced."

"The way I got sick, it just sort of struck me; it was such a quick moment to such a life-changing experience that it is with me now forever."

"I was fortunate to have a great living donor; I had a match in my brother James, who gave me his kidney. He's an actor, and I said to him, 'You're going to have this scar.' And he said, 'I will wear that scar like a badge of honor.'"

Despite all her literary success, Maddie says her proudest moment was getting into university on scholarship. "It meant that something else would be possible. I was in a high school where very few people went on to university, so it was a big thing."

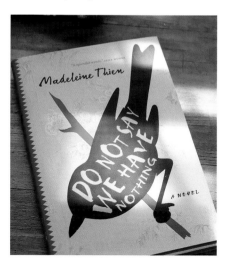

"Initially I was trained as a
dancer,
and I think that's one
way of interpreting the
world, but
literature felt like
it could give me
more control in a way."

Maddie

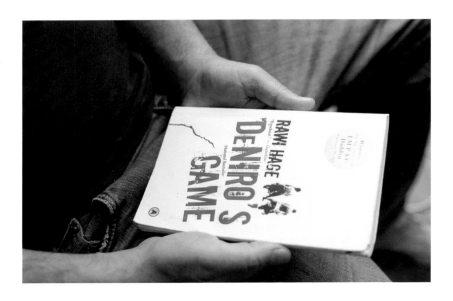

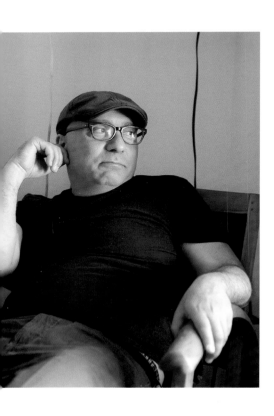

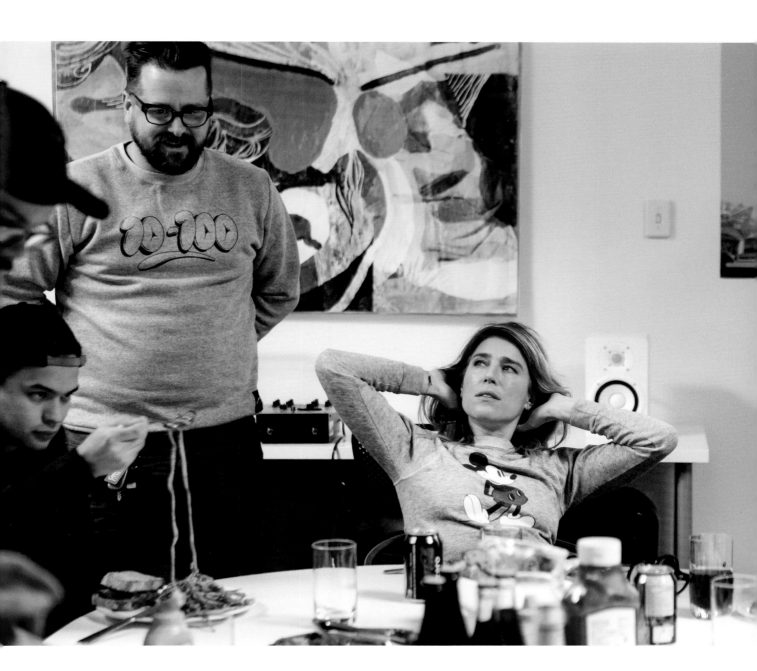

Cameron Bailey

54 years old

Film programmer and artistic director

In the summer of 2008 Cameron Bailey was in a London screening room to see an unfinished cut of a movie that its makers hoped he'd program for the Toronto International Film Festival (TIFF). "This film was having all sorts of trouble getting out into the world," Cameron remembers. It had already been a tough sell for the producers: a film set in Mumbai with a mostly Indian cast and much of the dialogue in Hindi. The once-celebrated director had been in a slump. And now the company that was supposed to release it was falling apart. The film seemed fated to go straight to DVD.

A World of Discovery

Toronto, ON

"We loved the film, so we invited it," says Cameron. His decision was soon vindicated when its TIFF screenings netted both a new distribution deal and the People's Choice Award voted on by moviegoers. That film, *Slumdog Millionaire*, directed by Danny Boyle, would prove to be the sleeper hit of the year, earning more than $370 million globally at the box office. It later crowned its run by winning Best Picture at the Academy Awards. But while the story of *Slumdog Millionaire* helped cement TIFF's reputation as a launch pad for Oscar contenders, the joy for Cameron always comes from somewhere simpler. "I just love the sense of discovery—being able to discover something you love and then share it with people for the first time. There's something thrilling and magical about that."

Cameron is quick to give credit to his Barbadian parents for instilling the sense of discovery that lies at the heart of his work. His mother was an emergency room nurse; his father a bus conductor who worked his way up to insurance salesman. As a kid Cameron hadn't yet developed a passion for film, but his parents encouraged his curiosity, insisting that he and his sister be open to new things. "They were always, 'Read this book, look at this magazine. Let's go out and try some food we've never had before.' Through them I developed a pleasure in discovering things."

The love of film didn't come until Cameron's second year of university, when he took a course in contemporary art cinema. "I'd grown up watching movies like everyone else," he says, "but this was my first exposure to French new wave, Italian neo-realism, Japanese cinema, Latin American political films, films from Africa. For the first time I saw movies that could do so much more than entertain." Cameron started writing reviews for the campus newspaper, which would lead later to a paid gig as film critic for *NOW*, Toronto's weekly magazine. There, Cameron's wide-ranging tastes and perceptive writing caught the eye of Piers Handling, TIFF's director and CEO. Handling asked Cameron to join TIFF as a programmer, but at first he said no. "I was only two or three years into being a film critic. I didn't think I knew enough at that point." Thankfully, Cameron adds, he gave a different answer when Piers asked again a year later.

Cameron quickly earned a reputation among TIFF-goers for his quality programming picks and charismatic onstage presence when introducing films. More than twenty-five years later, as TIFF has grown in both scale and prestige, he's seen his share of crazy days behind the scenes: "There have been so many where there's this bunch of stressful, disparate things come together." Aside from having a hundred tasks to do in a day—interviews, film introductions, socializing, managing staff—there's always the chance that something will go sideways. Cameron has had to learn to deal with projector malfunctions, wrong film prints, political crises, and controversies. Yet he never exhibits anything less than grace under pressure. At times the stars do, too; Cameron describes the French actor Marion Cotillard as "beautifully gracious and charming" for how she handled a print mix-up and rescheduling. But sometimes they don't: "There's a lot of ego in this business, and it gets boring."

In 2012 Cameron was named the festival's artistic director, a position that came with a whole raft of new administrative responsibilities—from overseeing cinema technology and programming to community outreach for an arts institution that shows films year-round at its permanent home, the TIFF Bell Lightbox. "Right now I'm obsessed with trying to harmonize everything we do so they amplify and support each other." To that end he recently took an intensive course at the Rotman School of Management.

Cameron admits it's not the most obvious dream job for a kid growing up. "Nobody thinks about being the artistic director of a festival or arts institution." Now that he's in the role, he is keenly aware of the festival's cultural and social influence. "I take the festival's mission seriously: to transform the way people see the world through film." He mentions a screening of *The Zookeeper's Wife* from a few nights before, a story of a Warsaw couple who harboured Jews from the Nazis. During the Q & A afterward, a Muslim woman spoke about how, under today's cloud of Islamophobia, she could identify with what the Jews must have faced. She felt that her own family is under threat. "There were people in the audience who might not have made that connection," Cameron says. "It's an example of how transformative movies can be."

"When I was a kid, living in
 Barbados with my grandparents,
 my mom sent me down one
 of those stereoscopic View-Master
things with these reels showing
off Canada's natural beauty.
 You know—Tobermory, Niagara
 Falls, Banff, the Rockies, and
 Newfoundland. Everything looked
 like it was in 3-D; it was so
 immersive. They're very retro now,
 but I remember just being so
 transported. I'd never seen
 Canada at that point,
 and here was this totally different,
 glorious landscape."

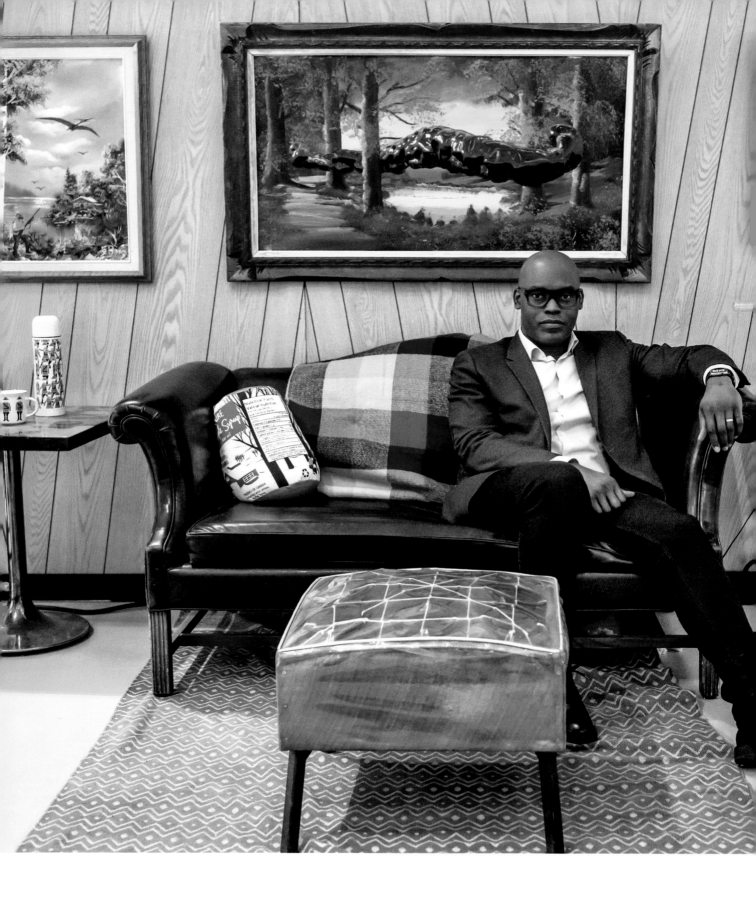

"Reading *Huckleberry Finn* at public school was incredibly traumatizing. Every time the N-word was read out loud—this was a long time ago, when people weren't as sensitive about that kind of thing—the class would giggle and snicker. I felt so isolated from my classmates through the reading of that book. I'm glad I read it, it's a great piece of literature, but it taught me how we each look at a book, a film, or any piece of art through our own experience. And how that can profoundly shift based on your experiences."

"When you watch movies, you're often projecting yourself into someone else's life. Think of LGBT people, who also want to see their own stories, their own dilemmas reflected up on screen. Which is why a film like *Moonlight,* which we showed at the festival, was so moving and a bit of a relief. Until you see a film like that you don't even know what you've been missing."

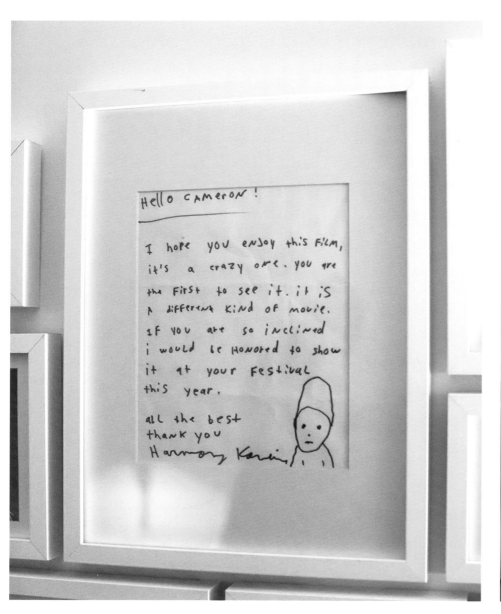

Classic movie posters at the TIFF Bell Lightbox in Toronto. "When things go wrong at a festival screening," Cameron says, "the Canadian response is much calmer, more measured, more accepting than it would be at Cannes, Mumbai, or other festivals."

1963 Born in London, UK

1967 Moved to St. James, Barbados, where he spent four years

1987 Became a staff film critic at *NOW* magazine

1990 Joined the Toronto International Film Festival as programmer for the Canadian section

1997 Co-wrote the screenplay for *The Planet of Junior Brown* with Clement Virgo. Later wrote and directed the 2004 short *Hotel Saudade*

2012 Appointed artistic director of TIFF

FUTURE "Using the power of the art form to increase people's empathy, to show them different ways of living, different perspectives. If I can help do that, then I will have done whatever I'm here to do."

Scotty
Sussman

Artist

When asked his age, Scotty Sussman says, "Timeless." When asked what a standard workday looks like for him, he says, "Working hard is not about sitting at a desk and having a product. It's about getting up out of your bed, picking a place on the dartboard and throwing a dart, and hopefully it lands somewhere." When asked what inspired the gap tooth that has become an iconic part of his look, he responds, "I had to do everything I could not to look like the photo on my ID."

The Full
Fantasy

London, UK

"I am such a Jewish Libra. Libras are all about the full fantasy. And I'm Jewish because I'm super specific and really driven."

Scotty felt stifled as a young teenager in Toronto. The gay village was too small for his outsize personality, and the school he went to—an alternative school specializing in canoeing and other forms of outdoor education—didn't fit his interests. "I needed that area where I could go anywhere dressed up," he says, "so I could be more rambunctious and always try something new." By the time he was fifteen he had to get out. Scotty's parents—a former Hollywood reporter turned children's writer and a television executive—supported his decision. "Everyone I've met in New York hates their family and had to run away from home and have an expulsion moment. But for me, my parents loved what I did. They said if I want to be happy, go! We'll visit you ... just get a plane ticket and go!"

In 2014, newly arrived in New York, Scotty launched his career as an artist. "The nightclub is the venue, and the costume is the art. I'm just wearing it." Spending time in queer clubs, he got to know Ladyfag, a fellow expat Canadian, who helped him establish himself on the countercultural edge where the fashion world meets the nightlife world. Scotty began hosting nights at upscale clubs. "So clubs will hire influencers, I guess you could call them. They pay you however much money to sit there and have a few drinks with your friends. But I'm also displaying my art. So people show up to my art gallery without even knowing it's my art gallery."

Scotty's creations—some of which he wears as Sussi, a drag queen version of himself—are, as he likes to say, "very full fantasy." Along with the gap tooth, his trademark is big red lips. "Big lips are everything," he says. "All my idols have big lips, and you will become whoever you idolize if you're smart enough and you care enough." He changes his entire look every night. "I spend a lot of my day putting together costumes and organizing my life. I come up with the concepts myself—it's all about the creation. So I'm creating myself every day, and I try to do some sort of self-portrait work. Half of it is the creation of myself, and the other half is the creation I make with other people."

In 2016 Scotty's style caught the attention of photographer Bruce Weber. Weber's ad campaign for Barney's, a luxury department-store chain headquartered in New York City, was called "Our Town" and featured Sussi along with other downtown style icons. "The way it was shot, we were right in the middle of Park Avenue, on that divider in the street—the median—a little floral moment," Scotty remembers. "The cars are honking, and Bruce Weber is taking my picture, and models are walking past, and everyone is smoking a cigarette—it's just such a scene. It was like whiplash, in the best way. I was like, everything is real; I am living this life." The ad hit the pages of *Vanity Fair*, and Scotty saw himself on the sides of taxicabs on all the streets in the city.

Now living in London, UK, where he attends a design college, Scotty plans on transferring his own flair for fashion into designing for customers. "Let me do it on myself first, let me create myself, and then I'll create everyone else." His main piece of advice is to find the milieu that's right for you. For him, that means refusing to settle for anything less than the fantasy he craves. "Go where you are celebrated."

Scotty Sussman's younger brother, Jack, has also defied expectations at a young age. At fifteen he makes a significant income from his Instagram account—thanks to ad placements from the likes of Nike —where his million-plus followers view the photos and videos of basketball games he posts at least three times a day. Recently, Jack gave a presentation to the University of Toronto's business school on how best to grow a social media platform and how social media influences business. "I get basically the same number of viewers that a commercial would get on TV, so I feel like advertising is slowly moving into social media, and social media will eventually take over." Jack's newest project is Best Crosses, a lifestyle brand named after a basketball play. "My dad and mom have always told me to do what you want in life, to make sure your job doesn't feel like a job."

Jack, Scotty's younger brother, at home in his room. "I couldn't understand Scotty's culture, and he couldn't understand my basketball culture. I learned about Scotty's and accepted it. I understand it's what he loves."

"For me, the gap tooth is a rebellious thing — against the braces I wore for years — and the red lips are the most gorgeous thing."

LIBRA Born in Los Angeles, CA

2011 Attended Walnut Hill School for the Arts, Natick, MA, as a voice/acting student and switched to fine art

2014 Moved to New York, NY

2016 Appeared in a campaign for Barney's department store shot by Bruce Weber

2016 Moved to London, UK, to study fashion communication at the Condé Nast College of Fashion & Design

FUTURE "Once my character Sussi is completely evolved, I will slowly start to peel it away and sell it to other people. I want to use that identity—the hunger out there for costume and fantasy—and give it to other people."

"I don't consider myself a drag queen," Scotty says. "I'm not trying to impersonate anyone. I'm just trying to look like myself."

"I come up with the concepts myself, but other people often make the costumes. I'm creating myself every day—a different look. That's half of it; the other half is what I make with other people, whether it's in conversation or hosting events for people I really like in the nightlife community."

"The best way into the celebrity world is just to sneak right on through the door and become someone interesting and important."

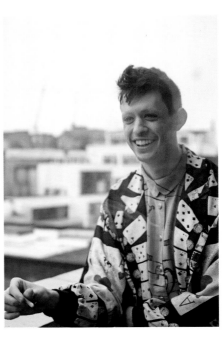

Crystal Pite

46 years old

Choreographer and dancer

Vancouver, BC

Ask Crystal Pite to describe one of the craziest, most memorable nights of her thirty-year career, and you'd expect the first thing she'd answer might be the premiere of a new work at London's Royal Ballet or the Paris Opera Ballet—and the effusive press reviews that followed. Or the opening night of her adaptation of Shakespeare's *The Tempest* for the Kunstlerhaus Mousonturm in Frankfurt, one of the world's foremost stages for cutting-edge contemporary dance. Or the time she won the UK's National Dance Award for choreography, when she didn't even know she'd been nominated.

Choreographing Doubt and Joy

Instead, Crystal reaches back to a panicked night of technical preparations at the opulent Palais Garnier, home to the Paris Opera Ballet since 1875, a few days before *The Seasons' Canon* had its debut. "We were running behind, so six of us—my lighting designer, rehearsal director, three technicians, and I—stayed in the opera house all night working on lighting cues," she remembers. The entire theatre was dark except for the stage—the same stage on which such illustrious choreographers as Serge Lifar and Rudolf Nureyev had once revolutionized the art of dance.

"Every corner of that place has a story to tell," she says. "It was a little creepy at first, but to be alone working there at four o'clock in the morning, knowing we were about to become part of its history, was magical and surreal."

On opening night the *New York Times* called *The Seasons' Canon* "visceral, crowd-stirring stuff," noting that the audience "leapt to their feet (unusual here), applauding wildly at the end." Notices like that have helped make Crystal one of the most in-demand choreographers working today, busy with commissions from the world's pre-eminent ballet houses while continuing to run her own Vancouver-based company, Kidd Pivot.

Though her love of text, story, and theatrical device is woven into every aspect of her creations, Crystal's work is always underpinned by the mastery of her choreographic craft. She connects with her audience most profoundly in the way she sculpts, moves, and articulates her dancers, delivering some of the most challenging, ineffable ideas through the dancing body. Of *Betroffenheit*, her heart-rending 2015 collaboration with playwright Jonathon Young, inspired by Young's personal story of trauma and loss, the *Globe and Mail*'s critic wrote: "I can't remember the last time I heard so much audience-sobbing at a curtain call."

Growing up in Victoria, Crystal took to dance early, starting lessons in tap at four years old, and ballet soon after. She was already experimenting with choreography as a child, thanks to a teacher who gave her keys to the studio in its off-hours.

By seventeen Crystal was dancing professionally with the British Columbia Ballet in Vancouver. "I was a bit shocked by that," she says. "I thought my next destination out of high school would be another four years of training at a big institution. But I'm lucky to have jumped straight into professional life. I had to be resourceful and learn quickly."

Perhaps her most formative period came when she signed on with Ballet Frankfurt in 1996, then under the direction of American choreographer William Forsythe, whose work has been credited with rewriting the vocabulary of contemporary ballet. Forsythe would prove to be both a mentor and major influence on Crystal's career.

In 2002 Crystal moved back to Vancouver and launched Kidd Pivot. The company name, she says, was carefully crafted. "The word 'pivot' describes a technical move that is precise and rigorous. It evokes something crucial and a change of direction or point of view." In counterpoint, she chose something "more reckless, irreverent ... brutal and spectacular." "Kidd" is the outlaw, the pirate, the prizefighter. "Together they sound dynamic, like a superhero. Holding contrasting ideas in a kind of tension has always been one of my artistic ideals."

Crystal's ascension to the elite tier of the dance world has presented at least one new challenge: balancing the globe-trotting nature of her work with the demands of home. With her partner, Jay Gower Taylor, who provides set design for most of Crystal's productions, she has a six-year-old son, Niko. When Niko was younger it was easy to take him wherever they were working. Now that he's in school, it's less of an option. But motherhood, she says, has only fuelled her creativity, whether it's making Halloween costumes with Niko from scratch or engaging with even bigger ideas in her art.

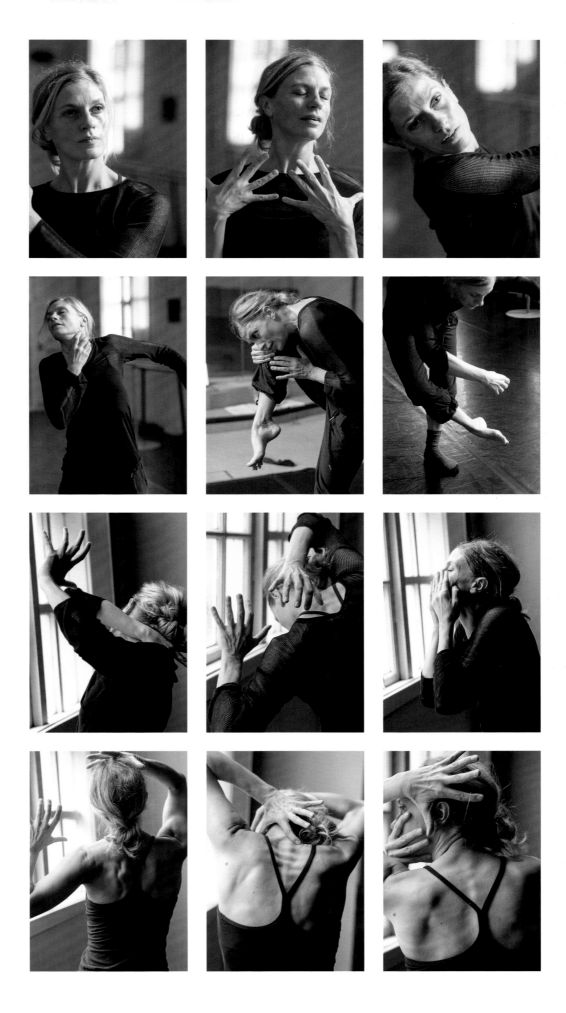

Crystal at home with her son, Niko. "The birth of our son was obviously life-changing and totally profound. It's shifted my whole perspective on the world and the art that I make. Now I'm more focused on spending my time meaningfully, trying to be grateful and present."

"My parents were an important part of my development as a creative person. They were both really into crafts and making things. Choreography for me was an extension of that, this idea of crafting the body and making things with dance."

"I like to work off the tension between doubt and joy, which are both powerful experiences in creation. It's the tension between those two elements that has become the engine for my work."

"Creation for me is about trying to understand things. I use choreography to work with big ideas and things I can't understand or that can't be understood. My choreography is a way of coping with feelings of awe and how humble I am in the face of a colossal subject."

"I don't experience what it is that I've actually made until I share it with an audience. I often experience the first performance of a work through a fog of fear. The creation is out of my hands in the same moment when it is the most exposed."

"Every time I finish something I'm
convinced it's the last thing I'm going
to make. And that I'm never going to
have another good idea."

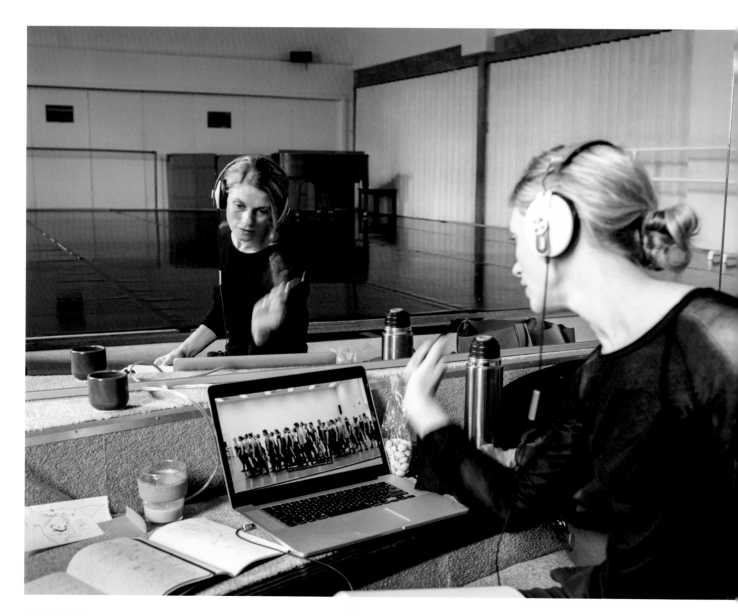

1970	Born in Terrace, BC	2013	Named associate choreographer of Netherlands Dance Theatre
1987	Began her professional dance career with Ballet British Columbia	2015	Won prestigious Olivier Award, the highest honour in British theatre, for Outstanding Achievement in Dance
1996	Joined Ballet Frankfurt under direction of influential choreographer William Forsythe	2017	Her most recent new work, *Flight Pattern*, had its world premiere with the Royal Ballet in London
2002	Launched her own Vancouver-based dance company, Kidd Pivot	FUTURE	"To keep challenging myself, always reaching a bit further than I think I can manage."
2008	Won the Governor General's Performing Arts Award, Mentorship Program		

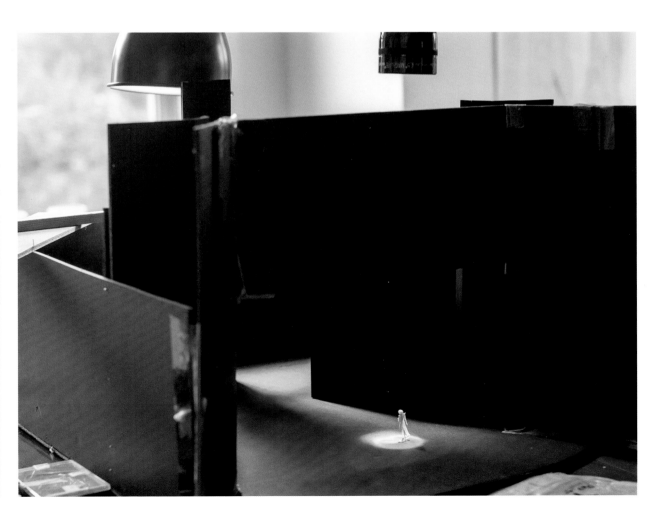

Alexa Hatanaka

By 2011 Alexa Hatanaka and Patrick Thompson had been a couple for one year, but when they got lost in the Thai jungle overnight, they knew, if they survived, they would be together forever. "We were covered head to toe in leeches within two hours and surrounded by the sound of a million cicadas and howler monkeys—it was insanity," Patrick remembers. "And one thing we had was tampons, so we stuck them in our ears because we didn't want bugs to go in there," Alexa adds. When these artists—smeared with blood and their clothing in tatters—finally stumbled back to the temple they were visiting, they couldn't explain themselves in words to the concerned monk. Instead, they drew him a picture.

Artists

Patrick Thompson

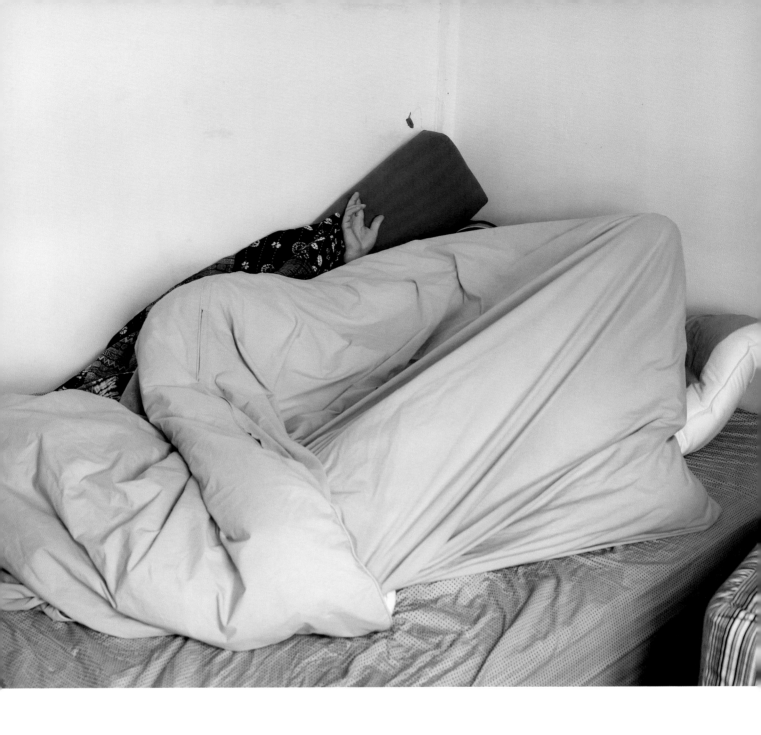

Ambassadors of Imagination

Toronto, ON

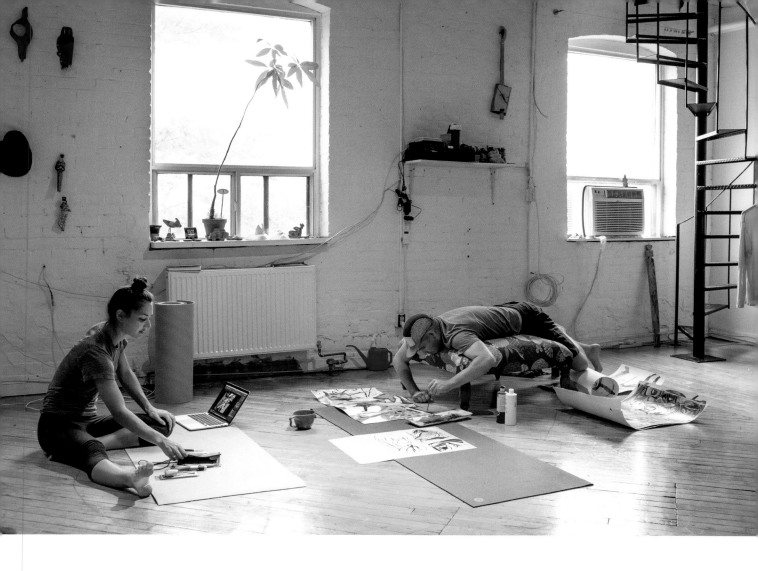

"It's a very nice way to spend time together creating these 'children'— these pieces of art. It's a massive amount of work before you finally give birth, and there's this great joy. And then you can let it go and you never have to worry about it again. You can think about the next thing you want to do."

Patrick

Alexa and Patrick's art practice, PA System, infuses every moment of their lives together. "It never stops," Patrick says. They both attended OCAD University at different times, and, after meeting in 2009 on a collaborative project, their paintbrushes got too mixed up, they joke, for them ever to separate. Alexa started out in printmaking and weaving, both of which she still practises, while Patrick became fascinated by graffiti as a child. "I had this strange idea of these seven-foot-tall people lurking around and making these things," he says. Both have their own projects, but their joint practice—ruled by what they refer to as "mistake-ism," an approach where they welcome imperfections and feel free to alter each other's work—is focused on wall-sized murals, video, installations, and carved paintings on wooden panels. "We have a combined visual language that just develops naturally from working together so often," Alexa says. Patrick adds, "That's one thing that's great about working in a true collaborative spirit: you must trust your team."

Alexa grew up in Toronto, and Patrick in the country outside Ottawa, but their life together has taken them to such far-flung places as Egypt, China, and Sri Lanka. They currently divide their time between Toronto and Kinngait (Cape Dorset) in Nunavut, where they run Embassy of Imagination—a multidisciplinary arts initiative for youth. "Cape Dorset is a place that has this history of art, has an incredible lineage of artists," Patrick says, "but it also has a lot of social problems and can benefit from young people becoming engaged in public discourse through art, through film, through sound. Canada needs young voices from Aboriginal communities to speak louder, and I think art is a natural tool."

Alexa and Patrick have been painting outdoor art in Igloolik, Iqaluit, Kangiqsujuaq, and other small northern communities for years, but recently they've been helping Inuit youth create their own murals. In the summer of 2015 they hosted five teenagers from Kinngait—one of whom, Parr (Etidloie) Josephee, still lives with them—to conceptualize and execute a large mural on Church Street in downtown Toronto.

In one of their creative sessions, Parr told a story about his grandfather carrying a broken-down snowmobile home over the tundra, and this vision became the basis for the mural: a man in a parka bearing a snowmobile crowned with a stylized profusion of fish, birds, seals, and people on his shoulders. Of the painting's deeper significance, Patrick says, "Parr defines it well: 'The Inuit are strong, and we can carry any load the world throws on us.'"

In terms of ambition, the couple is always working with the heaviest load they can carry, which means they've got their life hacks figured out. Patrick offers a trade secret: "We've become bean-atarians. When we're doing big, outdoor art projects, we've found that it's easy, fast, and keeps your energy going. That's the magic serum, bean salads." They both like to keep active—in his teens, Patrick was a competitive snowboarder. Alexa, who has struggled with depression, has found that working with Indigenous youth plays an important role in her own healing and has allowed her to connect with her Japanese-Canadian heritage. "My grandparents were in the internment camps in BC," she says, "so when they came out they wanted to make sure their kids had English names and spoke English only and really blended in. Right now Inuit kids are in the thick of defining how they will persist in their culture against very difficult pressures and traumatic things that have been thrown at them. So I think that speaks to me in a specific way."

Both Alexa and Patrick have travelled widely within Canada and abroad. Patrick has hopped freight trains across the country seven times. "When you travel coast to coast on the land, and you're in the prairies in the wheat, and you're in the suburbs of Calgary, and you climb up into the mountains, you get this sense of this incredibly diverse land," he says. Alexa adds, "It's not glorious and free for every Canadian—that's the difficult part. We like to think we are making our contribution to work toward reconciliation."

"I think the particular place Canada is in right now — being one of the last frontiers of clean water, the last mass wilderness, a place of democracy and sanity, and also a place that's making an effort toward reconciliation - has definitely made us who we are."

Patrick

"What draws us to travel so much is to experience different places, different cultures, and different human expressions."

Alexa

Above right: *Papa-Yaya* by PA System

Parr (Etidloie) Josephee, pictured at left, has participated in most of Alexa and Patrick's workshops and projects over the last three years. "He's been living with us in Toronto," says Alexa, "so he can complete his final year of high school at the Oasis Skateboard Factory School, where he designs skateboards and learns entrepreneurial skills. He comes from a family of Kinngait (Cape Dorset) artists. His father was the carver Isaaci Etidloie, and his grandfather was Parr Parr, one of the region's first graphic artists."

Following spread: *Training*, a public mural by PA System in Toronto, 2016.

"The North has a very particular magnetic pull, and it's hard to describe, but you just fall in love with it."

Alexa

1978 Born in Ottawa, ON

1996 Began painting graffiti, producing works across
 North and South America, Asia, and Europe

2007 Invited to participate in the Barcelona
 Contemporary Arts Festival

2008 Created installation for *Housepaint, Phase
 2: Shelter*, an exhibition presented at the
 Royal Ontario Museum

2013 Contributed work as an official selection to the
 Guanlan International Print Biennial Exhibition
 in Shenzhen, China

2014 PA System founded Embassy of Imagination,
 a multidisciplinary arts workshop for youth
 in Kinngait

2016 PA System was part of the group exhibition
 *Flow Edge: New Art and Collaborations from the
 North* at Canada House, London, UK

FUTURE "Realize the collaborative projects we've been
 developing with our good friend and outstanding
 artist Danny Osborne."

1988 Born in Toronto, ON

2009 Was artist-in-residence and part of the
 group exhibition *No Holds Barred* for the
 Manifesto Festival

2010 Presented *Choose Your Own Adventure*, Alexa
 and Patrick's first collaborative show as
 PA System, in Cairo

2012 Graduated with a Bachelor in Fine Arts,
 specializing in printmaking, from
 OCAD University

2013 Awarded a Chalmers Fellowship from the
 Ontario Arts Council

2015 Completed an artist residency at the renowned
 Kinngait Studios in Cape Dorset, Nunavut

2015 Embassy of Imagination, with Mural
 Routes and Nunavut Arts and Crafts
 Association, orchestrated the creation of
 the mural *Piliriqatigiingniq* by young Inuit
 artists at the corner of Church and King
 Streets in Toronto

FUTURE Establish with the community a dedicated
 creative space for youth in Kinngait.

Creative Team

Kim Bozak
Author and creative director

Originally from Regina, Saskatchewan, Kim is active in numerous art and social causes. A former co-chair of the Canadian Art Foundation, she currently serves on the board of the National Arts Centre and is also a member of the Sotheby's Advisory Board. Kim was also part of the group that helped bring Volt Hockey—a version of the sport that enables kids with physical disabilities to play by using a specially designed chair —to Canada.

Rita Field-Marsham
Author and creative director

Rita is a Dutch-Kenyan new Canadian and former prosecutor and public defender in Kenya. After moving to Toronto in 2004, she founded Kenya's first turnkey school library model and has now built twenty-seven libraries. She is currently in the process of drafting new legislation with the Kenya Law Reform Commission to ensure that all school-aged children have access to libraries and the knowledge they need to shape their future.

Joanne Ratajczak
Photographer

Joanne is a Polish-Canadian photographer currently driving around South America in a minivan. Her photos have appeared in a variety of publications—including the *Walrus*, the *Globe and Mail*, and *Toronto Life*—and been exhibited at spaces such as Toronto's Harbourfront Centre and the Moscow Museum of Modern Art.

Frank Viva
Illustrator

Managing director of Toronto-based branding and design agency Viva & Co, Frank is an illustrator, writer, and graphic designer whose work has won over three hundred awards. His illustrations have appeared in *Time*, *Esquire*, the *New York Times*, the *Boston Globe*, and on the cover of the *New Yorker*. He is also the author of several books, including the acclaimed illustrated novel *Sea Change*.

Siavash Khasha
Designer and art director

Siavash is an Iranian-born Canadian designer and an associate creative director at Viva & Co with multidisciplinary experience. He is driven to create designs with a purpose, demonstrated in digital and environmental experiences for K11 Hong Kong, the rebranding of Air Canada, and complete visual identities for Le Creuset.

Rosemary Shipton
Executive editor

Australian-born Rosemary has edited over six hundred books, several of which have won major Canadian and US awards, and was founding academic coordinator of the Publishing Program at Ryerson University. In 2007 she was granted an honorary doctorate by Trinity College, University of Toronto, for her contribution to publishing in Canada.

Chris Frey
Editor and writer

A six-time winner at the National Magazine Awards, Chris is the founding editor of *Hazlitt* and the Toronto correspondent for *Monocle* magazine. His work has appeared in the *Guardian*, the *Walrus*, the *Globe and Mail*, and *Azure*. He is currently finishing a non-fiction book of international reportage called *Broken Atlas.*

Jason McBride
Writer

Jason is a Toronto-based freelance writer and editor whose work has appeared in *Toronto Life*, *Maclean's*, *New York*, and many other publications. He is currently working on the first authorized biography of the late American writer Kathy Acker.

Linda Besner
Writer

Linda Besner is a freelance writer and poet living in Montreal. Her books include *The Id Kid* and *Feel Happier in Nine Seconds*.

Megan Cuff
Project manager

A graduate in art history from the University of Toronto, Megan previously worked in advertising for Leo Burnett where she managed several large, integrated campaigns for major brands. As project manager, Megan helped oversee all aspects of production.

Sarah Angel
Consulting editor

Sara Angel is the founder and executive director of the Art Canada Institute, dedicated to the education and promotion of Canadian art history. She is also one of the country's leading visual arts journalists.

different, we free others to do the same.

When we embrace what makes ourselves

Acknowledgements

We've produced *Glorious & Free* during one of the most hectic times in our lives—amid busy careers and raising teenagers. Driven by a creative passion, it began with the two of us embarking on a years-long, cross-continent odyssey that would be full of deep research and chance encounters—all in search of fomenting a new understanding of life in Canada.

Thanks to all of you who helped us on our way, first and foremost our families—Phil, Charles, Natasha, Eliana, Davina, Linus, Wylie, and Holden. Your constant love and support kept us inspired. Thank you Elisa Nuyten for starting this book with us and for the modern sensibility that helped to shape the design aesthetic of *Glorious & Free.*

We've been most fortunate in the professional team we assembled to make this book a reality. Joanne Ratajczak, our photographer, travelled all over North America and made it easy for each of the thirty-three individuals profiled in the book to fall in love with our project and relax with it. Frank Viva, our legendary illustrator, provided fine leadership in producing the volume and gave it a special touch with his unique, imaginative drawings. Siavash Khasha, our designer, brought a fresh, sophisticated sensibility to bear in bringing the pages of this book to life, making each spread feel so personal.

Chris Frey, Jason McBride, and Linda Besner, Anna Fitzpatrick—our writers—skillfully turned our interviews into stories that make readers feel as though they have spent time with every person featured here. Thank you, Chris, for pushing back and granting us the book we love. Tabatha Southey and Raihan Abir, our narrative writers, shared their personal impressions of Canada and enriched our book. Rosemary Shipton, our executive editor, brought her wealth of experience in overseeing development from concept to finished book. Doug Laxdal of Gas Company Inc. skillfully retouched the photographs. Our friend Sara Angel gave us sage advice and introduced us to Charles Foran, Yann Martel, and PEN Canada. A special thank you to Yann for having faith in our project and writing such a thoughtful and passionate Foreword. Megan Cuff, our project manager, supported us throughout our uphill battles as first-time authors—and joined in the fun times. Harry Endrulat, our copy editor and proofreader, ensured that every detail was perfect. We're also grateful to the team at Camp Jefferson for making our voice stronger—and the talented teams of 123w, Jumpwire Media, House of Anansi Press, and Viva & Co.

In addition, we want to thank our family and friends Julie Albert, Marion Annau, Anne Marie Armstrong, Reuven Ashtar, Barry Avrich, Rosalie Baybay, Lawrence Baslaw, Amar Bhalla, Alexandra Bennett, Andrew Black, Vickery Bowles, Randy Boyagoda, Stacey Bozak, Rick Broadhead, Sarah Bull, Susan Caron, Jennifer and Heejae Chae, Rob Collins, Michael Cuff, Girlee De Assis, Carol Devine, Cecily and James Eaton, Amoryn Engel, Marilyn Field-Marsham, Patricia Fogler, Charles Foran, Mark and Maryann Gaskin, Naomi Gaskin, John Gerhardt, Anneke and Wandia Gichuru, Lisa Gnat, Tamzin Greenhill, Kyra Griffin, Rudyard Griffiths, Jane Halverson, Kevin Hanson, Victor Harding, Jennifer Harkness, Samantha Haywood, Peter Herrndorf, Zoe Huggins, Glen Hunt, Valerie Hussey, Rhoda Jakobsson, Victor Jakobsson, Magda and Scott Jeffrey, Vida Juozaitis, Scot Keith, James Kemble, David Kent, Derek Kent, Elisabeth Klem, Esther Koimett, Alek Krstajic, Anna Kwiecien, Myles Lane, Dale Lastman, Heidi Legg, Brian Levine, Cathy Levy, Jennifer Lombardi, Melissa Manly, Brett Marchand, David Maughan, Michael McAllister, Kristi McCormick, Gavin McGarry, Mark McQueen, Alexandra Milenov, Niccola Milnes, Abena Morgan, Ben Mulroney, Mark Mulroney, Amie and Anthony Munk, Logan Munk, Joanne Niblock, John Ozikizler, Gillian Pitt, Lynda Prince, Dave Purdy, Mary Puyawan, Roger Rai, Jeffrey and Lucia Remedios, Alexandra Rideout, Kim Ridgewell, Mike Robitaille, Safta, Robert Samuels, Reza Satchu, Sarah Scott, Daniel Shapiro, Colene and Tony Sharpe, Louise Sicuro, Kiren Singh, John Stackhouse, Sharon Stewart-Guthrie, Marlo Sutton, SVBS, Anne Ullman, Ayca Uzumeri, Margot van Bers Stresser, Angela Warburton, Grace Westcott, Paula Whitmore, Sydney Wills, and Moira Wright for understanding the book madness and being there for us.

Finally, special thanks to all thirty-three Canadians featured in this book. Your humility and desire to champion our country's idea of freedom and the power it has to transform lives is heart-warmingly selfless and patriotic. To express our gratitude for what Canada has given us, proceeds from book sales will be donated to PEN Canada to support its efforts to educate, protect, and defend the fundamental right to freedom of expression. Why? Because *Glorious & Free* is about challenging, exploring, and imagining a better world—about being whoever we dream ourselves to be. And freedom of expression protects our right to do so.

Additional Credits

Photography

Michael Graydon, image of Alex Josephson's apartment, page 19.

Christian Pondella, image of Will Gadd, courtesy of Red Bull Content Pool, page 129.

Greg Mionske, image of Will Gadd ice climbing on Mount Kilimanjaro, Tanzania, courtesy of Red Bull Content Pool, page 136.

Richmond Lam, images of Aurélie Rivard at Olympic Park, pages 176, 177, 181.

Joseph Hartman, image of Ed Burtynsky on riser at Bonneville Salt Flats, Utah, page 183.

Richmond Lam, images of Coco Rocha, beginning on page 314.

François Goupil, courtesy of Orchestre Métropolitain, image of Stéphane Tétreault and Yannick Nézet-Séguin, page 331.

Angela Lewis, images of Liane Thomas, beginning on page 334.

Peter Schiazza, images of Scotty Sussman, beginning on page 352.

Susan Rowsell, image of mural Qanuqtuurniq, courtesy of MU, page 382.

Art

Edmund Alleyn (b. 1931-2004), *Iceberg Blues*, 1973-1975, page 238. (Acrylic and oil on canvas, acrylic on Plexiglas. Painting: 183 cm diam.; 3 panels: 188 x 75 cm, 188 x 150 cm, 188 x 75 cm. Courtesy Montreal Museum of Fine Arts; gift of Jennifer Alleyn and the R. Fournelle, Robert Allard, and Charles Cole Fund, the Museum Campaign 1988-1993 Fund.)

Claude Cormier (b. 1960), *Stuffed Animals*, 2012, page 246. (3,000 stuffed animals, wood. Assembly: Georges Audet. On loan from Claude Cormier, Claude Cormier et Associés Inc.)

Qanuqtuurniq, an Embassy of Imagination mural project in Montreal created by Saaki Nuna, Johnny Samayualie, Tommy Quvianaqtuliaq, and Salomonie Ashoona, page 382 at left.

Typography

Classic Grotesque
Designed for the foundry Monotype by Canadian designer Rod McDonald (b. 1946), Classic Grotesque is a sans-serif typeface family influenced by three vintage, early twentieth-century fonts: Venus, Ideal Grotesk, and Monotype Grotesque. Unveiled in 2016, the new typeface was the culmination of eight years of research, sketching, testing, and redefinition by McDonald—widely regarded as one of Canada's foremost typographers—with the goal of creating a flexible, contemporary font family that works equally well on page and on screen

Noe Display
Created by Lauri Toikka and Florian Schick, and released in 2013, Noe Diplay mixes many formal attributes of classic, Victorian-era display type with more bold and expressive mid-twentieth-century touches.